ANTHONY CARO

Thames and Hudson
London

William Rubin

ANTHONY CARO

This book was published on the occasion of a retrospective exhibition of Anthony Caro's work presented by The Museum of Modern Art, New York, and The Museum of Fine Arts, Boston. The exhibition was organized in association with The British Council, London, and with the support of The National Endowment for the Arts, Washington, D.C.

Originally published in 1975 by The Museum of Modern Art, New York
First published in Great Britain in 1975 by Thames and Hudson Ltd, London
© 1975 by The Museum of Modern Art

Printed in the United States of America

Frontispiece: Anthony Caro. London, 1974

CONTENTS

LIST OF ILLUSTRATIONS

Works are listed in the sequence established by the artist's records. Page numbers marked with an asterisk indicate works reproduced in color.

Overleaf: Anthony Caro. Bennington, Vermont, 1965

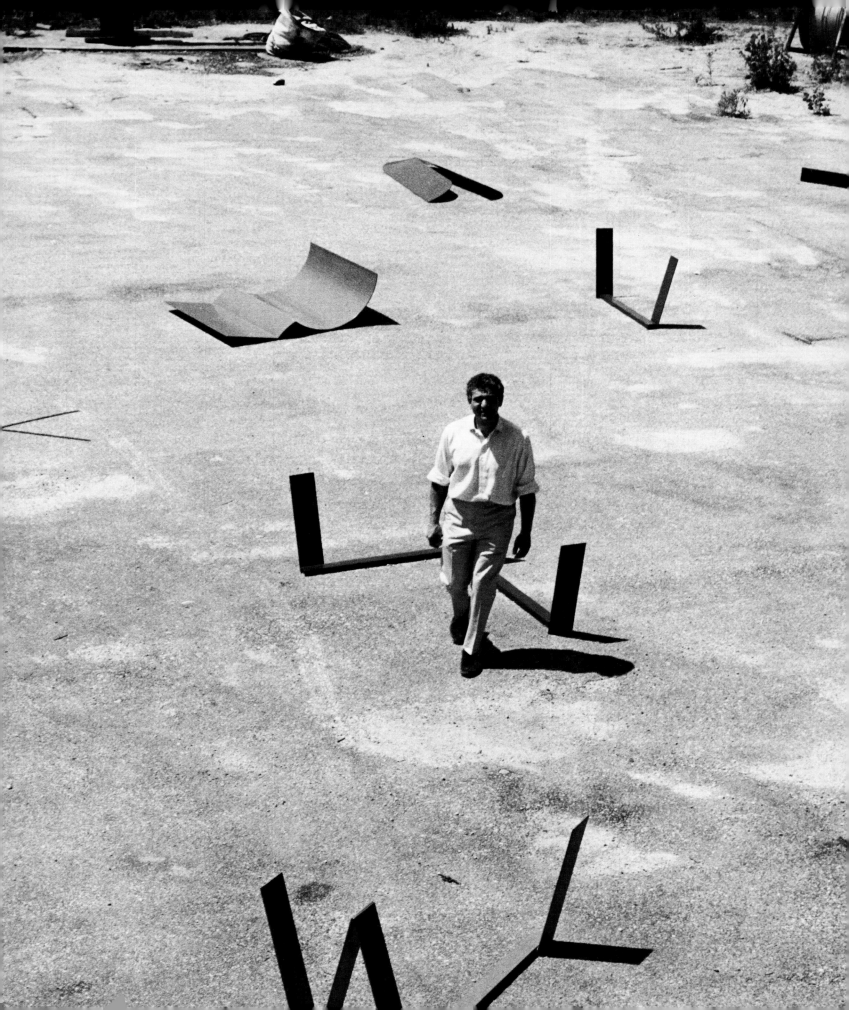

ACKNOWLEDGMENTS

WHILE not a catalog of the exhibition, this monograph commemorates the 1975–76 retrospective of Anthony Caro's work. As author of the book and codirector of the exhibition, I am obliged to many individuals and organizations for their generosity and assistance in bringing this project to fruition. Foremost among these are the artist himself and his wife, Sheila, whose knowledge of her husband's work and perceptive judgments about it have been most helpful. Both have participated in all phases of the exhibition and the book. (Any citations of the artist in the text of this monograph which are not attributed in the notes derive from my conversations with him.) Also participating in the planning of the exhibition, since its inception, has been Kenworth Moffett, Curator of Contemporary Art at the Museum of Fine Arts, Boston, which has coproduced the exhibition with The Museum of Modern Art.

A sculpture exhibition as comprehensive as the Caro retrospective—especially given the size and character of the work—is an unusually difficult project from the logistical and, hence, also from the financial point of view. Richard E. Oldenburg, Director of The Museum of Modern Art, undertook with immense energy and goodwill to obtain the funds which would enable the show to take place. His success in this has been enhanced by assistance from Richard L. Palmer, the Museum's Coordinator of Exhibitions, who has firmly taken in hand all the complicated logistics of the project and the negotiations with participating museums.

The funds that have made the exhibition possible have come largely from two sources: The National Endowment for the Arts, whose Chairman, Nancy Hanks, and John Spencer, Director, Museum Program, have given enthusiastic support; and The British Council, to whose Chairman of the Fine Arts Advisory Committee,

Sir Norman Reid, and whose Directors of the Fine Arts Department, John Hulton (active during the inception of the project) and Gerald Forty, we are especially indebted. We are also grateful to the North Atlantic Westbound Freight Association for making a reduction in the ocean transport costs from England to the United States.

The Fine Arts Department of The British Council has also played an important part in the planning and execution of the exhibition. Its officers, consulted in establishing the catalog, have taken in hand all the logistics of restoration, packing, and shipping associated with the many English loans, and have helped by supplying much detailed information and photographs needed for this monograph. For all these enthusiastic services, we are especially beholden to Margaret McLeod, Assistant Director, and Ian Barker, Exhibitions Officer.

Dealers representing Anthony Caro have been of great assistance in the various aspects of the exhibition, notably the André Emmerich Gallery, New York, and the David Mirvish Gallery, Toronto. John Kasmin, Caro's earliest champion among dealers, was of great help, especially early in the project, and his assistant, Ruth Kelsey, obtained many photographs and documents for us.

The sculptors Willard Boepple and James Wolfe, friends of Tony Caro, have participated from the beginning in connection with the restoration and shipping of the works, and have joined with the Museum staff in installing the exhibition. In England, Carlos Granger and Pat Cunningham, Tony Caro's assistant, lent their efforts to restoring the works and making arrangements for their transport; Tom Hunter and Charlie Hendy assisted with the restoration. Meg Perlman, a Ford fellow in the Museum Training Program, made the scale models of the sculpture necessary for the planning of the installation.

Many members of the Museum staff beyond those already mentioned have made important contributions to the exhibition or the book, and, in a few cases, to both. Principal among them, Jane Necol, Curatorial Assistant for the exhibition, has attentively coordinated matters relating to loans and installation, and dispatched numerous other tasks associated with the publication. Carolyn Lanchner, Chief Researcher, made important contributions to the text and notes, and William Feldman to the bibliography; Elinor Woron, of the Boston Fine Arts Museum staff, prepared the chronology. Judith DiMeo, Researcher, worked diligently at gathering

documentation early in the project. My secretary, Sharon McIntosh, has had a hand in almost every phase of the book and exhibition and has done yeoman work as always.

Once again I had the pleasure of working with Francis Kloeppel, who perceptively edited a difficult manuscript. Fred Myers, working against an imminent deadline, designed a most handsome book, which was ably and enthusiastically seen through production by Jack Doenias. Frances Keech, Permissions Editor, has also worked earnestly on the publication.

Among the staff members whose important contributions apply to the exhibition in particular are Jean-Edith Weiffenbach, Senior Cataloger, Betty Burnham, Associate Registrar, and Pat Houlihan, Sculpture Conservator.

The success of any exhibition depends on the generosity of the owners of key works, who are deprived of the pleasure of their works during what is, in this case, a lengthy tour. Apart from four important lenders who wish to remain anonymous, our deepest thanks are due to Leslie Feely, Henry and Maria Feiwel, Helen Frankenthaler, Mr. and Mrs. Robert Geddes, Guido Goldman, E. Donald Gomme, Mr. and Mrs. Clement Greenberg, Kenneth Noland, Jules Olitski, and Hanford Yang; Acquavella Contemporary Art, Inc., André Emmerich Gallery, Kasmin Limited, The David Mirvish Gallery, and The Waddington Galleries; The Arts Council of Great Britain, Cleveland Museum of Art, Storm King Art Center, and The Trustees of The Tate Gallery.

W.R.

Dimensions of sculptures are given in feet and inches, with height preceding width and depth. SIGHT is dated 1965/69 to indicate the date of the original conception and the execution of the actual work. FARNHAM is dated 1965/69 because it is a 1969 reconstitution by the artist of a 1965 work (titled BARFORD) which was inadvertently destroyed.

ANTHONY CARO

IT TAKES only one great artist to keep a tradition alive. And through much of its history, the tradition of constructed sculpture has lived almost that precariously. Invented by Picasso, whose constructions offered the first alternatives to certain fundamental assumptions about sculptural aesthetics and methods since ancient times, it was virtually reinvented by David Smith. Since the latter's death, its destiny has been very much in the hands of Anthony Caro.

Of the diverse sculptural traditions of the past hundred years, this Cubist-derived constructivism is the most paradigmatic of the modern sensibility—and the most liberating for sculptors. Yet up to now its practitioners have produced far less major art than sculptors who continued the familiar methods of carving and modeling. The liberation from the monolith accomplished in Picasso's 1912 constructions did not produce broad immediate repercussions. Perhaps because of its very radicality, Picasso's sculpture was not as readily assimilated as Cubist painting, and its full implications were realized only after World War II.[1] Cézanne had prepared the way for Cubist painting, which was thus a chapter in an ongoing history, and such painters as Léger and Delaunay owed as much to Cézanne as to Picasso and Braque. Picasso's invention of openwork constructed sculpture, on the other hand, had not been anticipated by other artists.[2] It was a singular event, closer to the center of his particular genius than had been his role in the creation of Cubist

painting. From the present-day perspective it is clear that Picasso changed the art of sculpture more than any carver or modeler since the cavemen.

Despite its unexpectedness, Picasso's concept of construction did become a point of departure for a handful of sculptors—notably the Russians Tatlin, Rodchenko, Gabo, and Pevsner, but also Laurens (for a brief period), Gonzalez, and Calder. Their broadening of constructivism notwithstanding, the eve of World War II found most of the best modern sculptors—Brancusi, Lipchitz, Arp, Giacometti, Matisse, Moore, and even Picasso himself—working with modeled or carved solids within the aesthetic range these methods impose. From the perspective of that moment, it appeared that the then quarter-century-old practice of constructivism would remain a secondary aspect of sculpture.

Thus the situation might have continued had not David Smith extrapolated from the initiatives of Picasso and Gonzalez an immense range of sculptural ideas. Not only was Smith's the best sculpture of the decades immediately following the war, but in the United States at least, it firmly established welded construction at the center of the art. Within this propitious atmosphere a good deal of first-rate openwork metal sculpture began to be made in America[3]—besides Smith one thinks especially of Herbert Ferber and Seymour Lipton—and, unlike much of the best work of the century's opening decades, it was made not by painters but by full-time

sculptors. This situation gave rise to a considerable optimism in America regarding the immediate future of the art, an expectation supported by the best criticism of the time. Sculpture's inherent literalness promised possibilities of going beyond painting in the very direction that painting seemed to have staked out. "The same evolution in sensibility that denied to painting the illusion of depth and representation," wrote Clement Greenberg in 1949,

made itself felt in sculpture by tending to deny it the monolith, which in three-dimensional art has too many connotations of representation. Released from mass and solidity, sculpture finds a much larger world before it, and itself in the position to say all that painting can no longer say. The same process that has impoverished painting has enriched sculpture. *Sculpture has always been able to create objects that seem to have a denser, more literal reality than those created by painting; this, which used to be its handicap, now constitutes its greater appeal to our . . . positivist sensibility, and this also gives it its greater license. It is now free to invent an infinity of new objects and disposes of a potential wealth of forms . . .* [which have a] *self-evident physical reality, as palpable and independent and present as the houses we live in and the furniture we use.*[4]

By the end of the fifties, however, it was clear that this promise was not being fulfilled. "Art delights in contradicting predictions made about it," Greenberg was then to write, "and the hopes I placed in the new sculpture ten years ago . . . have not yet been borne out—indeed they seem to have been refuted."[5] When Greenberg published this in 1958, America had not only seen the coming of age of the pioneer Abstract Expressionist painters, but was on its

BULL. *1954. Bronze, 6 1/2" h. Art Gallery of Ontario, Toronto. Gift of Sam and Ayala Zacks.*

MAN HOLDING HIS FOOT. *1954. Bronze, 26 1/2" h. Private collection, London.*

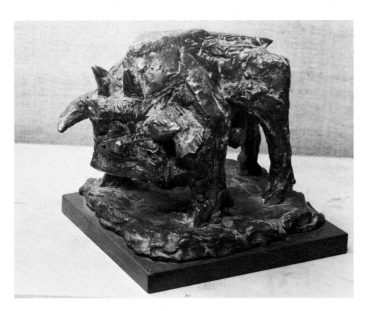

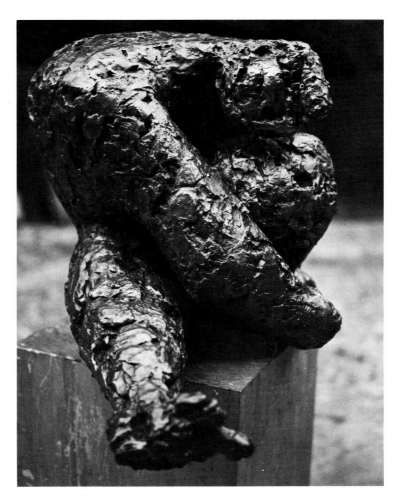

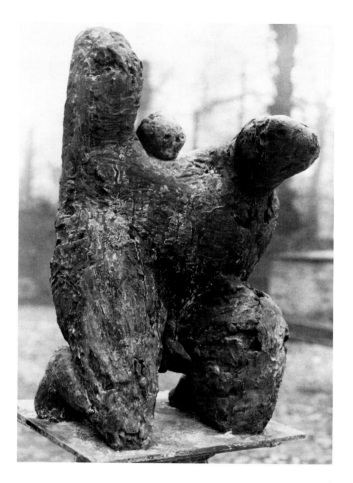

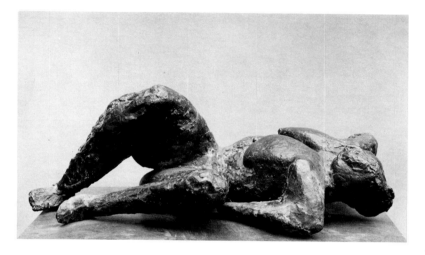

MAN TAKING OFF HIS SHIRT. *1955–56. Bronze, 31" h. Collection Phillip King, London.*

WOMAN WAKING UP. *1955. Bronze, 26" l. Collection Mrs. Henry Moore, Much Hadham, Hertfordshire.*

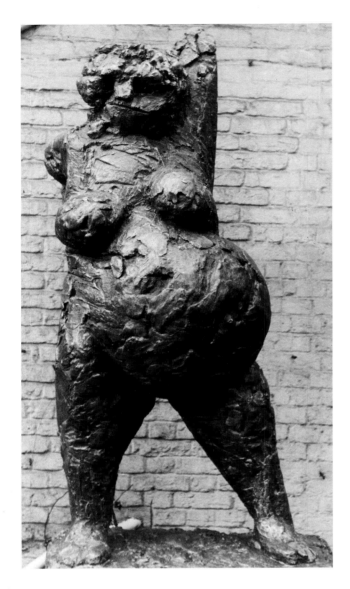

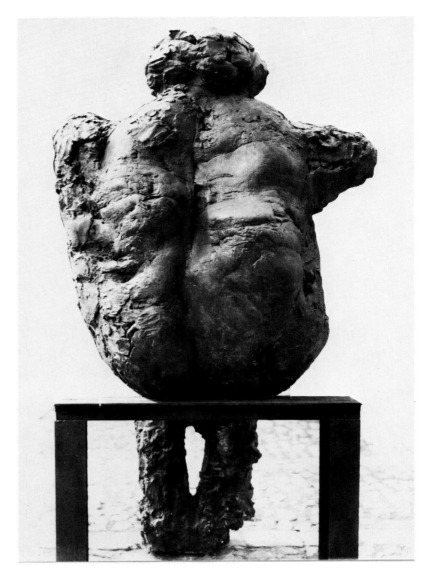

WOMAN IN PREGNANCY. *1955–56. Plaster for bronze,
79″ h. Destroyed.*

WOMAN'S BODY. *1959. Plaster for bronze, 74″ h. Destroyed.*

way to producing a younger generation worthy of comparison with them. Francis, Louis, Rauschenberg, Frankenthaler, Johns, Held, and Kelly had already established their styles; Noland was beginning his circles and Stella was moving into his Black series. Sculpture seemed, if anything, worse off than before, at least insofar as no second generation of real interest had appeared.

It became increasingly evident that the radical "breakthroughs" which marked the history of painting between 1947 and 1954 had had no counterpart in the history of sculpture. Even the work of Smith had remained visibly more dependent on inherited figurative conceptions than had that of Pollock in his "allover" period. The amalgam of Cubism and Surrealism that Smith shared with Pollock during the early and middle forties—the latter's "totem" period—persisted through most of the transformations in Smith's sculpture long after it had disappeared from Pollock's painting. That this relative conservatism of advanced sculpture bore no necessary qualitative implications was generally overlooked in a period when artists and critics put a maximal premium on "the new." Painting and sculpture, however, were at very different stages in their history. While painters were draining and discarding conventions very rapidly and were thus under pressure to invent new ones, Smith had found himself face to face with the original assumptions of constructed sculpture, which had hardly been explored, much less exploited.

The radical pictorial structures invented by the major Abstract Expressionist painters were, unlike Cubism, uniquely bound to the nature of painting itself (and therefore resisted transposition from one art to another). Some formal affinities can, of course, be observed between sculptures by Smith or Ferber and paintings by de Kooning or Kline. But these affinities are largely superficial; where profound—as in the parallelism of Lassaw and Guston—they represent functions of retardataire painting styles.[6] When, in the later fifties, some younger sculptors tried to adapt the de Kooning-Kline mode of painting to the purposes of sculpture, the results were disappointing. Di Suvero might substitute beams and chains for Kline's more abstract painted shapes[7] or Chamberlain adapt the morphology and color of de Kooning to crushed car parts, but in the process the pictorial ideas were vulgarized. The insistent tactility and frequently monumental size of the work of these younger sculptors made manifest a rhetoric implicit in some Abstract Expressionist painting. At the same time, the particularizing of the forms (e.g., chains and beams for brushstrokes) effaced the poetic ambiguity of the original pictorial conceptions. Twice removed from the original impetus of Abstract Expressionism (by passage of time and change of medium), this "Tenth Street" sculpture was inferior to "Tenth Street" painting. The secondary position of sculpture in the late forties and the fifties was not, however, totally disadvantageous. The relative absence of figures

TWENTY-FOUR HOURS. *1960. Steel, painted, 4' 6 1/2" x 7' 4" x 2' 9". Collection Mr. and Mrs. Clement Greenberg, New York.*

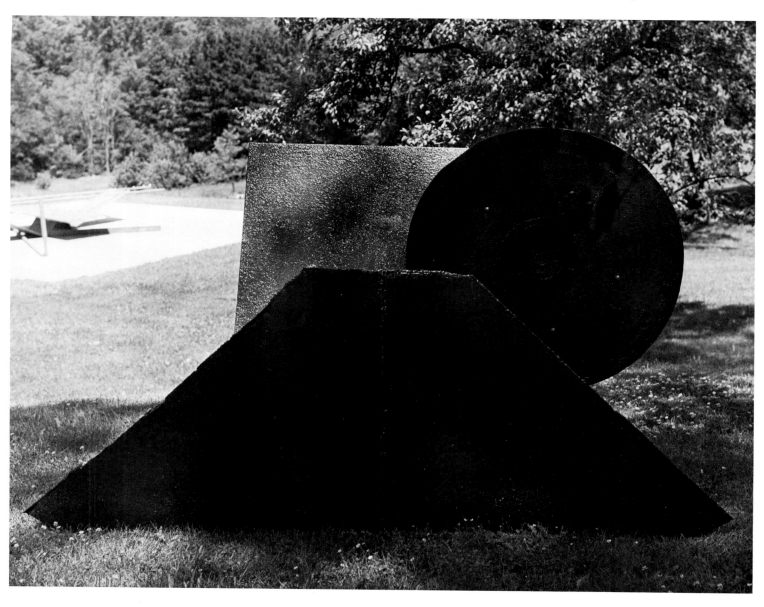

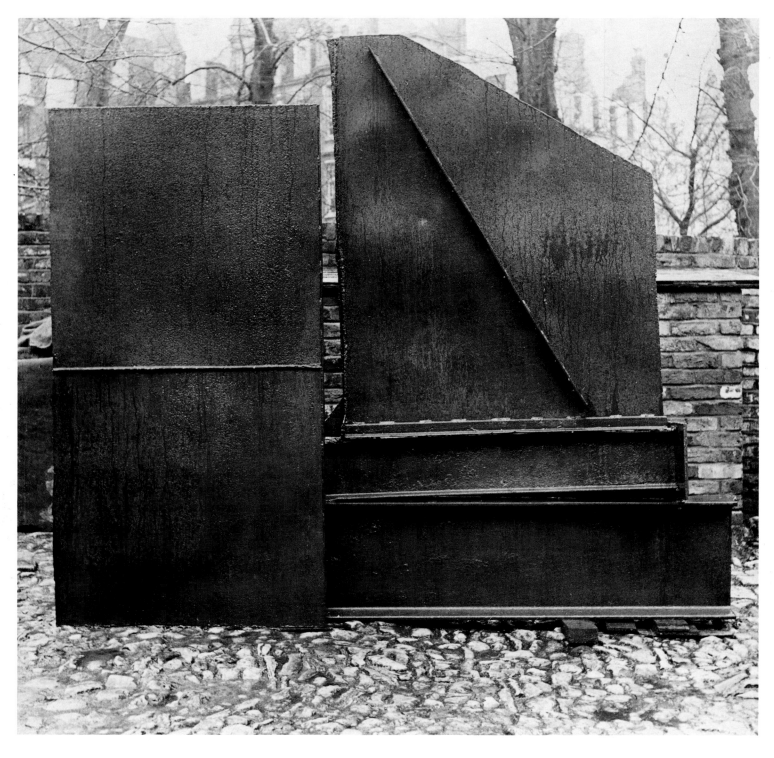

SCULPTURE 2. *1960. Steel, painted, 7' 6" x 8' 5 1/2" x 1' 4". Private collection, London.*

Opposite: MIDDAY. *1960. Steel, painted, 7' 3/4" x 3' 1 3/8" x 12' 1 3/4". The Museum of Modern Art, New York. Mrs. Bernard F. Gimbel Fund.*

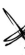

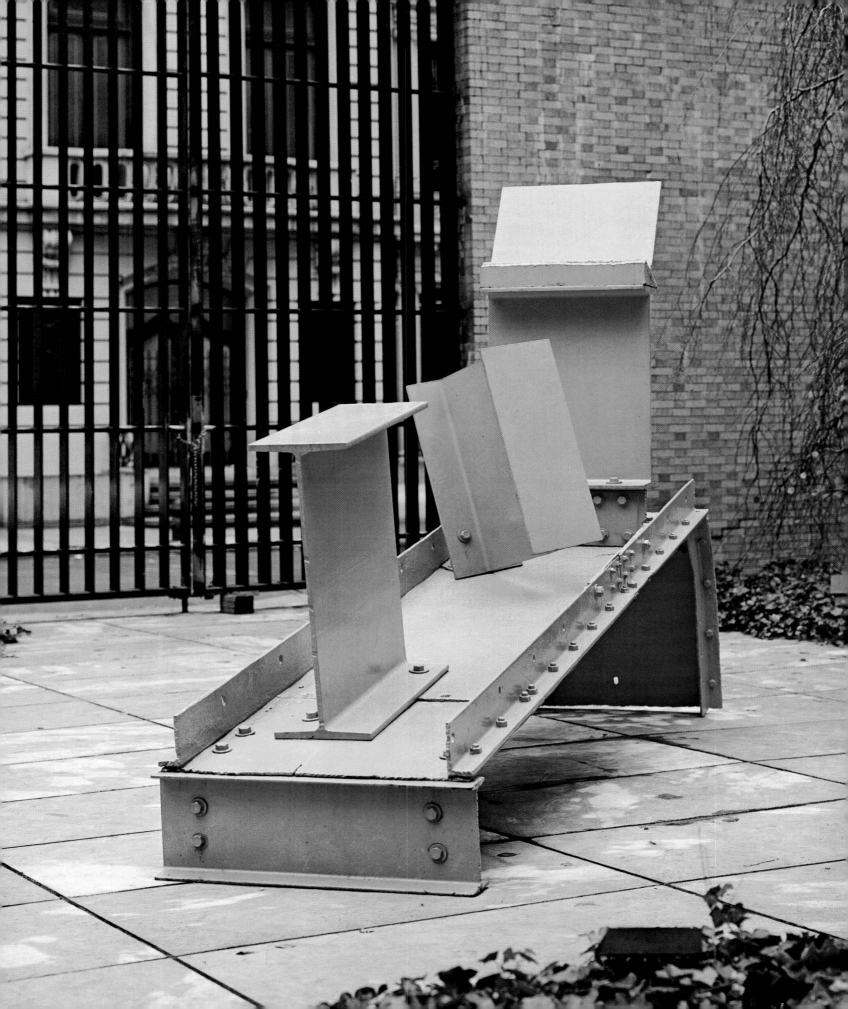

as towering as Pollock and de Kooning[8] lowered pressure and favored the development of such authentic if less ambitious talents as Gabe Kohn, Richard Stankiewicz, Peter Agostini, Louise Nevelson, and Louise Bourgeois. Sculptors seemed freer to explore tangential areas, meander stylistically, investigate more modest, more intimate ideas.

The work of both Smith and Caro bears witness to the inherent conservatism of the best postwar sculpture—a conservatism that would be challenged only in the sixties by the consciously programmatic radicalism of the Minimalists (whose work, despite superficial similarities, is at odds with the constructivist tradition).[9] To be sure, both Smith and Caro considered their break with past art as radical as that of the leading postwar painters, their stylistic focusing-down as stringent. And in some ways it was. Taken as a whole, however, their work emerged as much more varied and inclusive than that of the painters. Abstract Expressionism had progressed by means of an implicit dialectic that called for increasing the intensity (and, it was hoped, the profundity) of the pictorial statement by narrowing its means through jettisoning expendable conventions.[10] In effect, advanced painters intuitively posed the question: "Can I leave this convention out and still create a high order of painting?" This attitude produced a number of "signature" styles characterized by narrowly defined configurations. The range and variety of Smith's and Caro's work as much if not more suggest

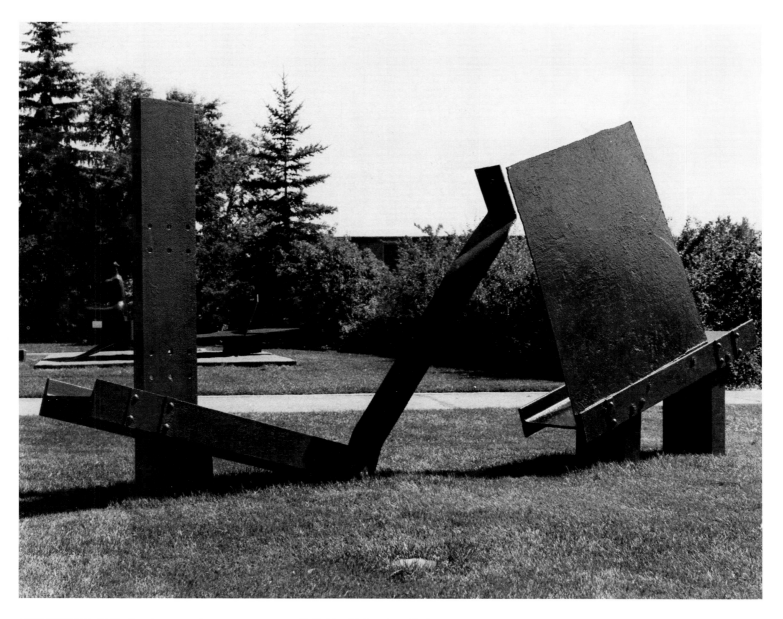

THE HORSE. *1961. Steel, painted, two parts, overall 6' 8" x 3' 2" x 14'. Collection Mr. and Mrs. David Mirvish, Toronto.*

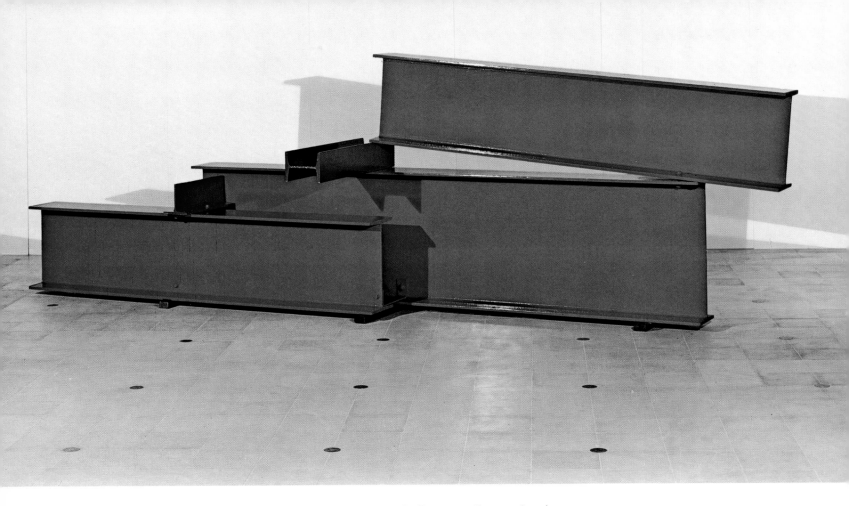

SCULPTURE 7. *1961. Steel, painted, 5' 10" x 17' 7 1/2" x 3' 5 1/2". Private collection, London.*

the question: "Is this convention still viable—can I leave it in (or reinstate it) and still make a high order of sculpture?" Given all his art left out of the vocabulary of sculpture, it may seem farfetched to consider Smith's oeuvre "conservative." But in the context of what the constructivist tradition had previously realized, it seems clear to me that Smith was bent on conserving the maximum range for the art of sculpture by incorporating into constructivism much of what its earlier exponents had omitted. In a decade marked by the severe reductionism of Minimalist sculpture, Caro adopted Smith's generosity vis-à-vis his art, and expanded upon it.

During the late fifties in his native England, Caro had modeled a series of massive expressionistic figures (pp. 18–20) whose intensity of feeling overstrained their sculptural means. Aware that his stylistic vehicle was inadequate, he was ripe for a change when, in 1959, he visited America. Here he saw one "sentinel"-type piece by David Smith (he would see more of Smith's work in 1963) and some work by Richard Stankiewicz and Gabe Kohn. Some months later Caro gave up bronze for steel, modeling for additive construction, and realism for abstraction. This rapid metamorphosis was encouraged by Clement Greenberg—"If you want to change your sculpture, change your habit of working"—and was confirmed by Caro's contacts with Kenneth Noland, with whom he formed a lasting friendship in 1960. Noland's influence was important in

giving Caro the necessary impetus for the total redirection of his art, and Caro feels that the fact that Noland painted on the floor had some influence on the evolution of the low, lateral character of his sculpture. For the most part, however, their respective enterprises turned out to have little in common."

Though Caro's new work followed logically in the development of large-scale construction sculpture, it had, from the first, only limited resemblances to that of Smith. Indeed, so secure has Caro been of impressing his own conceptions, his own personality and sensibility, on his work that he has freely incorporated in it elements shaped by Smith (as in *Cool Deck*, p. 110) that he purchased from the Smith estate. Along with the work of the painters he liked—Pollock, Newman, Louis, and Noland—Smith's work functioned as a point of departure for Caro, a model of freedom, ambition, accomplishment, and, above all, technique. Eighteen years older than Caro and at the height of his career, Smith worked in a way that opened onto possibilities very different from the models available to Caro in England or on the Continent. "His late work showed me how to get away from found objects,[12] patinas and the rest," Caro recalls, "everything that constituted the 'old look.'"

Despite the affinities, major differences existed from the start between Caro's and Smith's work. The most salient of these is the horizontal orientation of Caro's sculptures. Pieces tend to spread out laterally, sometimes hugging the ground, often entirely below

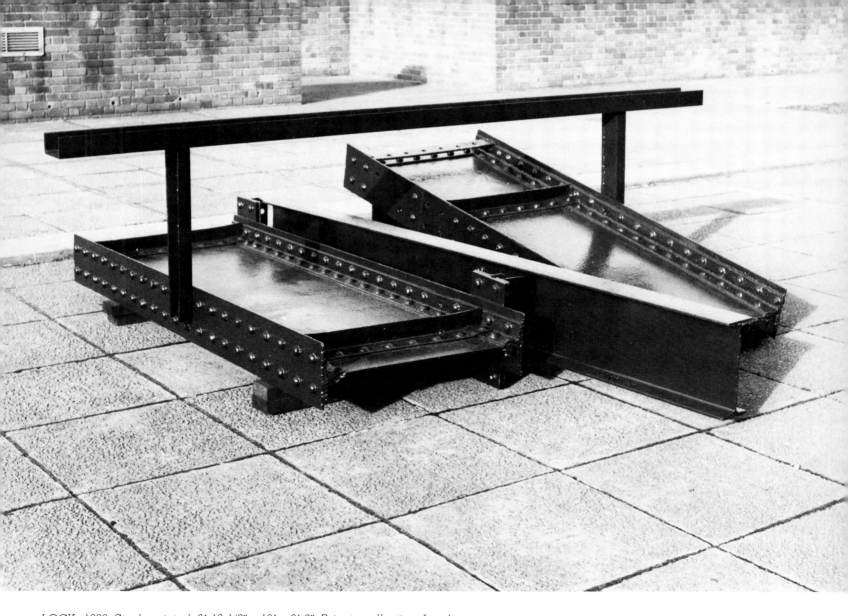

LOCK. *1962. Steel, painted, 2' 10 1/2" x 10' x 9' 3". Private collection, London.*

eye level. Smith's sculptures, despite their openwork character, remain largely totemic, not simply in the sense that they often suggest abstract *personnages* (which he sometimes titled "totems"), but in the broader sense that his work rises vertically from the ground, preserving the kind of "*personnage*-to-person" address that has been traditional for constructed as well as carved or modeled sculpture.

The notion of a sculpture that is to be seen below eye level, indeed against the ground, was not, however, entirely Caro's invention. Inroads into the traditional orientation of the sculptural object to the spectator's eye had already been made in small scale by Degas and Giacometti. Degas's radicality in this regard followed from the fascination with oblique perspectives he had already demonstrated in his paintings.[13] His bather in *The Tub* is revealed only when seen from above—the natural position of the eye when such a work is put on a tabletop or low stand. Giacometti's tabletop sculptures, such as *Point to the Eye* and *No More Play,* represented a more unexpected departure insofar as they were primarily concerned with delineating a lateral (if surreal) space, within which their "figures" function. These sculptures are virtually all base; the two tiny figures in *No More Play* are almost lost in the expanse of pock-marked "lunar" landscape. In *Woman with Her Throat Cut,* Giacometti totally eliminated the base; it was intended that the viewer look down at the piece *on the floor*—which is precisely

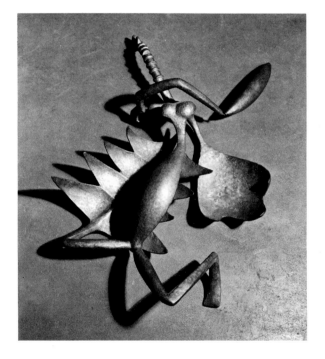

Top, left: Hilaire-Germain-Edgar Degas. THE TUB. *Wax original c. 1886. Bronze (cast posthumously 1920), 16 1/2″ l. The Metropolitan Museum of Art, New York. Bequest of Mrs. H. O. Havemeyer, 1929. The H. O. Havemeyer Collection.*

Top, right: Alberto Giacometti. POINT TO THE EYE. *1931. Wood and metal, 23″ l. Collection Tériade, Paris.*

Bottom, left: Alberto Giacometti. NO MORE PLAY. *1933. Marble, wood, bronze, 23″ x 17 5/8″. Collection Mr. and Mrs. Julien Levy, Bridgewater, Connecticut.*

Bottom, right: Alberto Giacometti. WOMAN WITH HER THROAT CUT. *1932. Bronze (cast 1949), 8″ x 34 1/2″ x 25″. The Museum of Modern Art, New York. Purchase.*

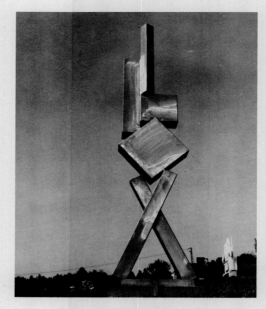

David Smith. CUBI VI. *1963. Stainless steel,
9' 10 1/2" h. Estate of David Smith, Knoedler
Contemporary Art, New York.*

where Giacometti kept it in his studio. While these works of Degas
and Giacometti constitute precedents[14] for low-lying horizontal
sculptures, they had no direct influence on Caro. Moreover, Caro's
low-lying pieces differ from those of Degas and Giacometti in being
altogether abstract and very large. Totally without bases, they
spread out in a way that forces the viewer into cognizance of large
areas of the ground as an integral part of the sculptural expe-
rience—this as opposed to Giacometti's tabletop pieces, which offer
an *illusion* of a ground.

Caro's sculpture is more abstract than Smith's as much by virtue
of its horizontality as its morphology. Sculpture that rises vertically
before the spectator retains by that very fact an inference of
anthropomorphism even if it is not monolithic in character. More-
over, Smith evinced no interest in repressing these implications; to
the contrary, they were essential to his particular poetry. Many of
his openwork pieces contained abstract forms that could easily be
taken to represent fantastic anatomies. Even the configurations of
many Cubi contain semaphoric "gestures" which promote anthro-
pomorphic readings—the "legs" of *Cubi VI* and the "arms" of *Cubi
X,* for example.

The prevailing horizontality of Caro's work militates against such
a reading. The same sort of tank end that suggests an "abdomen"
in Smith's *Voltri Bolton I* has no comparable figurative implications
when we see it in Caro's *Sun Feast.* One might plausibly assume

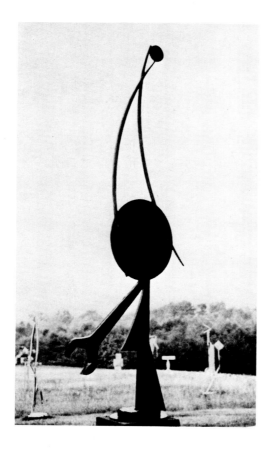

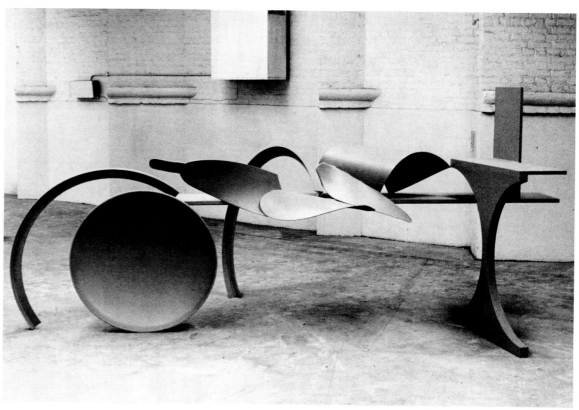

Top: David Smith. VOLTRI BOLTON I. 1962. Steel, 9′ 4 3/4″ h. Collection Dr. and Mrs. Paul Todd Makler, Philadelphia, Pennsylvania.

Bottom: SUN FEAST. 1969–70. Steel, painted, 5′ 11 1/2″ x 13′ 8″ x 7′ 2″. Private collection, Boston.

Below and opposite: SCULPTURE 2. *1962. Steel, painted, 6′ 10″ x 11′ 10″ x 8′ 6″. Collection E. Donald Gomme, Chichester, Sussex.*

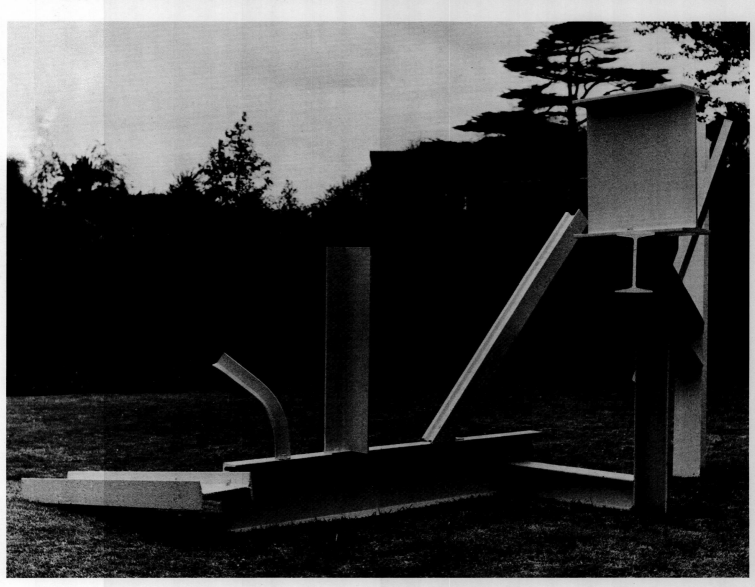

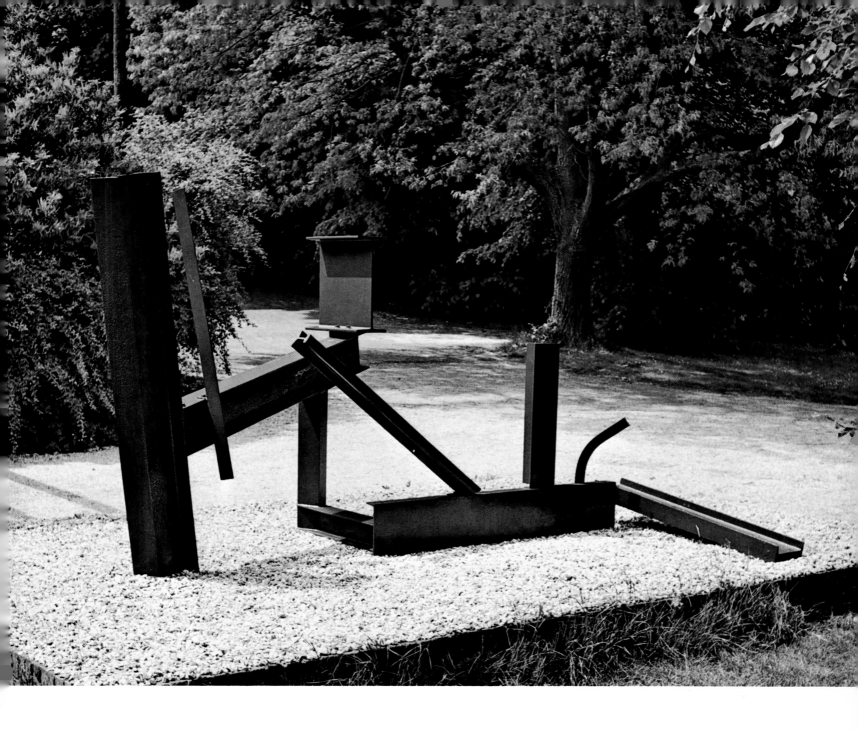

that Caro's horizontality would evoke the landscape or cityscape. But the tendency to form such gestalts from a sprawling configuration is much less strong than the urge to read the very same forms anthropomorphically when they are assembled in a vertical relationship.[15] Caro's suppression of organic shapes, indeed, his elimination of all but simple, constructivist elements, discourages associations with landscape.[16]

Abstraction achieved by using simple shapes had, as such, been characteristic of earlier constructivism; Smith eschewed this reductionism except in the restricted, geometrical vocabulary of his Cubi, on which he was working in 1963 when Caro got to know him well. But Caro's choice of a restricted morphology was dictated by his desire to shift the affective character of the work as much as possible from the forms themselves to the relations between the forms. This new approach was, in turn, favored by the laterally dispersed arrangement of many of his sculptures, which allowed the individual parts a separateness, a discreteness with respect to one another, that would otherwise have been impossible. Sometimes almost random in appearance, these sculptures do not reveal themselves as unities in the instantaneous manner of "totemic" works. Caro's horizontality enabled him to avoid the compactness and visual elision of forms that follow from the very fact of gravity in any vertical pile—a gravity whose functions are recapitulated or reenacted, so to say, by the eye. As a result of resting on the

HOPSCOTCH. *1962. Aluminum, 8' 2 1/2" x 15' 7" x 7'. Private collection, London.*

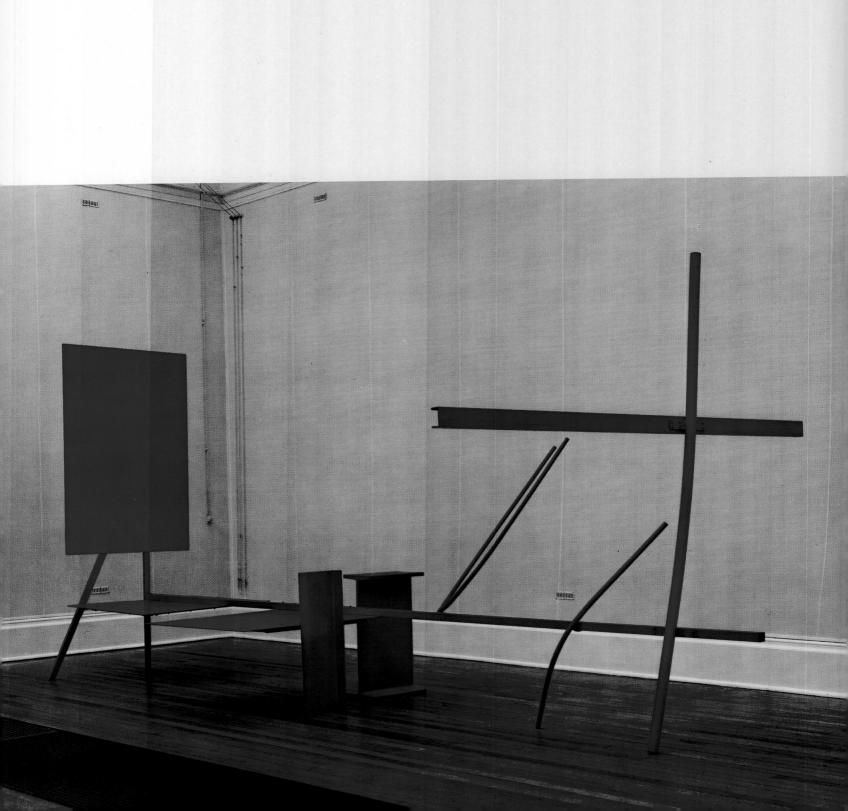

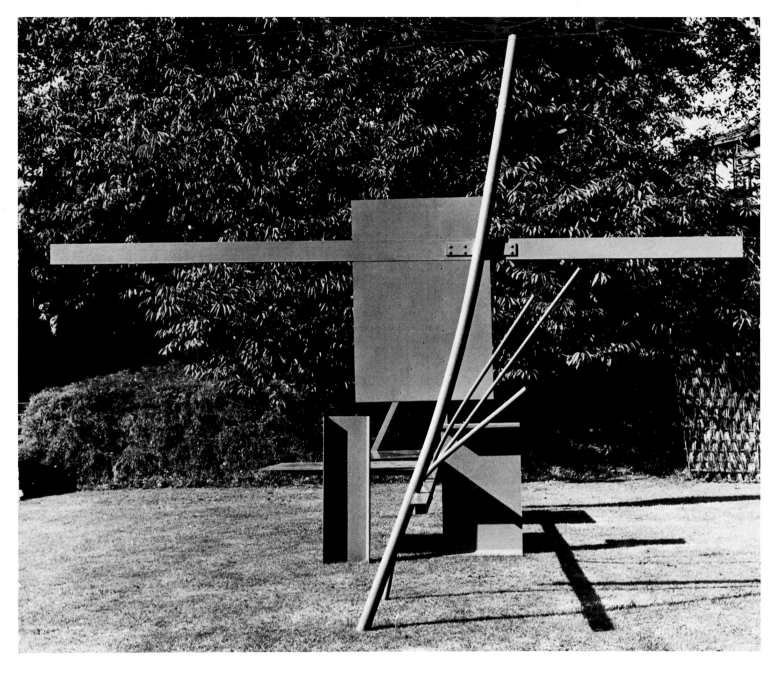

Opposite and above: EARLY ONE MORNING. *1962. Steel and aluminum, painted, 9' 6" x 20' 4" x 10' 11". The Tate Gallery, London.*

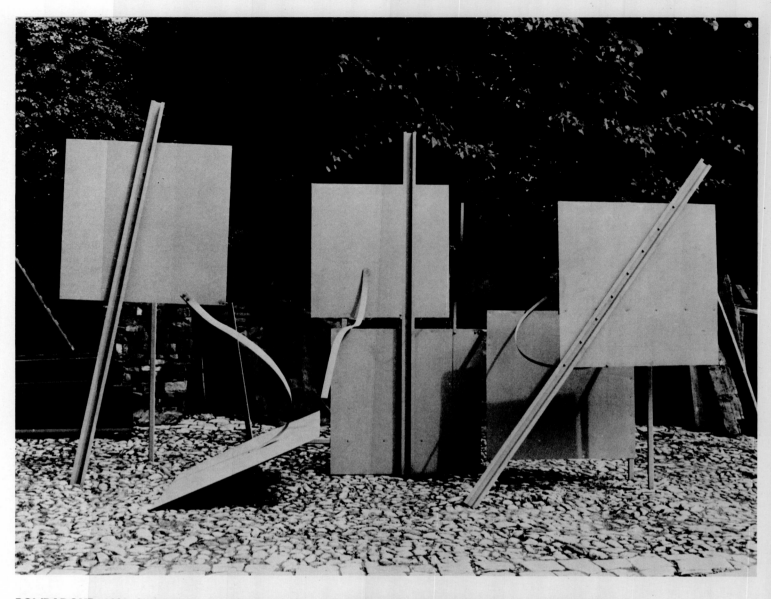

POMPADOUR. *1963. Aluminum, painted, 9′ x 15′ 9″ x 5′ 8″. Rijksmuseum Kröller-Müller, Otterlo, Netherlands.*

ground—or of the particular nature of their levitation (as in *Prairie*, 1967, pp. 86, 87)—the components of Caro's sculptures work relatively more against one another than against gravity.

That Caro's stress on the precise relationship between parts —rather than their individual profiles or morphologies—was the key to his sculpture was first observed by Michael Fried, who described it as a concentration on syntax. "Everything in Caro's art that is worth looking at, except the color," he argued, "is in its syntax."[17] Clement Greenberg, glossing Fried's text, noted that this meant "an emphasis on abstractness, on radical unlikeness to nature." "Caro," he observed, "is far less interested in contours or profiles than in vectors, lines of force and direction."[18]

In the sense that Caro's sculpture is thus, in Fried's words, "wholly relational,"[19] it is antithetic to Minimal sculpture, despite the fact that both styles use simple, geometrical forms. In the sixties there was a tendency to associate Caro with the Minimalists. The simple and restricted forms used by the Minimalists, however, represented an attempt to get away from what these artists called "relational" art—a move influenced to some extent by the so-called "non-relational" configurations that had appeared in the painting of Stella, Noland, and others a few years earlier, which had in turn been implicit in the alloverism of Pollock. "You should have a definite *whole* and maybe no parts," Don Judd insisted, "or very few . . . The parts are unrelational . . . I wanted to get rid of any

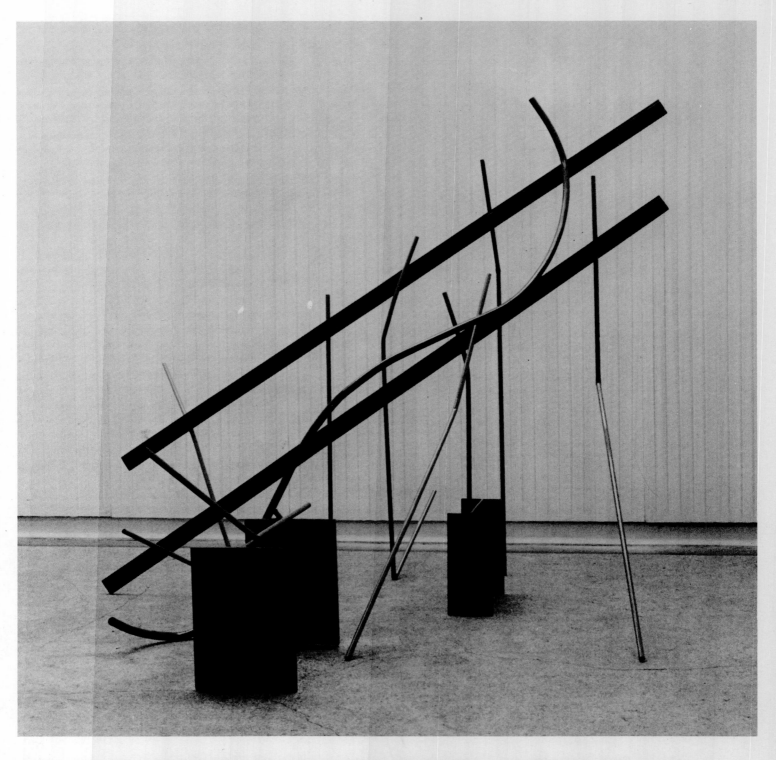

Above and opposite: MONTH OF MAY. *1963. Aluminum and steel, painted, 9′ 2″ x 10′ x 11′ 9″. Private collection, London.*

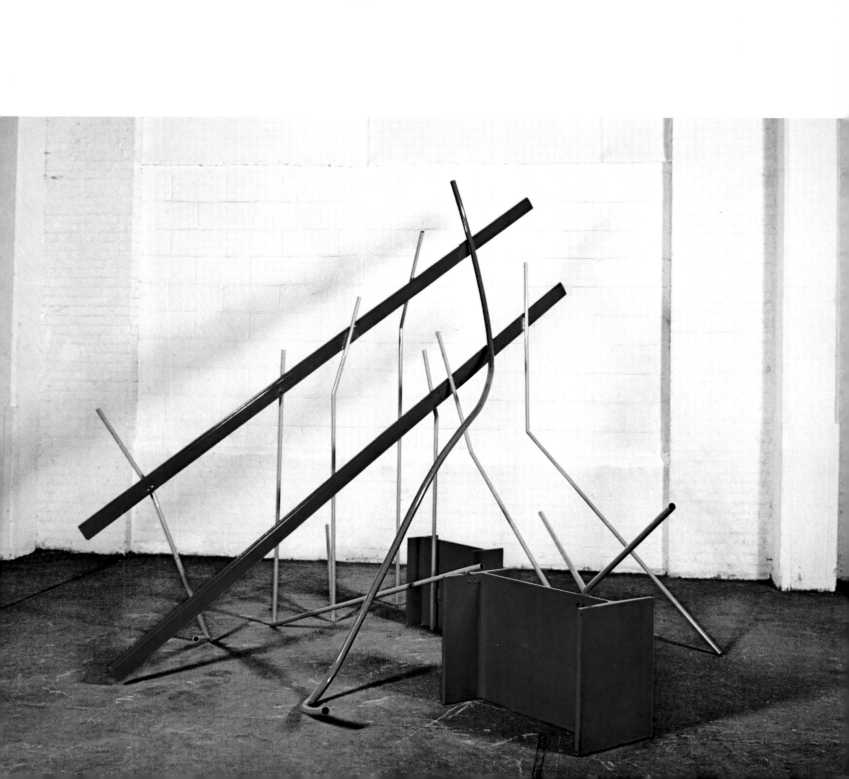

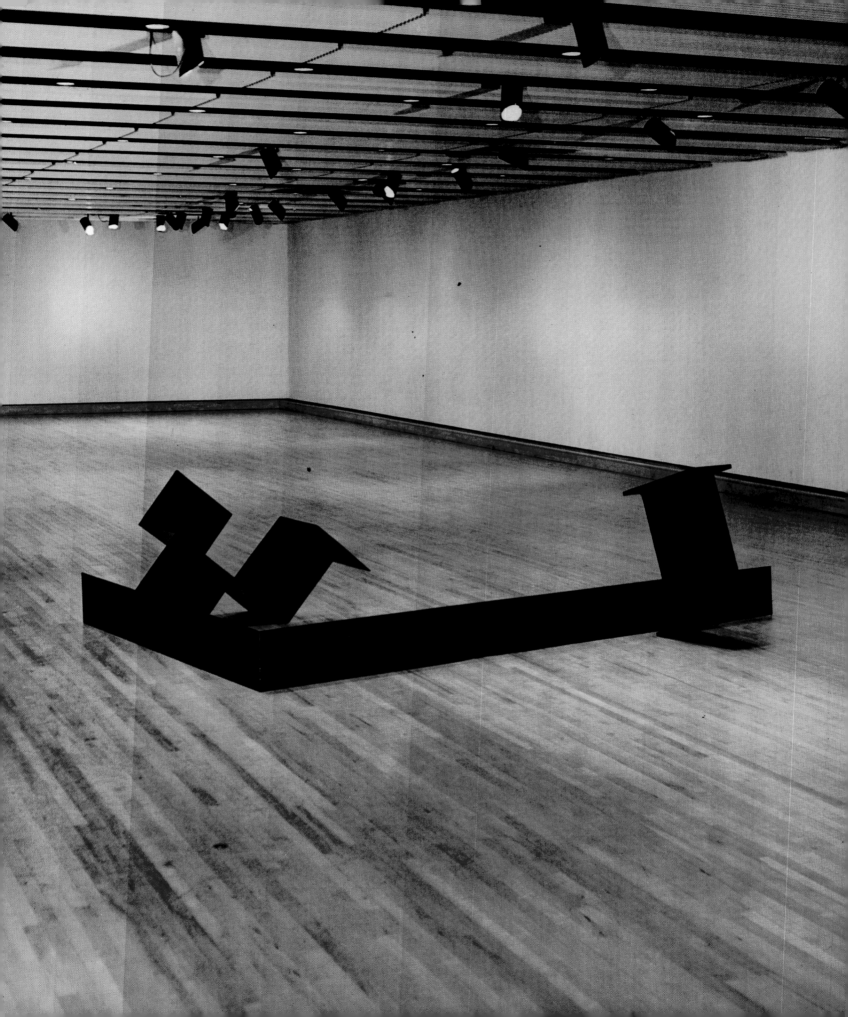

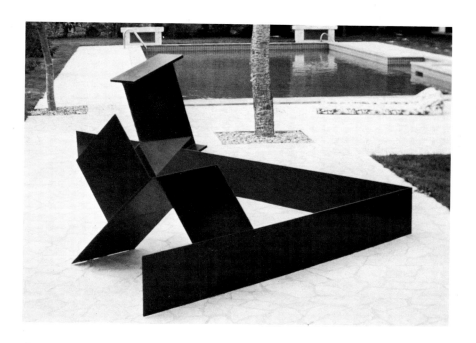

Opposite and above: TITAN. *1964. Steel, painted, 3' 5 1/2" x 12' x 9' 6". Private collection, New York.*

compositional effects . . ."[20] The simplicity of Caro's parts was intended to have precisely the opposite effect, that of thrusting interest entirely into the relations between them—or, otherwise said, into "composition" pure and simple.

If syntax is to be stressed, the parts of Caro's sculptures have to be strongly individuated through differences in shape, size, and inclination. At the same time, these differences must be prevented from being significant, in the sense that no unit may be so expressive that it might direct interest to itself rather than to its relation to other parts. The largely intractable steel components Caro finds for his sculptures are useful to him, as Harry Malcomsen observes, "not so much for what they are as for what they aren't."[21] The shapes are Caro's only insofar as he may cut them down or slightly alter them. With rare exceptions, their profile is chosen rather than made by him. His inventiveness is thus forced proportionately more into the area of their rapports. Some of Caro's best sculptures are limited to three or four discrete elements, all shaped differently, all posed differently, and none particularly interesting in itself. *Titan* (p. 46), for example, is organized in relation to a low, L-shaped form that establishes a right angle; inside this is affixed a kind of opened box or "swastika" form of medium height; outside it is a still higher I-beam. The panels of the "L" are purely vertical, those of the "swastika" are at a 45° angle, and the I-beam is inclined at an angle between the two. Formal description makes the work seem cere-

bral, but in fact our experience of it is quite the contrary. The "swastika" and I-beam seem casually posed against the "L" as if, Andrew Hudson wrote, they had "fallen together by chance . . . their relationship [having] all the resilience and factuality of a natural event."[22]

Such an impression reflects the fact that Caro arrives at his configurations through improvisation—through literally pushing things around—rather than by realizing an a priori concept from a sketch, plan, maquette, or serial system. Lateral dispersion gives him not only a greater field of improvisation than any earlier construction sculptor, but also the opportunity—on the purely practical level—continuously to adjust, change, or eliminate any unit. This is not possible in vertical construction, where most elements in the system are essential to the support of those above them. With each volume that Smith, for example, added to his Cubi, he narrowed both the range of his subsequent moves and the possibility of changing what he had already done—which indicates why those sculptures were realized, with few changes, from drawings. Caro makes no drawings for his sculpture; he works entirely without an a priori plan.

The problem of gravity had already preoccupied Caro in his early figurative work. As Lawrence Alloway noted at the time, he had "an acute feeling for the force of gravity and its operation."[23] The expressionist pathos, the effortfulness of the gestures of figures

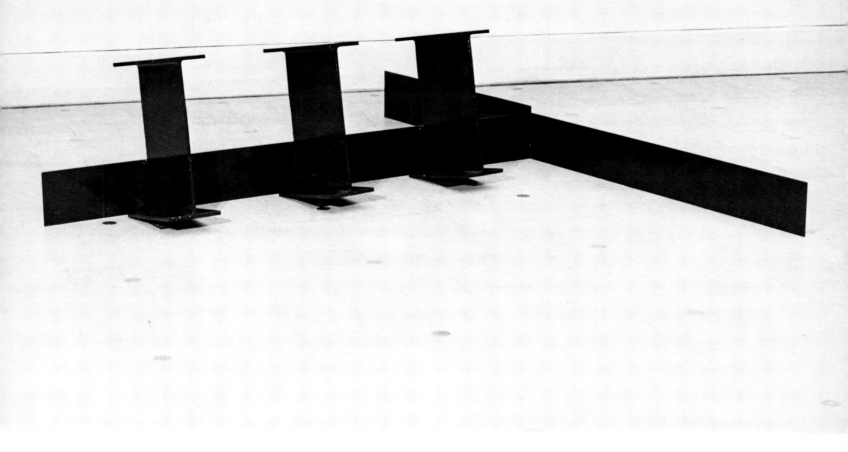

BENNINGTON. *1964. Steel, painted, 3' 4" x 13' 10" x 11' 1 1/2". Collection Jules Olitski, Bennington, Vermont.*

such as the *Man Taking Off His Shirt* (1955–56, p. 19), was carried by the impression of tremendous weight in the tumid bodies and limbs.

Caro's move into lateral construction sculpture freed him from this oppression and was accompanied by a new, anti-expressionist optimism—even gaiety—in the spirit of his work. Not only could he achieve a sense of lightness by cantilevering his parts—which had already been done by Picasso and others—but he could eliminate the sense of downward pressure created by any vertical pile by placing all his discrete elements directly on the ground. There they tend to touch rather than to overlap or support each other—a relationship expressed technically by the fact that they are often screwed or bolted together rather than welded. Use of the ground as the support was not entirely the case in his very first mature sculptures, such as *Midday* (1960, p. 25) and *Sculpture 7* (1961, p. 28). The three upper elements of the former and the raised and tilted I-beam of the latter exert, however, only a limited gravitational pressure against the larger lateral units supporting them. In *Hopscotch* (1962, p. 39) and *Early One Morning* (1962, pp. 40, 41), only very light planes and lines are supported in air. In such sculptures of 1964 as *Titan, Bennington* (p. 49), *Reel* (p. 52), *Lal's Turn,* and *Wide* (p. 51), however, every unit rests on the ground. "I realized," Caro recalled, "that if you can make the floor act as part of the sculpture and not just [as a] base, the pieces will float . . ."[24]

To heighten this sense of liberation from gravity, Caro chose, by

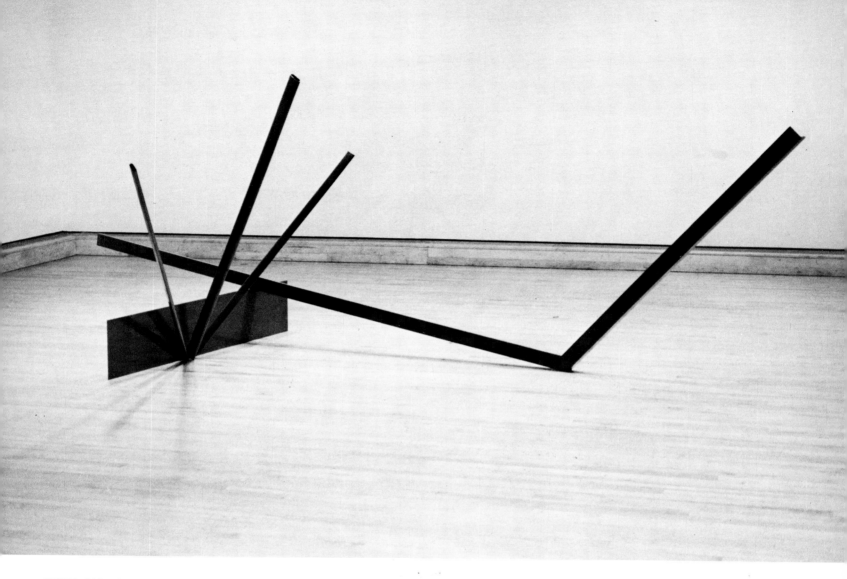

WIDE. *1964. Steel and aluminum, painted, 4' 10 3/4" x 5' x 13' 4". Private collection, Washington, D.C.*

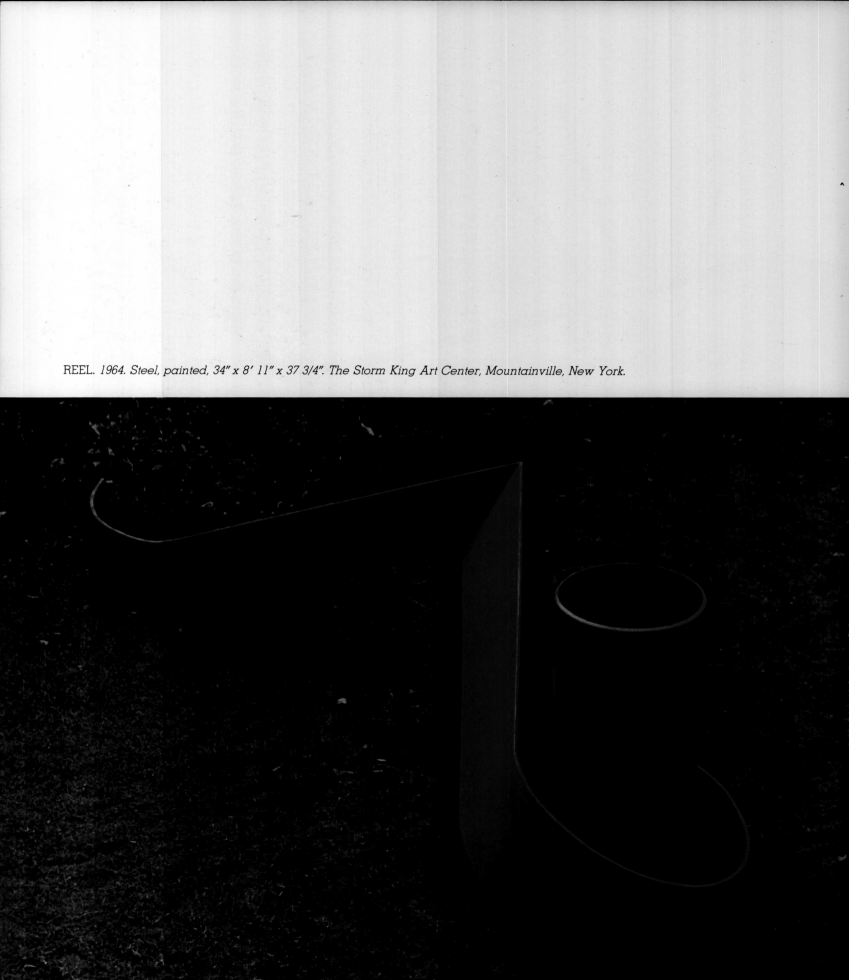

REEL. *1964. Steel, painted, 34" x 8' 11" x 37 3/4". The Storm King Art Center, Mountainville, New York.*

painting his sculptures, to suppress the viewer's recognition of the steel from which they are constructed. This disguise by color diminished the suggestion of the steel's gravitational pressure in the interests of what Fried describes as "achieved weightlessness."[25] Just as the weight of Caro's early figurative work was visually intensified through the associations evoked by the bronze from which they were cast, so our sense of the tactility and weight of the steel is diminished by color that is often bright and is rarely of a hue associated with steel. Caro would have liked to find a new material that was "completely anonymous, without associations to itself," but steel was a structural necessity for many pieces. To be sure, a few of Caro's "found forms"[26] are easily recognized as steel despite their color—most notably the I-beams. But even these are recognized less as objects (as in Surrealist *objet trouvé* sculptures, or even Smith's Agricolas) than as simple units of construction. Most of Caro's found forms are as unrecognizable as the plowshares of *Orangerie* (1969, p. 94).

Caro's monochrome color in most of his work helps visually unify a type of sculpture that, in the extreme dispersal of its parts, risked seeming disparate, too difficult for the eye to pull together. He arrived at this monochromy experimentally. A few of his earlier pieces are, in fact, polychromed. The simplicity of the predominantly green *Sculpture 7* (p. 28) and the small size and comparative recessiveness of its brown and blue units make these units easily

Below and opposite: SHAFTSBURY. *1965. Steel, painted, 2′ 3″ x 10′ 7″ x 9′. Private collection, Boston.*

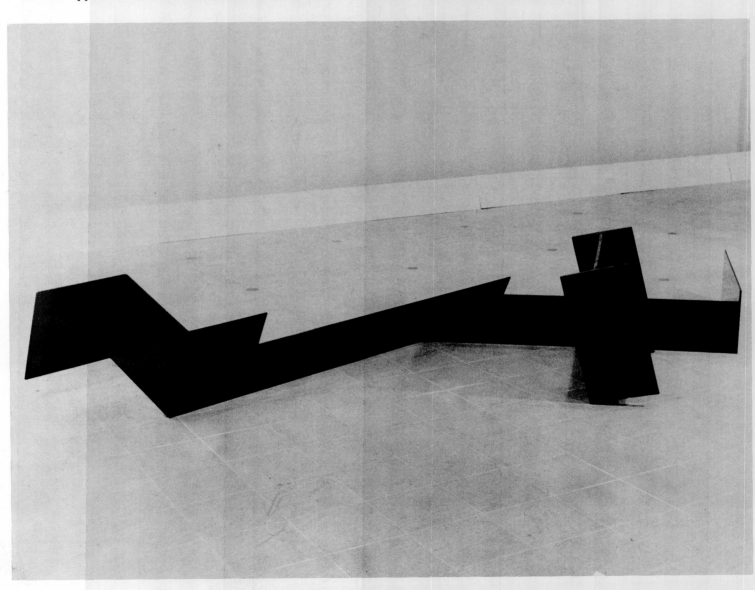

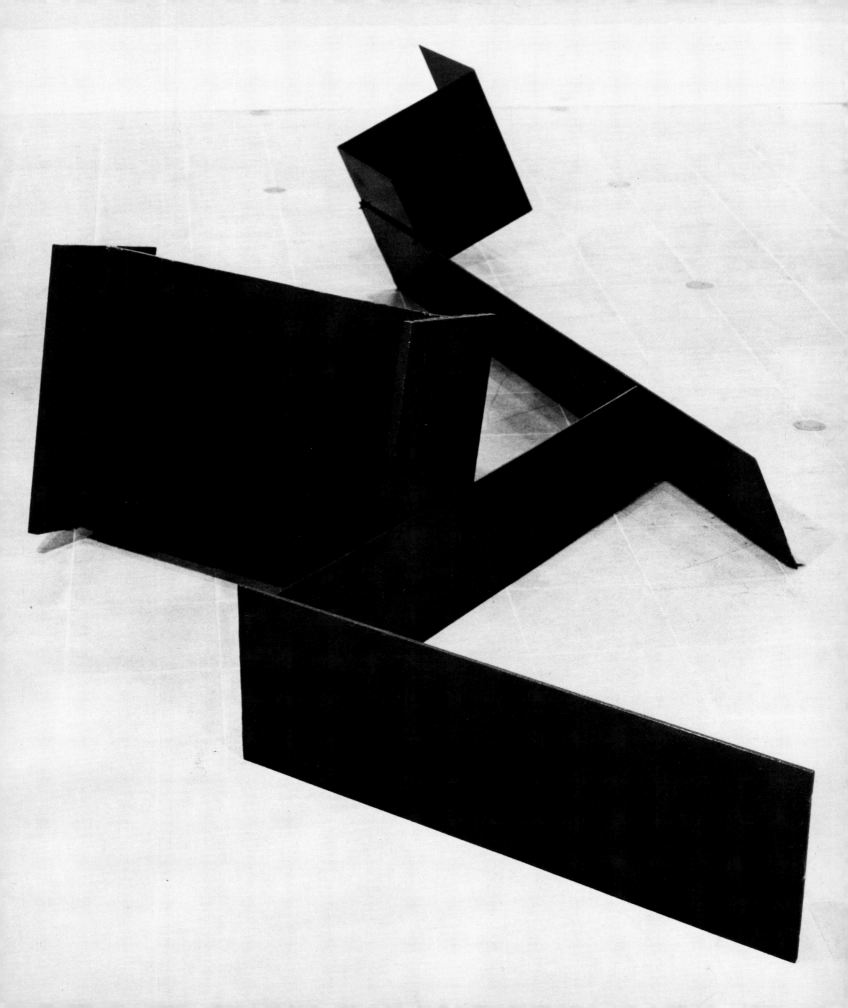

Opposite: SIGHT. *1965/69. Steel, painted, 9' 4 1/2" x 5' 6" x 3". Private collection, London.*

assimilable. In *Month of May* (1963, pp. 44, 45), on the other hand, the green, orange, and magenta of the linear units render a coherent reading of the already extremely complex configuration exceedingly difficult. Occasionally Caro chose to polychrome a piece after finishing it in order "to open it up more" and "discomfort" it. But sometimes, as was the case, for example, with *Prospect,* he subsequently repainted it a single color.

While most colors would serve to "denature" the steel and help unify the work, the choice of a particular hue is of great concern to Caro. He chooses the color as a function of the expressive and structural character of each piece, its precise hue and value seen as analogous to key and mode in music. The colors are chosen only after the work is completed (as are the titles, none of which are intended to be descriptive). In the last few years Caro has tended simply to varnish the steel rather than paint it, and this change has accompanied a mutation in the work itself, which now tends to mass higher and allows an overlapping of parts.

The prevailing horizontality of Caro's sculptures serves to make available to him configurations hitherto unknown in sculpture. The interrelationships of the "ground plan" and the vertical structures that rise from it—the rhyming, the analogies, even the puns of this dialogue—open a vast range of choices. This, in part, explains why the configurations of Caro's sculptures vary much more from one another than do those of other sculptors. At any given stage in their

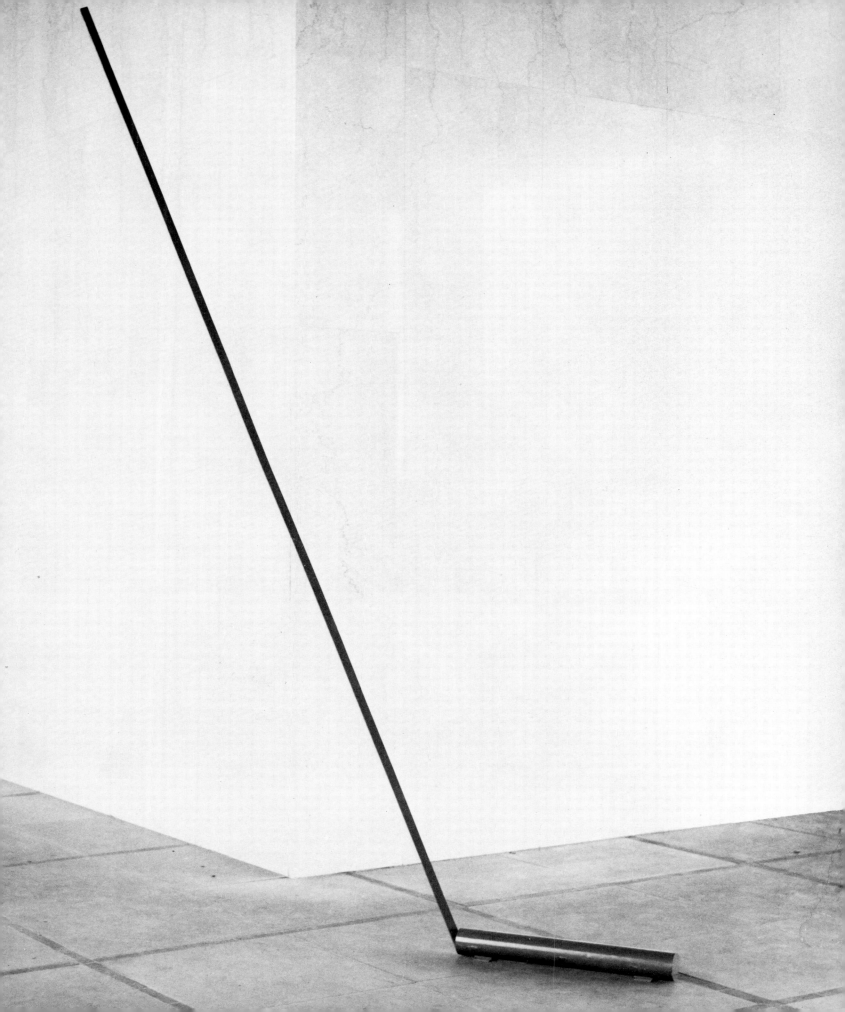

FARNHAM (BARFORD). *1965/69. Steel, painted, 7' 7" x 17' 11" x 7' 1". Private collection, New York.*

Opposite: SLEEPWALK. *1965. Steel, painted, 9' 2" x 8' 4" x 24'. Private collection, Bedford, New York.*

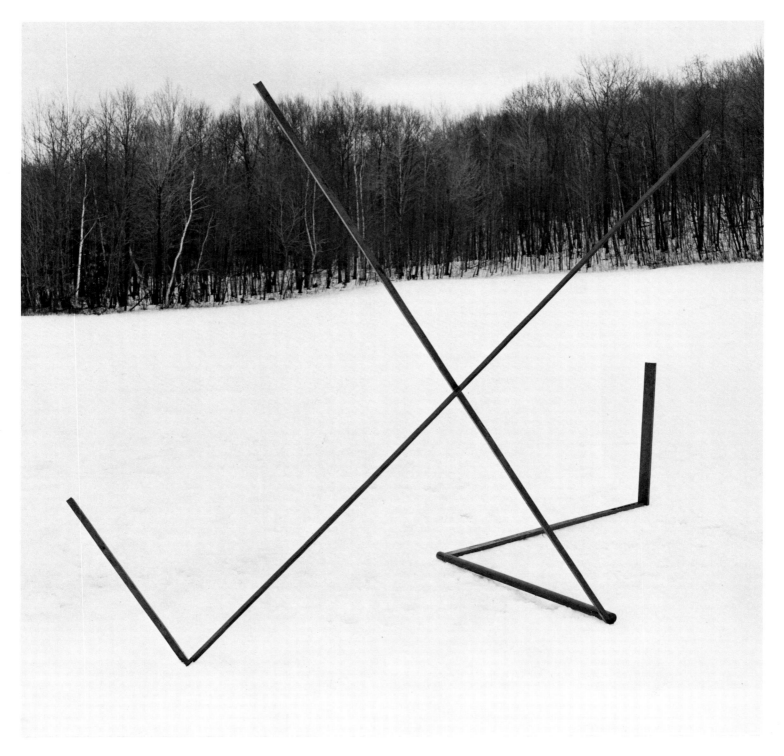

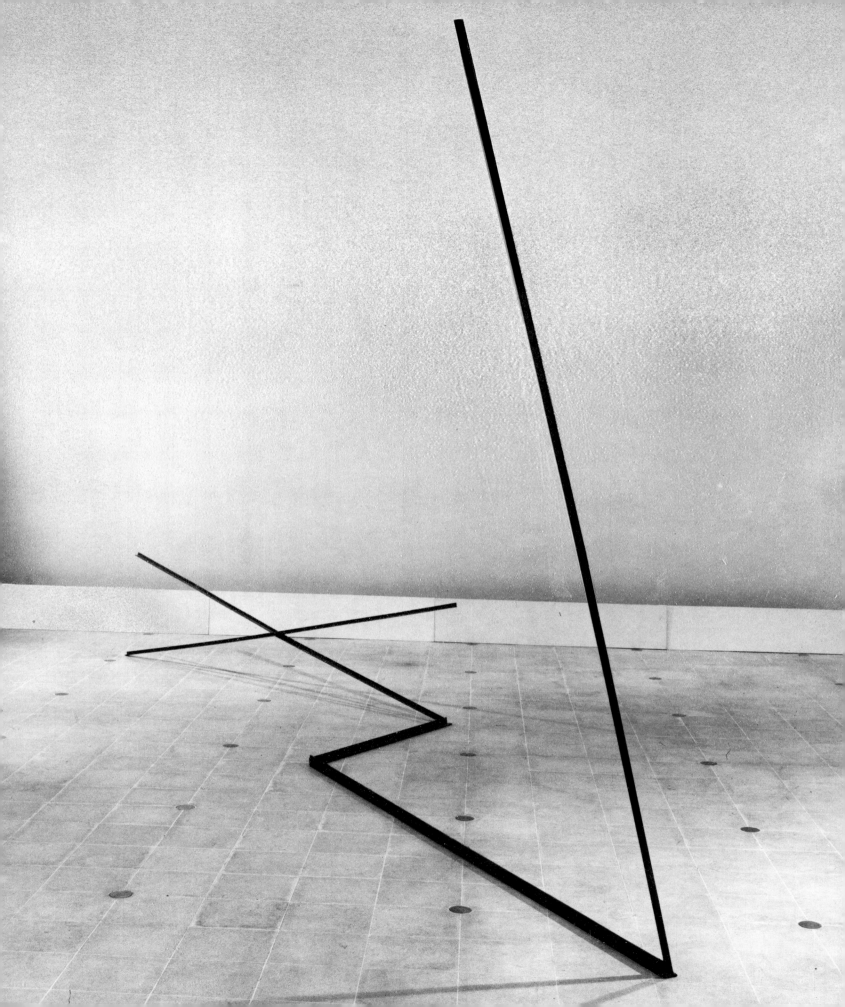

CLEEVE. *1965. Steel, painted, 4' 5 1/2" x 7' 11" x 9 1/2". Collection Carter Burden, New York.*

work, most sculptors face a single set of problems and opportunities. Caro had his choice of many sets. "One has the feeling," wrote James Mellow, "that in each of Caro's pieces, the sculptor has so successfully worked through the particular set of formal challenges and possibilities involved that he feels no need to repeat the effort."[27]

Only occasionally do Caro's works have a single focus toward which the eye is drawn. Usually there are multiple centers of interest or "nodes" dispersed through the space, and these take on different values according to the angle from which the sculpture is viewed. While Caro controls this cursiveness so that we can satisfactorily scan the work as a whole from most points, full comprehension of the configurations usually requires that we move around the piece. Even from a fixed point of view, the whole solicits us to read its parts syntactically as in the unfolding of a sentence. This gives the work a cumulative drama, almost a narrative quality, as its visual incidents are perceived in the duration of time—a phenomenon whose effects are intensified to the extent that we are invited, sometimes even compelled, to change position. The tilted I-beam of *Titan*, for example, has a particular character when viewed from inside the right angle (where the "opened swastika" reveals itself) and a very different character when viewed from the outside; the suspended rods of *Prairie* (1967, pp. 86, 87) function in one way when they traverse the spectator's field of vision and in a

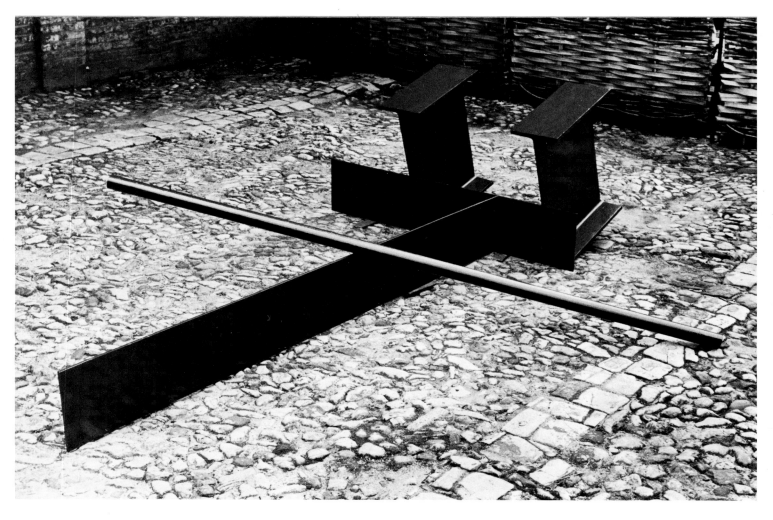

FROGNAL. *1965. Steel, painted, 3' 4 1/2" x 9' 1" x 12' 4". The Museum of Modern Art, New York. Gift of Mr. and Mrs. Richard Rubin.*

SLOW MOVEMENT. *1965. Steel, painted, 4' 3" x 8' 9" x 5'. The Arts Council of Great Britain, London.*

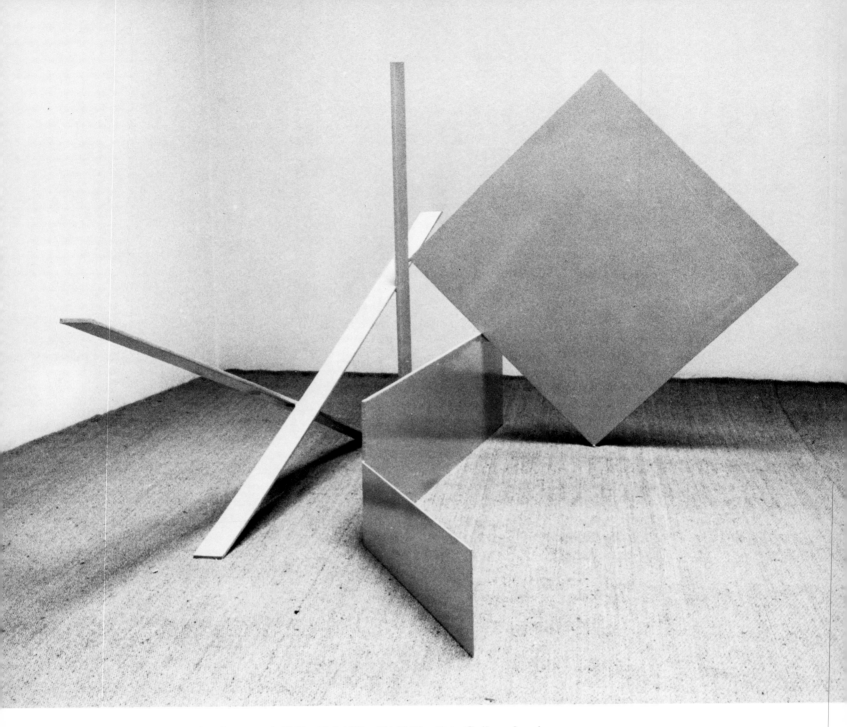

YELLOW SWING. *1965. Steel, painted, 6′ 2″ x 6′ 1 1/2″ x 13′ 4″. The Tate Gallery, London.*

very different way when they recede from him like perspective orthogonals.

Certain of Caro's earlier sculptures are approximately symmetrical and are characterized by an extreme economy of means—qualities that may have been intensified by Caro's closeness to Noland, and which, in any event, are most visible in those sculptures he executed during sojourns in the United States. Fried states that the "mode of expression that one finds in Caro's first abstract sculptures is in deep accord with that of Noland's paintings of the late fifties."[28] But while Caro's configurations were arrived at improvisationally, the symmetry of Noland's was both a priori and absolute. The three-dimensional counterpart of Noland's symmetry, like that of the early work of Stella, is rather to be found in Minimal sculpture, which shares with such painting an instantaneous givenness wholly alien to Caro's compositions.[29] Caro's sculpture is peculiarly English in the way it values lightness of touch, casualness, and digression. Abstract painting in America, especially in the generation of Noland, was more single-minded, more rigorous in spirit and less generous in its means. Unlike American art, Caro's appears eminently relaxed and, while equally serious, is never apocalyptic in tone. Its address is conversational rather than hortatory, and even at its most stately it avoids the rhetoric of "The Sublime."

In holistic painting such as Noland's, absolute symmetry itself

confers certain qualities on the work. But even in Caro's most symmetrical sculptures, the symmetry serves basically as a backdrop or foil, and interest lies primarily in asymmetrical variations from this norm. Many of Caro's works, however, are assertively asymmetrical, and thus invade space in a complicated way. A number of the latter pieces—*Titan* (pp. 46, 47) and *Shaftsbury* (1965, pp. 54, 55) and *Span* (1966, p. 82), for example—are polyaxial. Polyaxiality makes full visual assimilation of the work somewhat difficult, and Caro resolved these works best when he kept them close to the ground.

Cubism is the underlying discipline in all Caro's mature work. His pieces tend to be organized laterally as well as vertically in relation to straight lines and right angles, either given or implied. The right angles may be located in the individual elements, or in their interrelations, or both. The three-dimensional grid is never wholly explicit. Indeed, in certain of the more cursively organized sculptures it is hardly manifest, its role as the operative infrastructure being less seen than sensed. As in all Cubist work, however, this implied grid provides an a priori architectonic stability and order. But the essence of the compositions lies precisely in their inflections away from it. The most daring—though not necessarily always the best—of Caro's pieces open up the Cubist architecture to a point of seeming randomness. A few of his occasional failures occurred when the configurations were pressed so far in this direction that

SILL. *1965. Steel, painted, 1' 5 1/4" x 4' 8" x 6' 3". Private collection, New York.*

they became unglued, so to say. Conversely, there are some pieces that are uninteresting precisely because the Cubism is too much in evidence.

The units that make up a Caro sculpture are, individually, much more in the spirit of constructivism than are those of most post-World War II sculpture. Even in such seemingly calligraphic pieces as *The Deluge* (1969–70, p. 101), the lines are mostly segments of regular curves—very different from the freehand contours of Smith's more draftsmanly sculptures. To be sure, the Abstract Expressionist sculptors and the British sculptors of the forties and fifties tended to organize their configurations along Cubist lines. Like the later Picasso, however, they accommodated their Cubist armatures to morphological components of a surreal and expressionist nature. However different Moore and Smith, for example, were in other ways, they were both committed to a poetic art whose metaphors required an allusive figuration alien to Caro.[30]

But if Caro accepted the tenets of Cubism more conspicuously than these sculptors, it was in order to do something utterly new—to work, for the first time in modern sculpture, in a non-pictorial, integrally three-dimensional manner. This was made possible by identifying the essence of Cubism as its syntax, isolating this syntax (except incidentally) from other formal elements of the style, and projecting it into three-dimensional space. To understand the radicality of this approach, it is necessary to rid ourselves of the

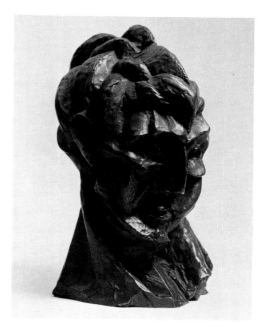

Pablo Picasso. WOMAN'S HEAD. *1909. Bronze, 16 1/4" h. The Museum of Modern Art, New York. Purchase.*

notion that Cubism was essentially an art of three-dimensional forms, i.e., of volumes "in the round." On the contrary, Cubism was an entirely *pictorial* invention which, while it reaffirmed—though only at its beginnings—the tactile solidity and weight of forms, did so through an illusion of *relieved* surfaces, not of forms in the round. In accommodating these relieved forms to the lateral plane of the picture surface, the Cubists in effect simplified and extended the pictorial means already established by Cézanne.

Picasso's sculptured *Head* of 1909 demonstrates that even the most tactile Cubist painting of 1908 to early 1910 was a matter of illusioned relief (a pictorial simulacrum, in a sense, of a rectangular bas-relief), and thus little inspiration to sculpture in the round. When, in *Head,* Picasso transferred into tactile actuality the ridged, modeled relief that he had illusioned through chiaroscuro in his paintings, he found that the result conveyed less a sense of mass than the impression of a stylized surface wrapped around 360 degrees. *Head,* in fact, was less convincingly tactile than the forms in Picasso's paintings of the period, partly because modeling with a brush allows light and shade to be both more controlled and more nuanced.[31] *Head* constituted a dead end—which explains why Picasso ceased during the remaining years of Analytic Cubism to translate that style into sculpture.[32]

Picasso concluded not only that the faceted structure of Analytic Cubism was unconducive to sculpture, but that to preserve the

Pablo Picasso. MONUMENT. 1972, from a maquette of 1928. Cor-ten steel, 12' 11 5/8" (including base) x 56 3/8" x 9' 5 3/8". The Museum of Modern Art, New York. Gift of the artist.

David Smith. AUSTRALIA. 1951. Steel, painted, 6' 7 1/2" x 8' 11 7/8" x 16 1/8". The Museum of Modern Art, New York. Gift of an anonymous donor.

syntax of even the less painterly, Synthetic form of Cubism in a literally three-dimensional art, the means would have to remain pictorial. Thus his construction sculptures of 1912–18—with one signal exception[33]—preserved the pictorial planarity of painting insofar as they were reliefs, not sculptures in the round. In 1928–29, when Picasso translated Cubism into free-standing sculpture in his great "see-through" linear works, he still preserved his pictorial base by organizing his compositions along an axis at right angles to the viewer. The four margins of the base of *Monument,* for example, imply four picture planes, in relation to which the sculpture rises.[34] With few exceptions, such as Tatlin's *Monument to the Third International,* which pulls the eye around itself like a Mannerist sculpture, constructivist works—like virtually all Cubist-inspired sculpture—remained tied to this pictorial conception until the advent of Caro. This is particularly true of the more complex linear works of David Smith. The more Smith opened up his sculpture to cursive "drawing in air," the more his drawing was organized in terms of an implied plane at right angles to the line of vision.

Caro's sculpture functions in space in quite another way. Like Picasso's *Monument* and Smith's *Australia,* it affirms space by articulating it rather than displacing it. But Caro's articulation implies no "picture plane"—nor any combination of them—and, hence, insists on no "preferred" view. Indeed, in the case of those sculptures not organized in terms of a right angle or based on a

STRIP. *1965. Aluminum and steel, painted, 7″ x 6′ 6 3/4″ x 3″. The Waddington Galleries, London.*

symmetrical principle—*Shaftsbury* (pp. 54, 55), *Sleepwalk* (1965, p. 59), and *Span* (p. 82), for example—the viewer is virtually undirected as regards orientation.

We can grasp the nature of Caro's possession of space by considering it in terms of his working methods. Caro begins his sculptures by assembling a few forms improvisationally, with no prior image in mind. An image, even in the mind, not to say on a piece of drawing paper, implies the flatness of a picture plane. This mode of thinking, Caro observes, is fundamental to "drawing in air," whereas he, on the contrary, almost never starts "from a flat beginning."[35] As the sculpture takes form additively from this nucleus, it begins to extend out into space. Sometimes an element that will constitute a center of interest is placed at some distance from the nucleus; the problem of connecting it is left for later.

In his first years, Caro worked close to his sculptures, in a studio space that did not permit much stepping back; many of his best earlier works were created in a small garage, the large sculptures "growing" into the space outside. "The advantage of making them where I couldn't stand back from them," Caro observes,

was . . . to prevent my falling back on my previous knowledge of balance and composition. Kenneth Noland told me in 1959 how he painted on the floor and on sawhorses for the same reason. Working in a one-car garage, as I used to do, was a way of trying to force my mind to accept a new sort of rightness that I wanted—I had to refrain from backing away and editing the work prematurely. When I took the work outside, it was a shock sometimes insofar as it looked different from sculptures that I was accustomed to.[36]

KASSER. *1965. Steel, painted, 23 1/4" x 48" x 12 1/2". Collection Mr. and Mrs. Richard Albright, Boston.*

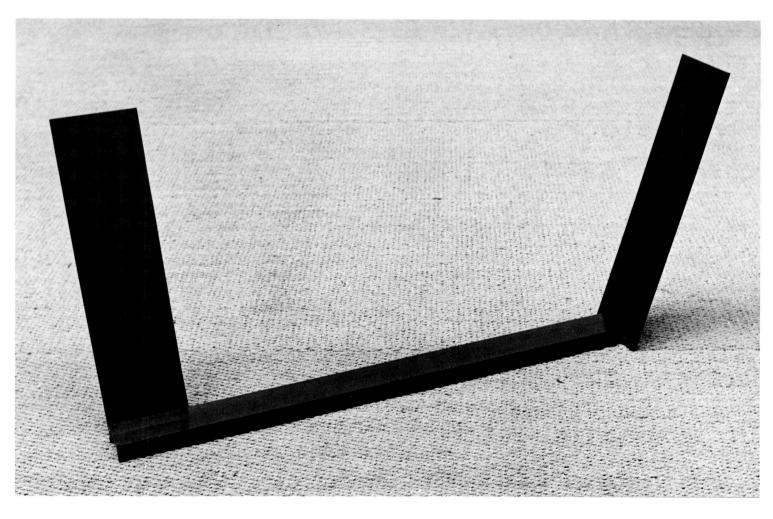

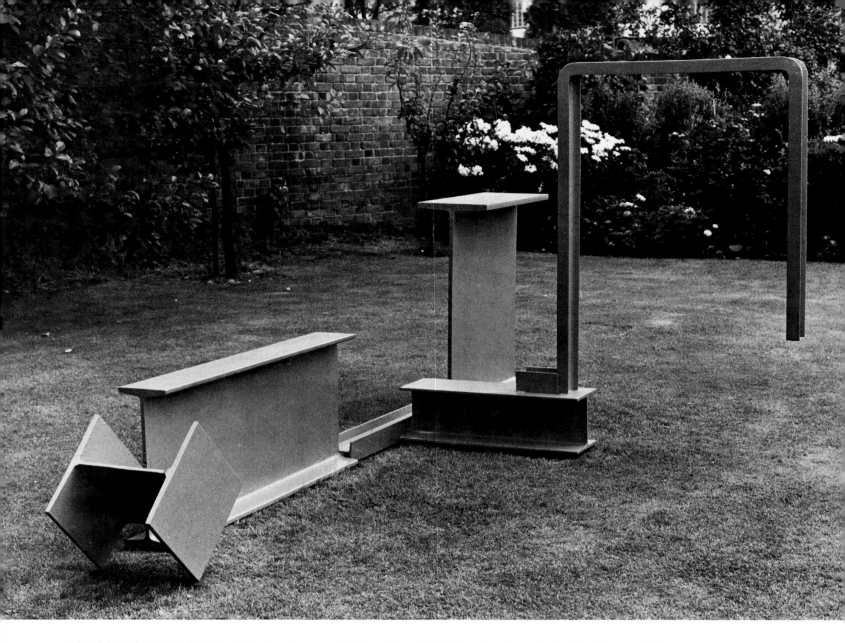

HOMAGE TO DAVID SMITH. *1966. Steel, painted, 4' 6" x 10' x 5' 4". Collection Mary Swift, Washington, D.C.*

Caro's sculptures occupy a purely literal space. In representational sculpture—and, indeed, much abstract vertical sculpture—the space established by the base and inhabited by the figure is immediately perceived by the viewer as *other* than his own. The space articulated by Caro's sculptures is coextensive with our own. By the same token, representational sculpture establishes an autonomous scale. Whether a figure is two feet or ten feet tall the eye accepts it as an illusion of human form and scales all its parts accordingly. In Caro's work, scale is not just a matter of internal aesthetic relations, but is fixed by the height of the human being and relates to his size in a literal way. Unlike most figurative and abstract sculpture, which is capable of enlargement or reduction —and has often been so treated—Caro's works are fixed in rapport to the height of the eye and the viewer's perception of the floor. Enlarged so that their centers of gravity would be at or above rather than below eye level, they would cease to be the same pieces. Indeed, they would largely cease to be visually comprehensible.

Though Caro necessarily works inside the literal space claimed by his sculpture, he prefers the viewer to perceive the spatial rapports purely optically. We are encouraged to walk around the pieces, but not into them. Walking around them allows us to perceive the thicknesses of the steel plates, to see parts that are hidden from some perspectives, and to clarify the angles at which

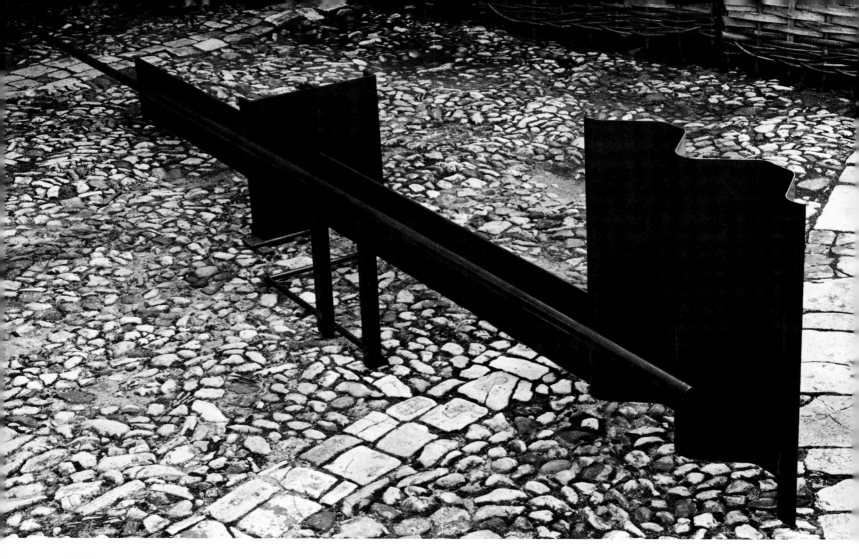

AWAY. *1966. Steel, painted, 3' 4 1/2" x 17' 3" x 3' 5/8". Private collection, London.*

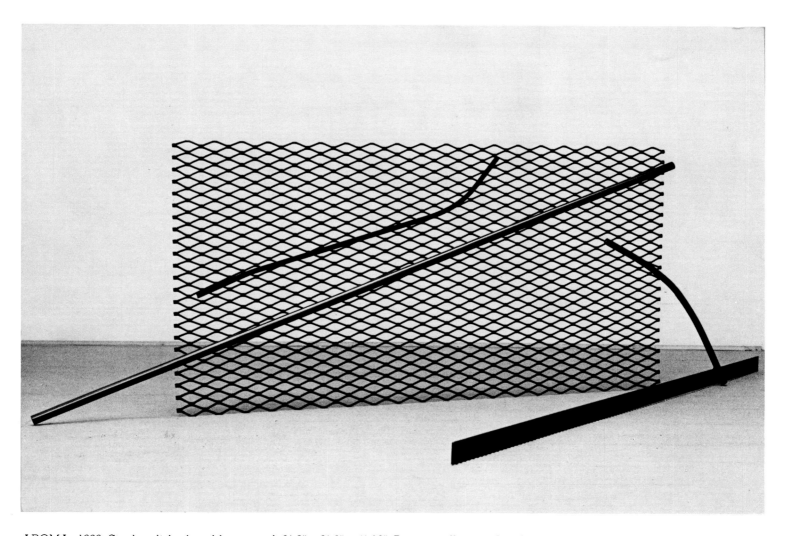

AROMA. *1966. Steel, polished and lacquered, 3' 2" x 9' 8" x 4' 10". Private collection, London.*

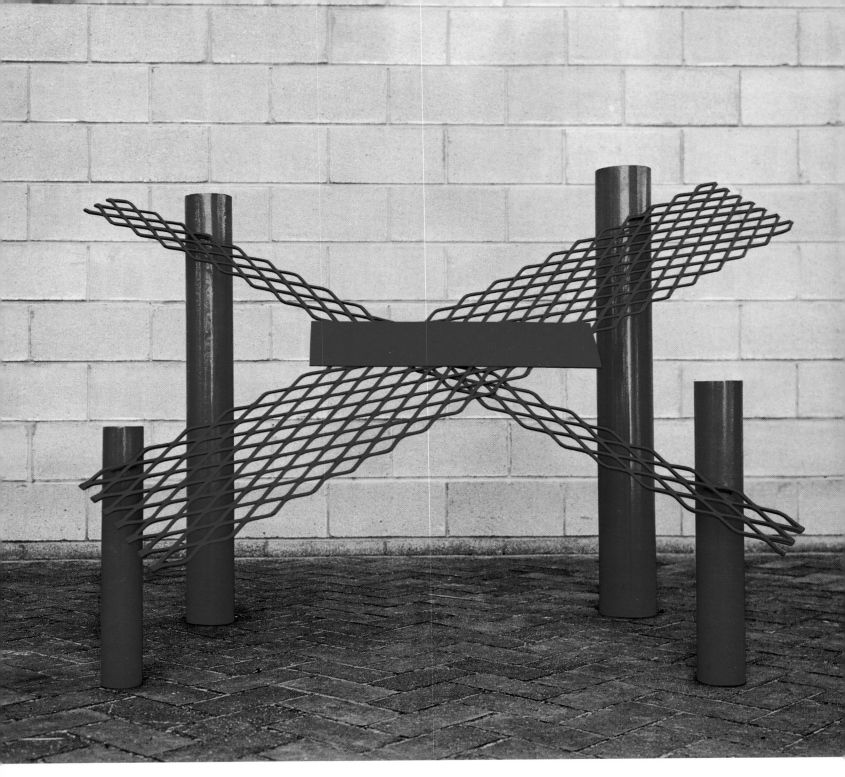

RED SPLASH. *1966. Steel, painted, 45 1/2" x 69" x 41". Collection Mr. and Mrs. David Mirvish, Toronto.*

forms join. In the latter regard, we must remember that while most of Caro's sculptures are ordered by right angles established as "normative,"[37] these right angles are rarely *seen* as such. Unlike vertical sculpture, in which the perception of the right angle is assured by our position *face à face* the front plane of the work (as in Smith's Cubi), the elements that form Caro's horizontal right angles recede from the eye as orthogonals. Right angles can therefore be seen as such from one position only—from which other right angles in the work necessarily appear oblique. In some cases they have almost to be assumed; the right angle of the L-shaped form in *Titan*, for example, cannot be seen as such except by looking directly downward from over the weld—an artificial and unlikely position for the viewer. As we move around Caro's sculptures, we maintain an image of the essential relationships—what Gestalt psychologists call the principle of constancy—against which we are constantly counterpointing the changing configurations we actually see.[38]

It is, in part, the maintenance of a certain proximity between the work and the viewer, a proximity less intimate than Caro's own in the making of it—and yet based on that—which leads him to prefer indoor settings for his sculptures, despite their frequently large size. Caro doesn't want his work viewed from distances that reduce it to a small segment of the visual field, as may be the case outdoors. On the other hand, he is not an intimist. Nothing in the configuration or facture of the work invites savoring its parts and surfaces from very

THE WINDOW. *1966–67. Steel, painted, 7' 1" x 10' 6 3/8" x 12' 9 1/2". Private collection, London.*

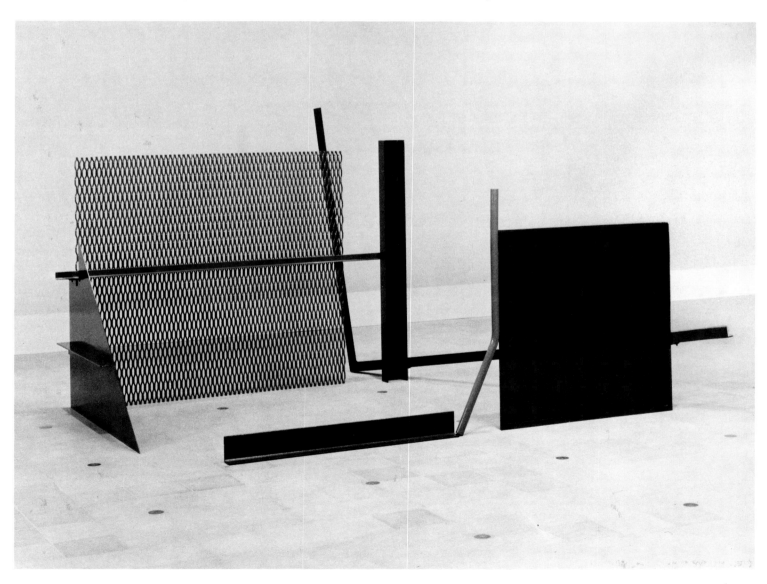

CARRIAGE. *1966. Steel, painted, 6' 5" x 6' 8" x 13'. Collection Henry and Maria Feiwel, New York.*

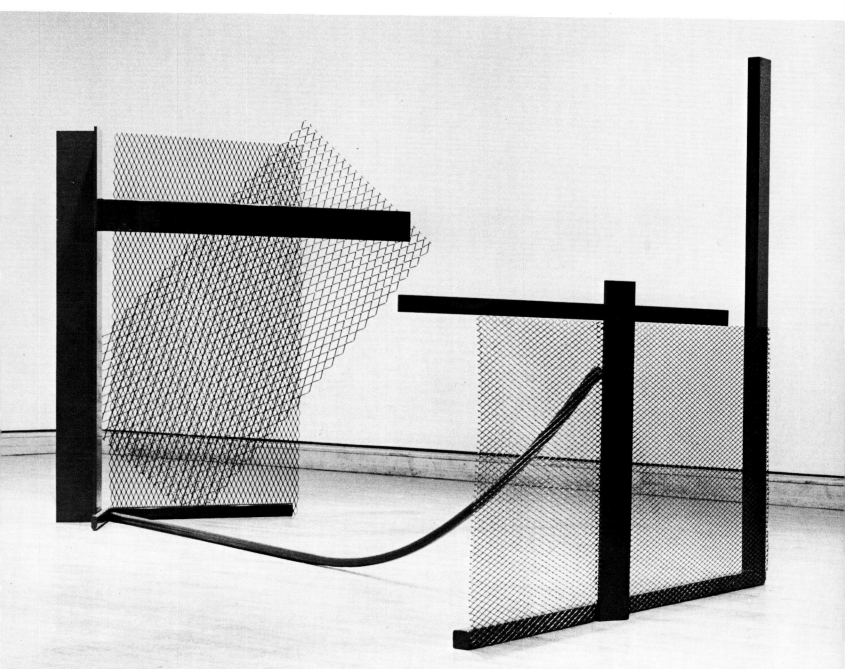

SPAN. *1966. Steel, painted, 6' 5 1/2" x 15' 4" x 11'. Private collection, Boston.*

close up. Rejecting the notion of "environmental sculpture," Caro does not wish the viewer to enter the spaces articulated by the extensions of his pieces; even less does he wish to elicit any desire to touch them. He wants the experience to be totally optical.

Caro does not preclude the out-of-doors as a setting for his sculptures so long as the areas selected provide a firm, flat surface, a delimited space, and are sufficiently free of visual incident. The outdoor environment that most closely conforms to the "tranquil and enclosed space" Caro has defined as optimum is the private garden. There, what he considers another common "danger" of the outdoors, the sense of a public space, is eliminated. Caro's work is not monumental and does not address itself to the collectivity that monumental sculpture implies. "All my sculpture (however large)," he insists, "is unpublic."[39]

The private nature of Caro's sculpture—a characteristic that, in fact, sets off most modern art from the styles of the past and from certain recent pursuits (such as Earthworks)—may underlie Michael Fried's effort to characterize even Caro's mature abstract work in terms of the nature and functioning of the human body. "Caro's sculptures have always been intimately related to the human body," he writes:

The changes that took place in his art in late 1959 and early 1960 . . . were not the result of any shift of fundamental aspirations . . . Even in his figurative bronzes Caro was not chiefly concerned with the appearance of the body, its external form. Above all he seems to have wanted to render sculpturally his

HORIZON. *1966. Steel, painted, 5' 9 1/2" x 13' 9" x 34 1/4". Brandeis University Art Collection, Waltham, Massachusetts. Gift of Mr. and Mrs. Max Wasserman.*

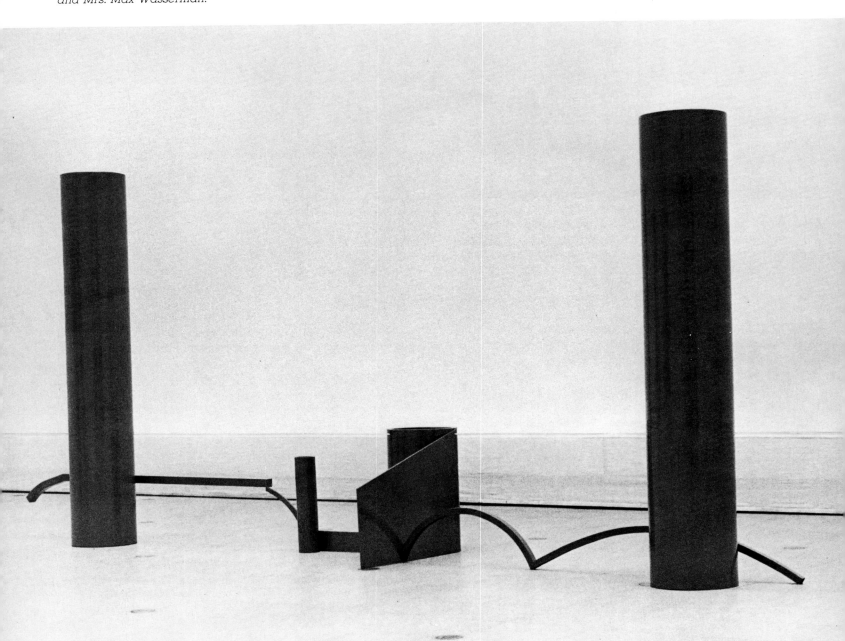

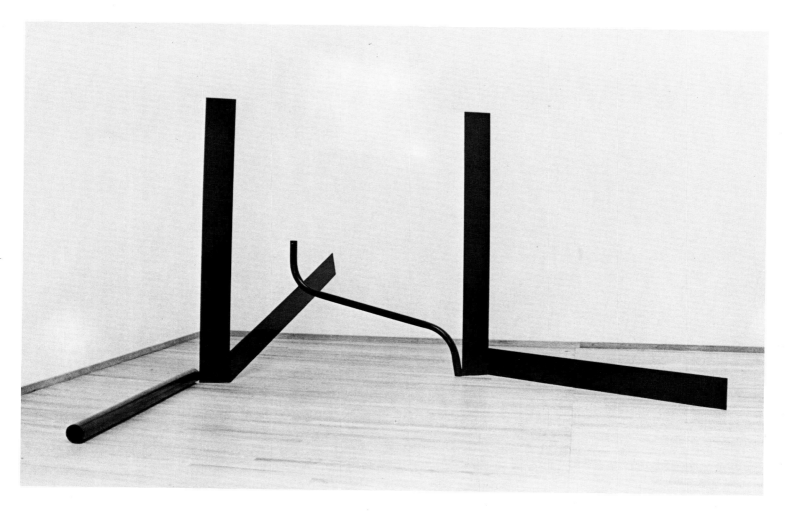

DEEP BODY BLUE. *1967. Steel, painted, 4' 10 1/2" x 8' 5" x 10' 4'. Private collection, Boston.*

Below and opposite: PRAIRIE. *1967. Steel, painted, 3' 2" x 19' 1" x 10' 6". Private collection, Princeton, New Jersey.*

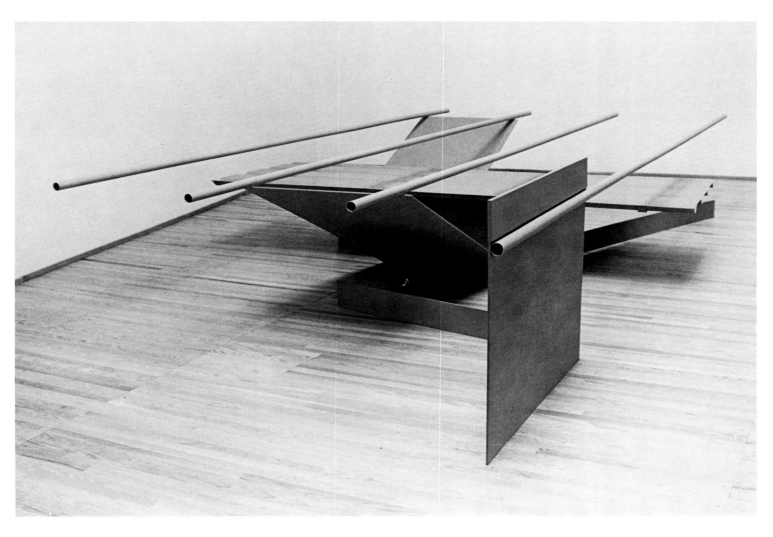

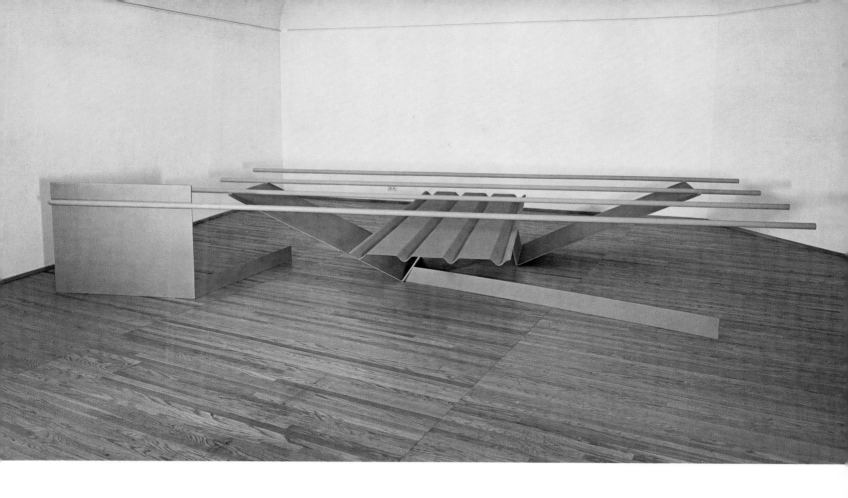

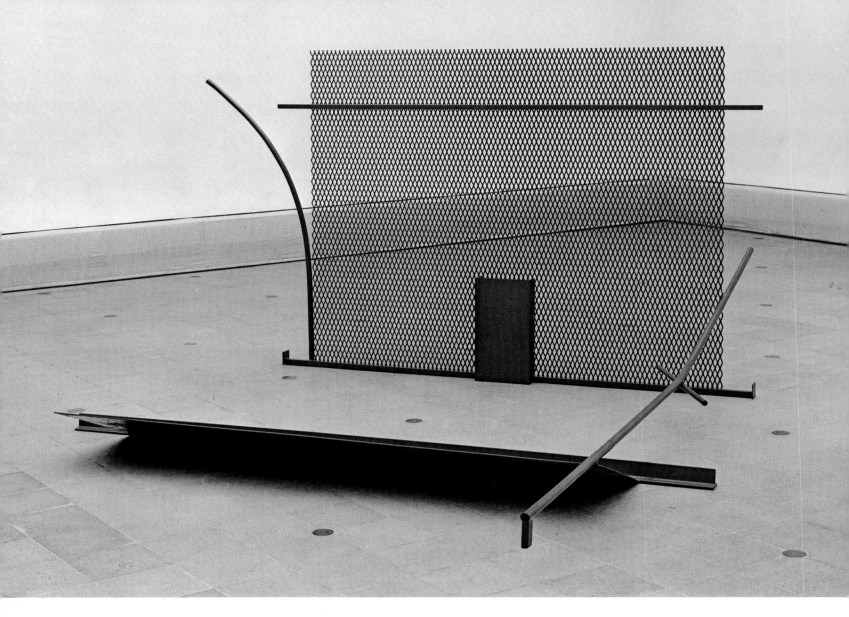

SOURCE. *1967. Steel and aluminum, painted, 6' 1" x 10' x 11' 9". The Museum of Modern Art, New York. Blanchette Rockefeller Fund.*

Opposite: SHORE. *1968. Steel, painted, 8' 7" x 12' 8" x 7' 4". The Arts Council of Great Britain, London.*

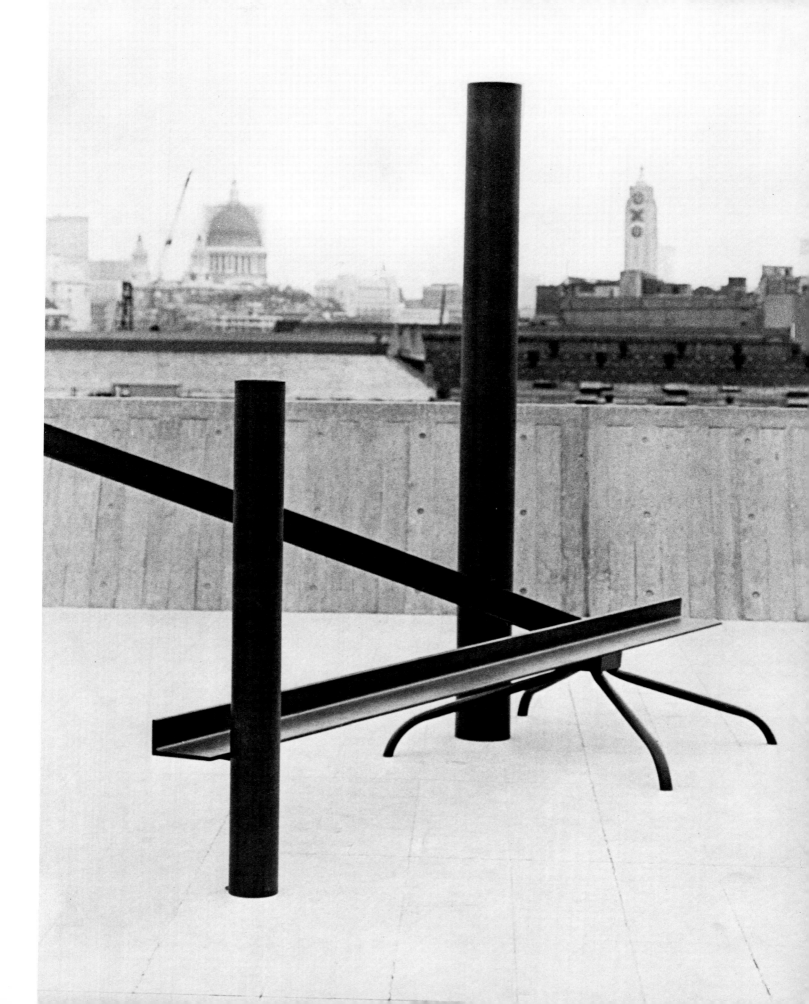

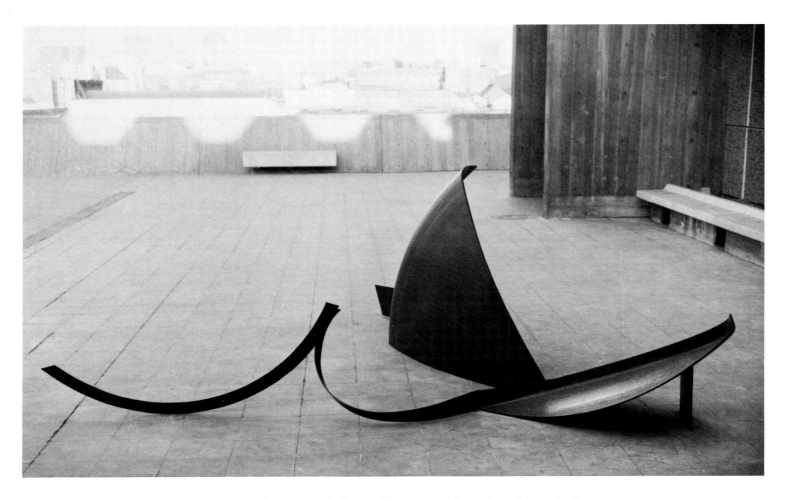

ARGENTINE. *1968. Steel, painted, 59" x 11' 8" x 10' 4". Collection Henry and Maria Feiwel, New York.*

TREFOIL. *1968. Steel, painted, 6′ 11″ x 8′ 4″ x 5′ 5″. The David Mirvish Gallery, Toronto.*

Below, top and bottom: AFTER SUMMER. *1968. Steel, painted, 5' 2" x 19' 8" x 24'. The David Mirvish Gallery, Toronto.*

Opposite: SUN RUNNER. *1969. Steel, painted, 6' 1/2" x 3' 8" x 8' 4". Guido Goldman Sprinkling Trust, Cambridge, Massachusetts.*

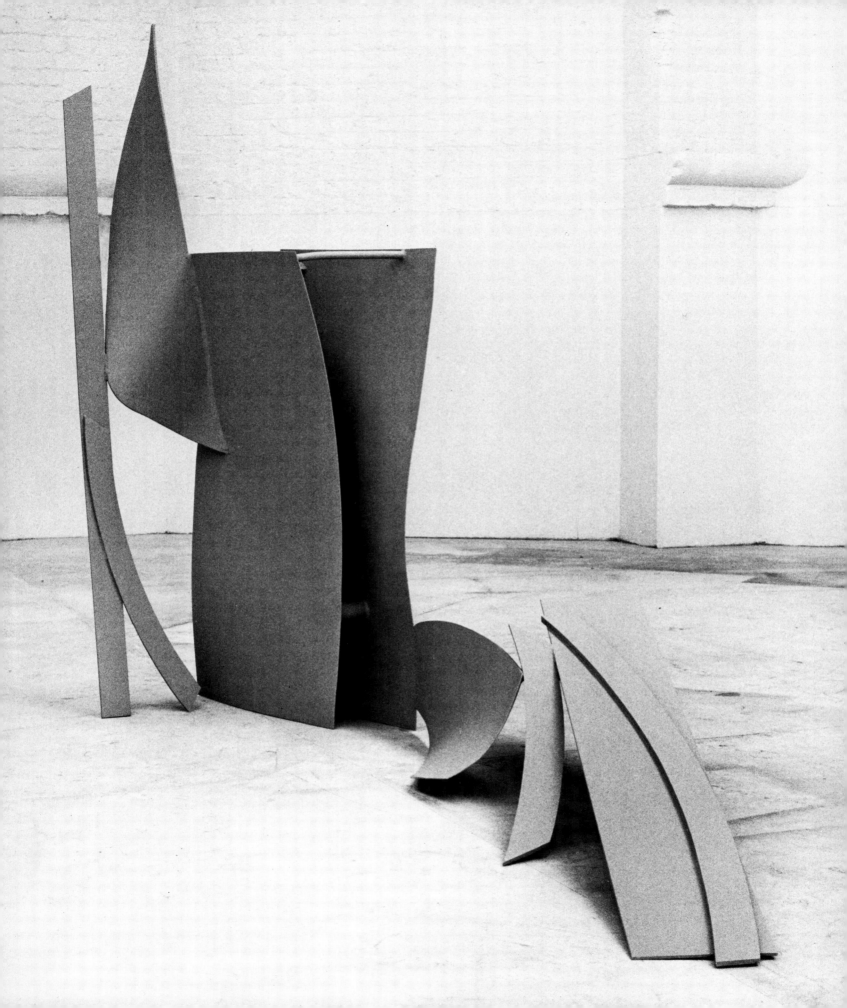

ORANGERIE. *1969. Steel, painted, 7′ 4 1/2″ x 5′ 4″ x 7′ 7″. Collection Kenneth Noland, Shaftsbury, Vermont.*

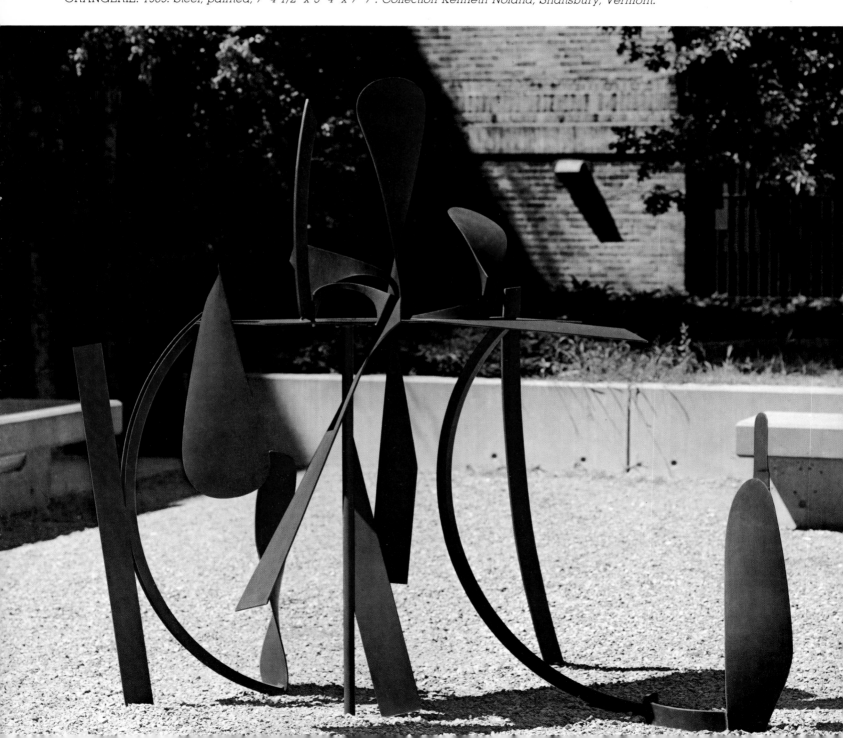

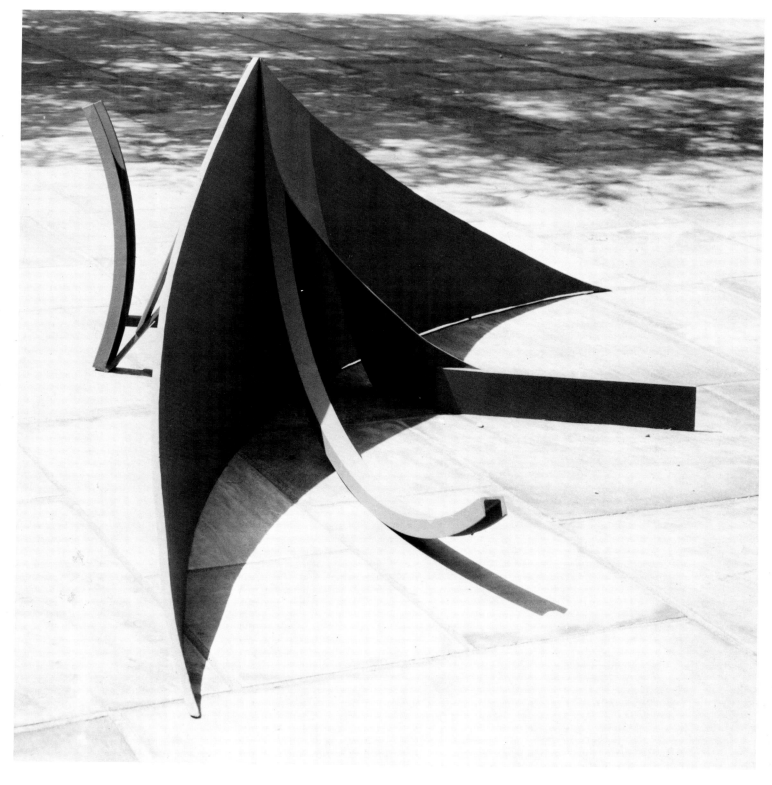

WENDING BACK. *1969–70. Steel, painted, 35″ x 10′ 6″ x 8′ 6″. Contemporary Collection of The Cleveland Museum of Art.*

Below and opposite: SUN FEAST. *1969–70. Steel, painted, 5' 11 1/2" x 13' 8" x 7' 2". Private collection, Boston.*

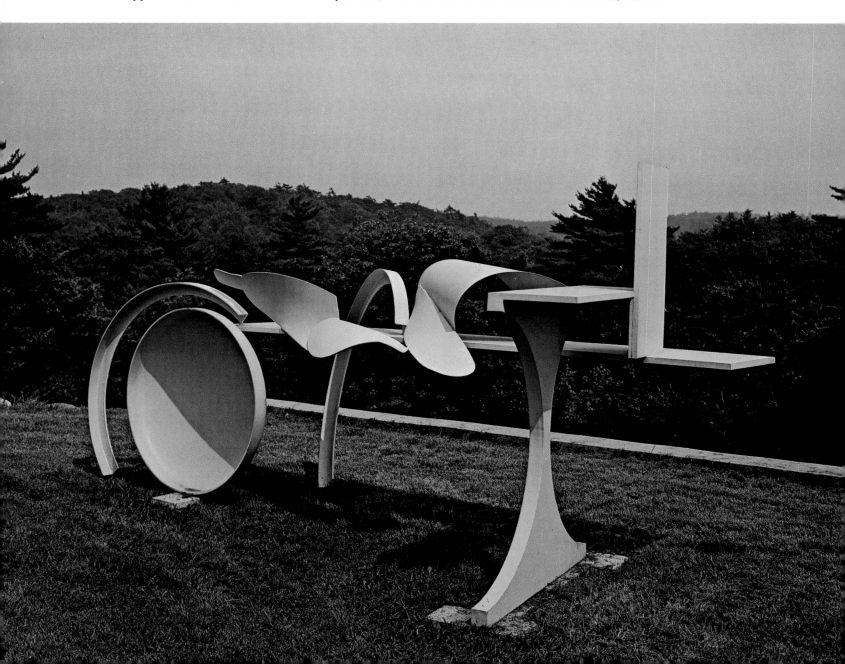

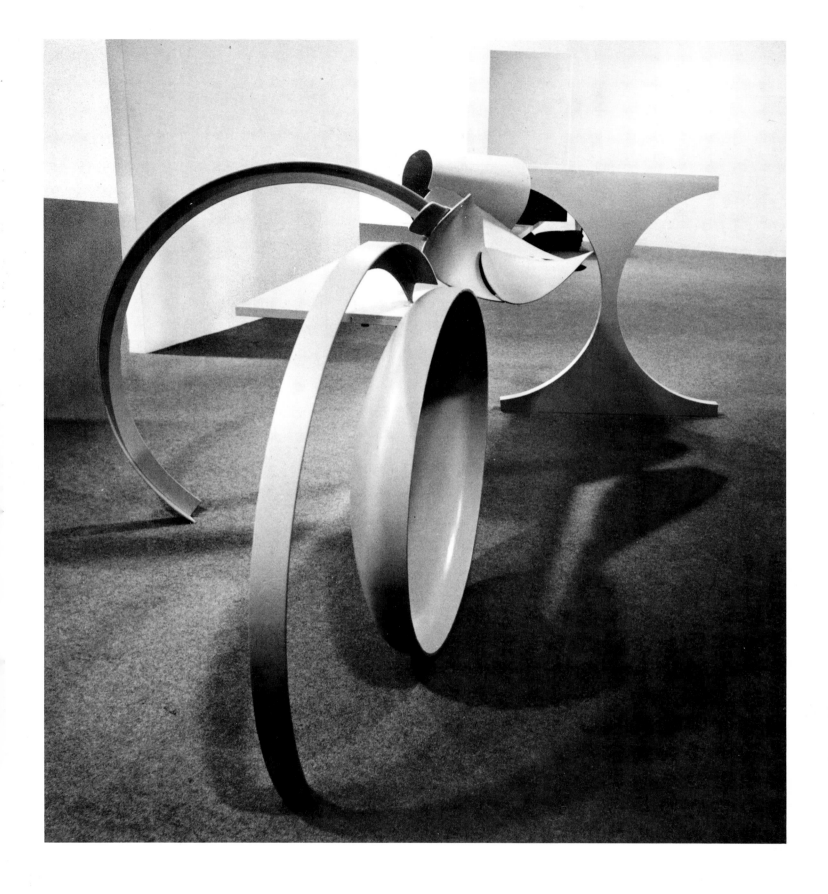

innate sense of the human body *as actually lived—as possessed from within* so to speak . . . The desire to find sculptural equivalents for what might be called the *livedness* of the body impelled Caro to the often extreme departures from verisimilitude that characterize [the] works of the [early] period. In *Man Taking Off His Shirt,* for example, the disproportion between the small head and the heavy arms seems to have been intended as an equivalent for the figure's concentration upon an action in which the arms do all the work and the head is mostly in the way. . . .

[Caro] has been able to render wholly abstract various actions and states that are themselves paradigmatically situational: e.g. being led up to something, entering it, perhaps by going through or stepping over something else, being inside something, looking out from within. . . . In Caro's art, the physicality of the body is itself liberated from the body's limits.[40]

Doubtless certain of Caro's sculptures (or, at least, passages in them) evoke a response in our nervous systems that might warrant calling them plastic correlatives of "body situations"—translations into purely abstract terms of that "internal" or "felt" image of the body explored by Picasso and the Expressionists. Like most analogical interpretations of nonfigurative art, however, Fried's thesis risks narrowing our sense of the expressive range of Caro's work. One could propose other, no less speculative, interpretations that seem to me to ring equally true. For Fried's essentially somatic emphasis, one might, for example, substitute an analogy with the psyche. The eye, as it follows the contours of a Caro sculpture, speeds up, slows down, is blocked by an impenetrable screen, penetrates a perforated screen, is confused by divergent paths,

interrupted by a traversing form, led to a dead end, pleased or deceived. The eye, in its progress, has enacted a bodily experience—taking an obstacle course, if you will—but just as validly it has enacted the mind apprehending a situation and coming to grips with it. The visual itinerary has recapitulated the processes of thought. In a discussion of the sculpture, references to discursive reason or to intuition would be no more remote than references to kinesthesia.

These two analogies—to the experience of the body and to the nature of thought—are not mutually exclusive, nor are they incompatible with other analogies one might construct. But they are purely speculative and cannot be said to represent—as is possible in some respects in figurative art—the subject of the work; even less can one propose them as its content. If forced to choose an analogy, the viewer would do well to explore the one Caro himself employs, the analogy to the most abstract of the arts, music. "I have been trying," Caro observes, "to eliminate references and make truly abstract sculpture, composing the parts of the pieces like notes in music. Just as a succession of these make up a melody or sonata, so I take anonymous units and try to make them cohere in an open way into a sculptural whole. Like music, I would like my sculpture to be the expression of feeling in terms of the material, and like music, I don't want the entirety of the experience to be given all at once."

THE IMAGE I have evoked of Caro's work thus far has necessarily been based on generalizations to which there are obvious exceptions, especially in his work of the last few years. Nevertheless, despite the immense differences in configuration from sculpture to sculpture, the entire body of Caro's work since 1960 is of a piece. Such period resemblances as can be perceived in Caro's work are in themselves less interesting than the differences between contemporaneous sculptures, perhaps because the very innovations that define a period, or group of works, so clearly represent an unfolding of possibilities already inherent in the work of his first few years as a mature sculptor.

The rapidity and assurance with which Caro established his mature style in the early sixties are, in part, explained by his long apprenticeship. Caro was thirty-six years old when he created his first important sculptures, but he had been actively working in the art since the age of fifteen. The figures and portrait busts he modeled at the age of eighteen evidenced such talent that the sculptor Charles Wheeler, later President of the Royal Academy, offered him an opportunity to work in his studio during vacations and holidays from school. After military service in the Naval Air Force and an M.A. in engineering at Cambridge,[41] Caro was admitted to the Royal Academy Schools, where he received a rigid academic training. There, in addition to the usual models, he studied and copied a great deal of antique and medieval sculp-

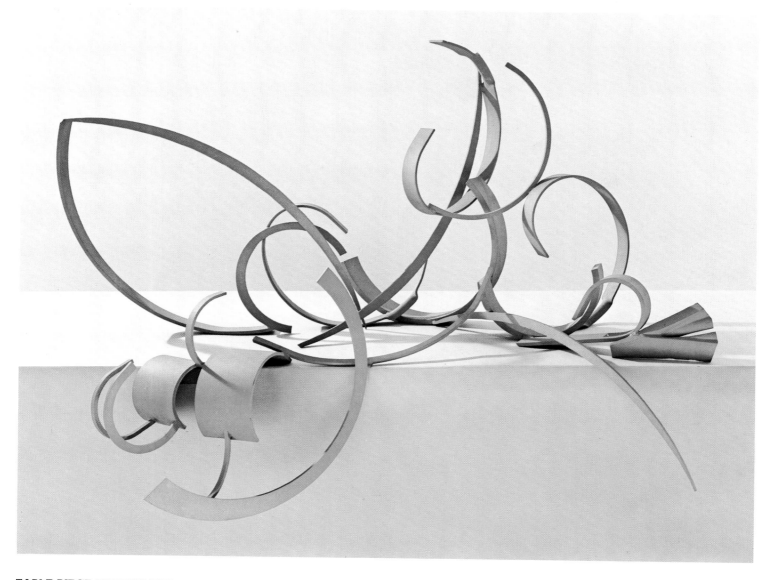

TABLE PIECE LXXXVIII (THE DELUGE).*1969–70. Steel, painted, 40" x 63" x 38". Guido Goldman Sprinkling Trust, Cambridge, Massachusetts.*

ture—Greek, Etruscan, Romanesque, and particularly Gothic.

There was a modicum of freedom in the methods and approach of the Royal Academy Schools. And Caro was, in any case, no born iconoclast. Indeed, like Manet, Matisse, and many other modernists, he has been a reluctant revolutionary. Caro spent over three years in the Academy Schools before the dissatisfaction that had been growing on him crystallized in a decision to seek out Henry Moore, to whom he applied for an assistantship in January 1951. Six months later Moore took him on, and Caro worked for him during the following two years, helping with carving and with casting lost-waxes as well as "pointing up" large sculptures from small models. Moore was generous with his time, criticizing Caro's work and discussing with him the art of the past and the present. This dialogue, along with generous loans from Moore's library, acquainted Caro with modern and primitive art, which had been largely overlooked in the Royal Academy. Some years later, Caro would say that much of what he took for granted "about the understanding of volume and space came from him [Moore] . . . The doors of a whole world of art, which I had not known as a student, he opened for me."[42]

After two years in Moore's studio in Hertfordshire, Caro felt ready to strike out on his own. He moved to a house in Hampstead, a suburb of London, and set up his studio in the garage. Somewhat earlier, he had begun teaching two days a week at St. Martin's

GEORGIANA. *1969–70. Steel, painted, 5' 1" x 9' 7" x 15' 6". Albright-Knox Art Gallery, Buffalo.*

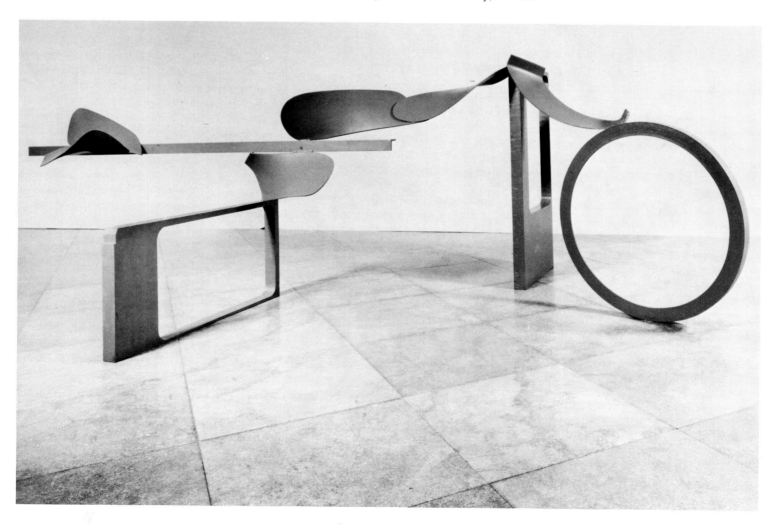

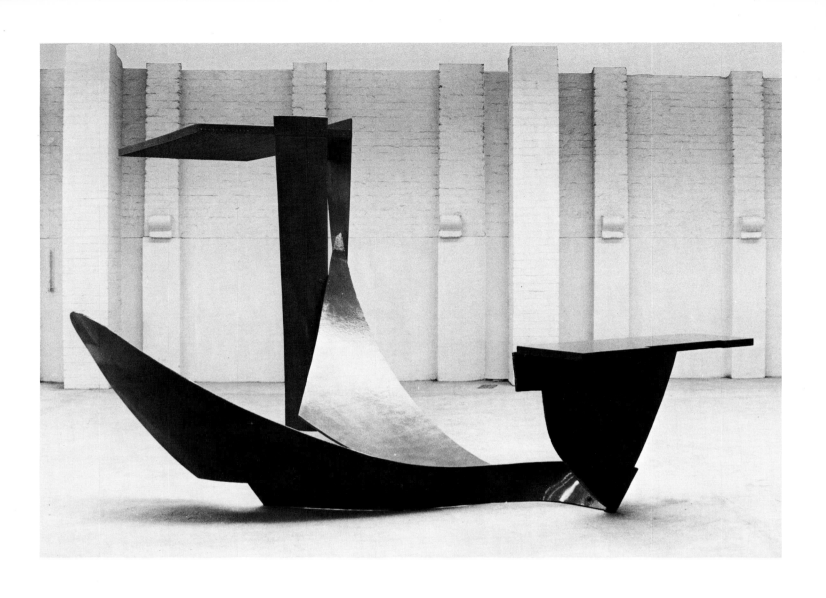

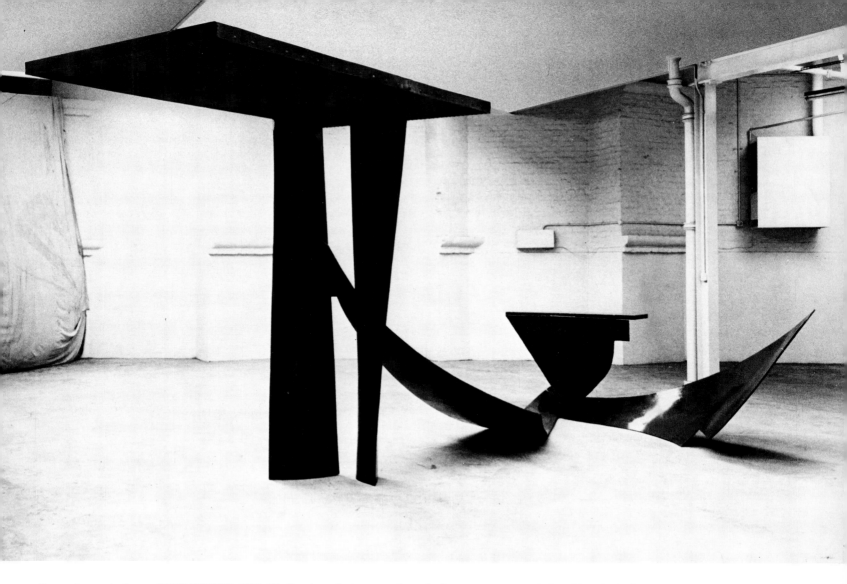

Opposite and above: DEEP NORTH. *1969–70. Steel, cadmium steel, and aluminum, painted, 8′ x 19′ x 9′ 6″. Private collection, New York.*

School of Art, where he joined the sculptor Frank Martin in establishing what developed into an important and well-equipped sculpture department. During the more than two decades that Caro taught there, his students included, among others, David Annesley, Michael Bolus, Phillip King, Tim Scott, William Tucker, and Isaac Witkin. In his teaching, Caro established a "workshop" situation that involved group collaboration on sculptural projects as well as much critical give-and-take, all in an informal atmosphere. Since so many of the young men who worked with him later emerged as a major new generation of English sculptors, it is not surprising that Caro found his teaching experience challenging. His pupils forced him to precise—and constantly reevaluate—his own ideas.

Shortly after his return to London in 1954, Caro modeled *Man Holding His Foot* (p. 18), the first of a series of expressionistic figure pieces that he continued to make until 1959, the year of his change to constructed sculpture. These pieces are indebted to a principle of distortion exploited in the work of Picasso, Bacon, and Dubuffet. Like them, Caro forms the limbs of his figures according to an internal image of the body rather than on the basis of one that is visually perceived. Inflated limbs and torsos, diminutive heads, and rough textures such as we see in *Man Taking Off His Shirt* (1955–56, p. 19) are especially prevalent in the early work of Dubuffet, whose 1955 exhibition at the Institute of Contemporary Art in London impressed Caro.

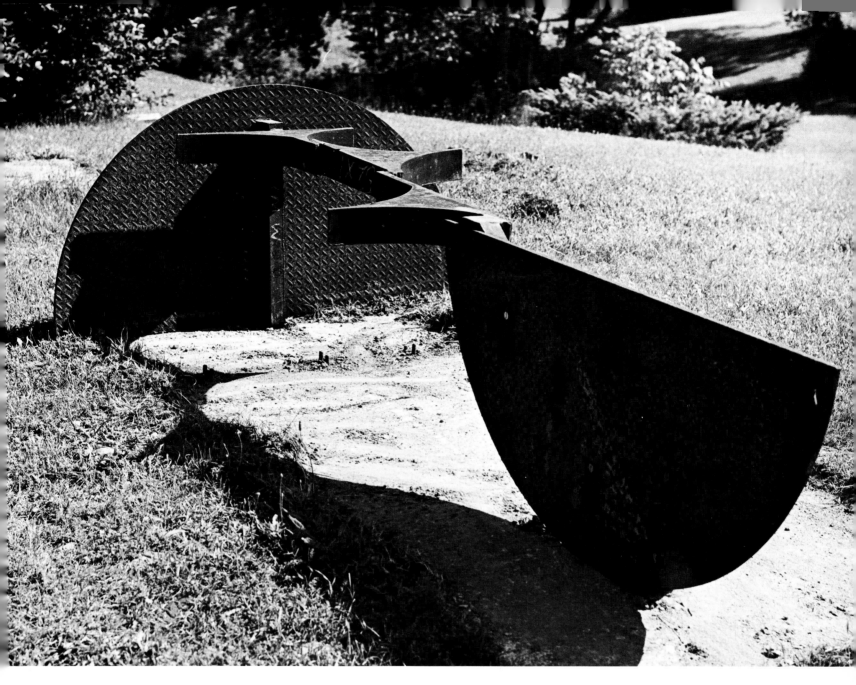

THE BULL. *1970. Steel, painted, 32" x 9' 11" x 57". Private collection, New York.*

In these figure pieces, Caro's intricate but shallow modeling and *art brut* textures—made by imbedding stones in the clay—tend to be seen almost independent of the mass. Insofar as these surfaces are read descriptively, they give the figures a repellent quality—almost an eczema. But when examined for a record of the hand and for their subtle shadings, they appear remarkably rich and bring the otherwise relatively inert figures alive.

Despite the prosaic titles, which would seem to indicate an interest solely in the physical implications of the figures' postures, these personages are endowed with a visible psychological content. This, in combination with Caro's extreme distortions of the human body, immediately set his work apart from that of other British sculptors—at the expressionist end of the spectrum. "I would rank [his sculptures]," John Russell was to write, "among the very few genuine expressionist works of art England has produced."[43] Nevertheless, the absolute integrity of the figures (expressionist truncation of limbs is nowhere to be seen) and certain attitudes of their postures suggest a kind of hidden classicism at the heart of these works, perhaps memories of models studied in the Academy. *Man Holding His Foot*, for example, harks back to the ancient Greek *Thorn Puller*,[44] and *Woman Waking Up* (1955, p. 19) recalls the antique Ariadne type. Other works echo more recent sources. Caro's *Seated Figure* (1955), for example, is based on a central figure from Courbet's *La Toilette*, which he had seen shortly before

in a loan exhibition at London's National Gallery. As the constructivist mode is predicated on a modern, Cubist form of classicism, one might say that in adopting it, to "get away from a wounded and bandaged art," Caro was making this innate classicism manifest. In this new language, the intensity of feeling attested to in Caro's expressionist bronzes is more contained than denied, more rechanneled than repressed.

Twenty-four Hours (1959, p. 23) and a few other steel sculptures (destroyed shortly after their fabrication) marked the transition in Caro's style and methods that followed hard upon his visit to America in the fall of 1959. "America was the catalyst in a change [in my work]," reported Caro eighteen months later. "There's a fine-art quality about European art, even when it's made from junk. America made me see that there are no barriers and no regulations. [Americans] simply aren't bound to traditional or conventional solutions in their art or in anything else . . . There is a tremendous freedom in knowing that your only limitation in a sculpture or painting is whether it carries its intention or not, not whether it's art."[45]

The transitional aspect of *Twenty-four Hours* is evident in the awkwardness of its execution and the targetlike circles painted on the surface of the steel disk. Such superimposed painted forms, though occasionally found in the work of Smith, were here certainly

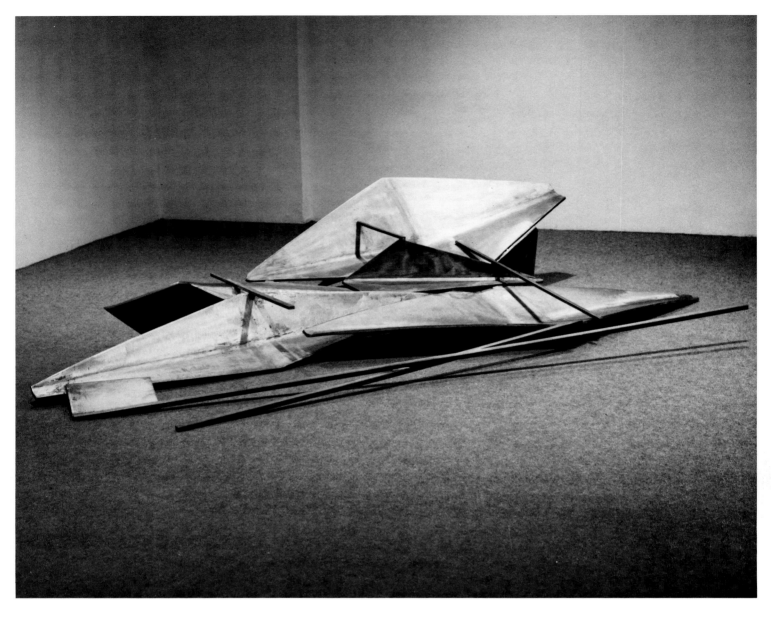

COOL DECK. *1970–71. Stainless steel, matte-varnished, 22″ x 5′ 4″ x 10′ 4″. Private collection, Boston.*

influenced by Noland's concentric-circle pictures. This device, along with the irregular edges and rough-textured surface, was to disappear in *Midday*, executed a few months later. For all these transitional earmarks, however, many of the essentials of Caro's new style are to be found in *Twenty-four Hours*. The piece is composed of three simple forms—a square, a circle, and a regular polygon (and their supports). The articulation stresses slight inflections from regularity (the polygon and circle are perpendicular and parallel, while the square tilts back from them), and the work stands directly on the ground rather than on a base.

Midday (1960, p. 25) is Caro's first wholly independent sculpture. The Smith-like frontality and verticality of *Twenty-four Hours* give way here to a horizontality enforced by the lone large beam of the work, to which all the parts, above and below, are subordinated. That girder was altogether horizontal until Caro was well into the work, when he brought it to life by slightly raising one end and gently curving the support below. Near its center he placed the only oblique unit in the piece, a section of I-beam tilted on one corner as if balanced on its center of gravity—an illusion that counteracts the weight we attribute to it in our recognition that it is steel. This interest in optically negating the actual weight of the piece is furthered by Caro's avoidance of any solid, volumetric forms, and by the bright yellow he painted the steel. By establishing for *Midday* a main axis that virtually parallels the ground rather than

SERENADE. *1970–71. Steel, painted, 47" x 8' 8" x 7' 6". Private collection, Chicago.*

Opposite: CADENZA. *1970. Steel, painted, 43" x 43" x 41". Collection Mr. and Mrs. Arthur A. Goldberg, New York.*

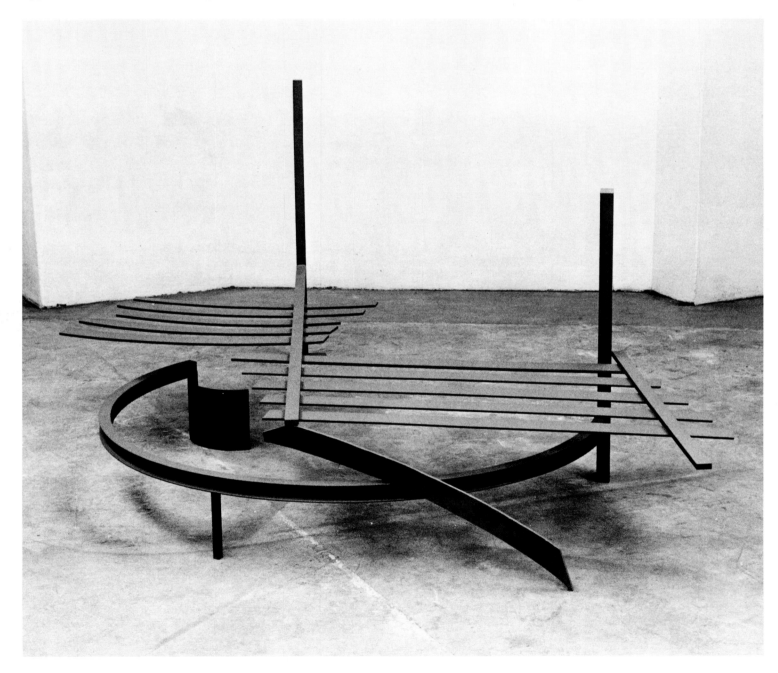

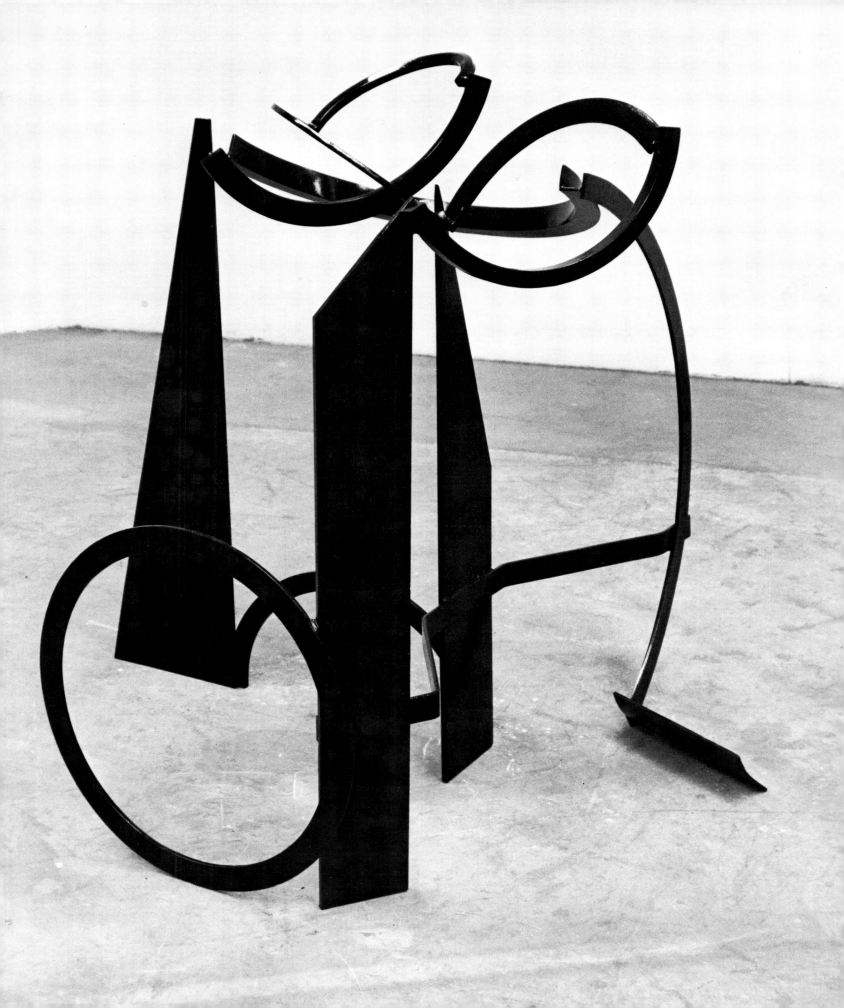

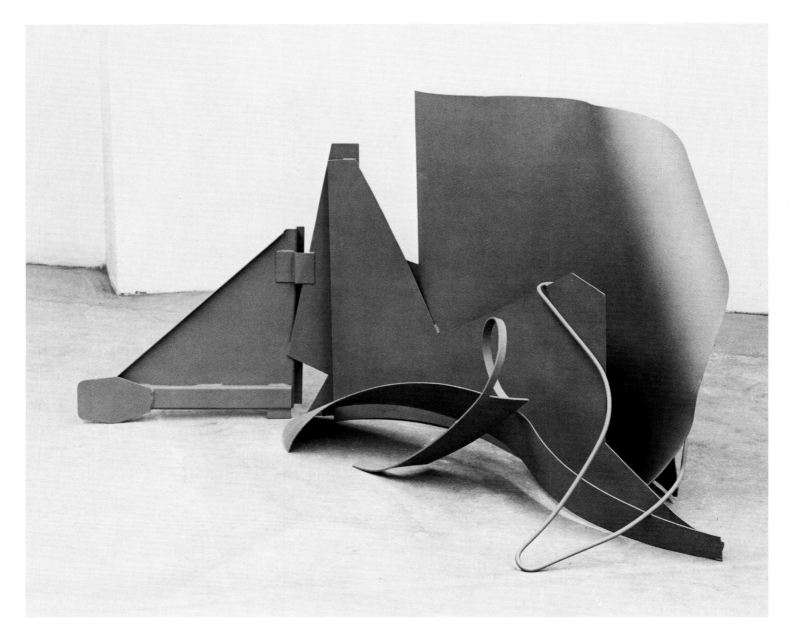

CROWN. *1970–71. Steel, painted, 42 1/2″ x 6′ 10″ x 32″. Collection Mr. and Mrs. David Mirvish, Toronto.*

Opposite: SIDESTEP. *1971. Steel and Cor-ten steel, painted, 4′ 3″ x 9′ 7″ x 4′ 10″. Collection Tom Quirk, London.*

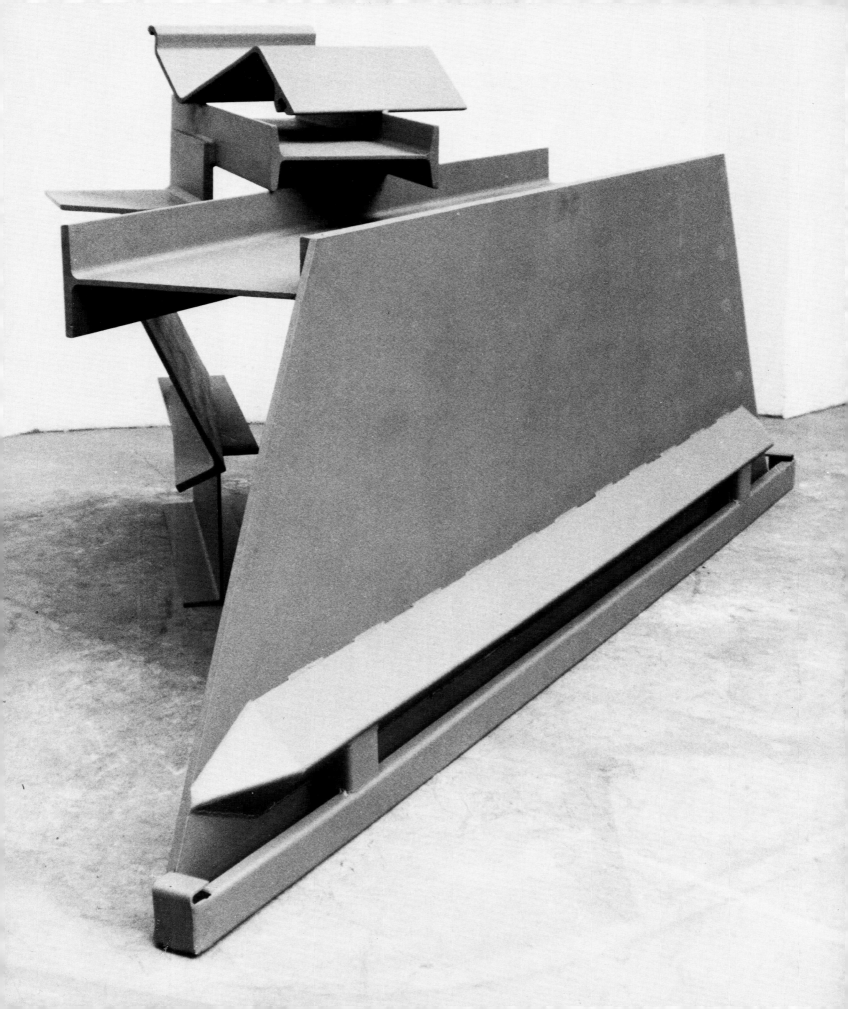

rising from it, Caro encouraged the spectator to move around the piece, to see it in three-dimensional space rather than in terms of a picture plane, though subsequent works would affirm the three-dimensional quality in a more dramatic manner. As compared to *Twenty-four Hours, Midday* is more frank and open. Everything is given to the eye. In *Twenty-four Hours,* the supporting elements are hidden in what we take as the "interior" of the piece. *Midday* is all exterior, even to the prominence of the bolts that hold much of it together.

In *Sculpture 7* (1961, p. 28), Caro's horizontality is more insistent, though the configuration is more conventionally planar. The work is composed of three very large and two small sections of I-beam. The two lower of the three large beams parallel the ground, and the piece is "made," so to say, by the way the third is inflected upward. *Midday* and *Sculpture 7* share a rawness that is characteristic of Caro's first two years as a mature sculptor. They attest to a certain emulation of the Abstract Expressionist spirit, the assumption of which was certainly designed to set Caro's work apart from the more finished, "fine art" tradition of sculpture operative in London, where *Midday* and *Sculpture 7* were executed.[46] Yet for all this manifest transatlantic influence, a work such as *Midday* suggests to this writer a monumentality as much in the spirit of Henry Moore as of David Smith, a monumentality that, in any case, would disappear from Caro's subsequent works.

AIR. *1971. Steel, painted, 1' 5 1/2" x 5' 8" x 5' 11". Kasmin Limited, London.*

In the work of 1962–63, Caro affirms and exploits the spatial innovations that are incompletely spelled out in his earlier sculpture and develops an anti-monumental weightlessness and transparency that belie the even larger size of his pieces. *Sculpture 2* (1962, pp. 36, 37), for example, is derived from the same family of steel components as *Midday* and *Sculpture 7.* Even its single small arching curve bears analogy to the curved element in *Midday.* But there are more components in *Sculpture 2,* and they are less massive in size and profile. The configuration is more open, and the individual units are more dispersed in space both vertically and horizontally.

The assurance with which *Sculpture 2* claims and defines space is stunning. On one end, both lateral and recessional space are defined by an L relationship, which also affirms the ground as the support of the work, much as a stretcher simultaneously affirms the actuality and the boundaries of a painting's support. The right angle on the ground is counterpointed by the T-shaped right angle in air—inflected obliquely to the vertical axis—which is formed by the intersection of the two larger beams on the other end of the piece. Throughout the sculpture there is an interaction, a dialogue in terms of sizes, rapports, shapes, and angles, between the "ground plan" and "elevation"; but the sculptural process here has less to do with architecture than with painting.

The airiness of *Sculpture 2* relative to the previous works is

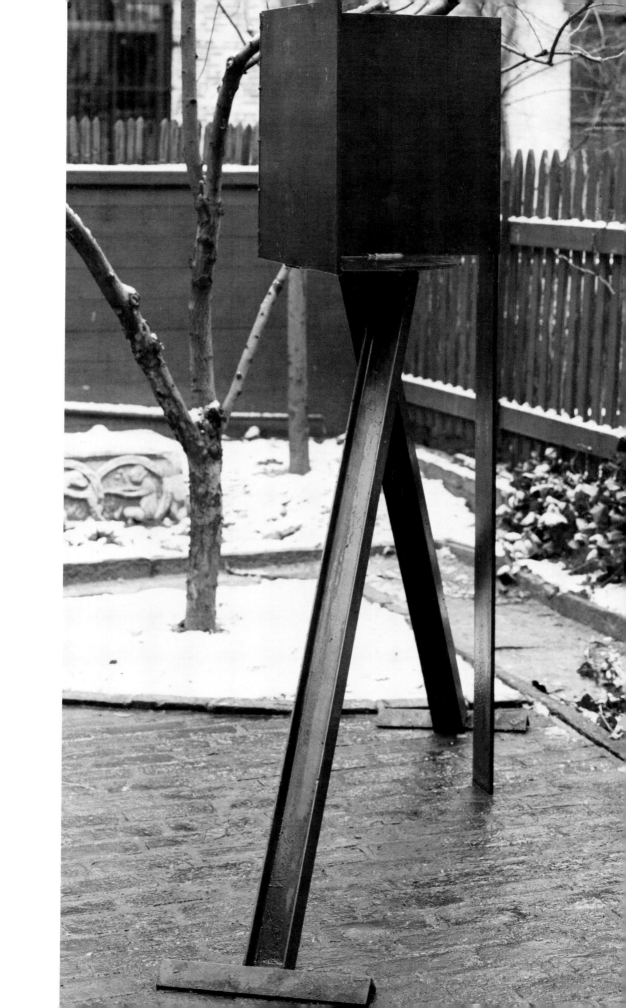

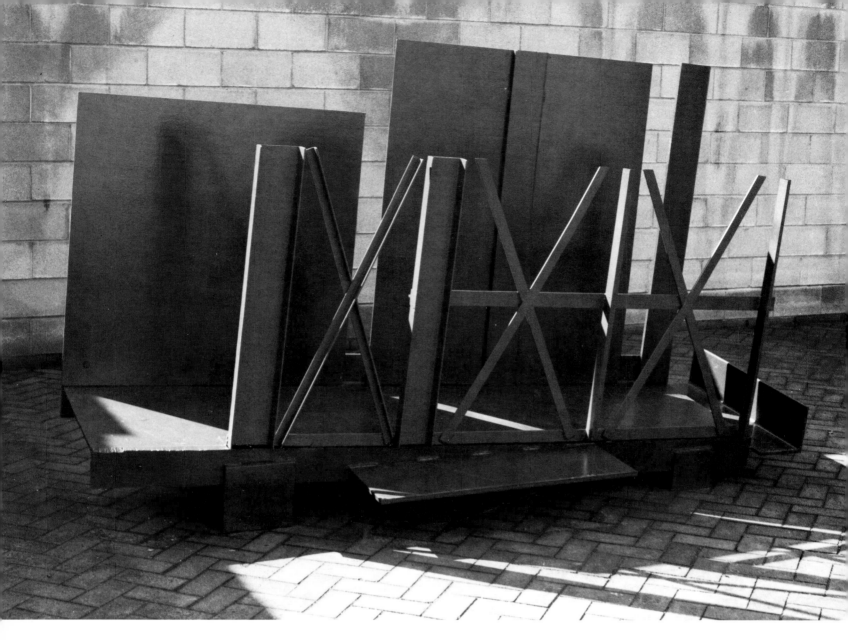

UP FRONT. *1971. Steel, painted, 5′ 9″ x 9′ 2″ x 3′ 10 1/2″. Detroit Institute of Arts.*

carried even further in *Hopscotch* (1962, p. 39). Here, long aluminum tubes, bars, and panels create a see-through spatial grid almost like a musical staff to which obliquely inflected smaller units cling as if magnetized. The staccato character of the piece suggested playing and jumping to Caro—hence its unusually descriptive title. Though the ancestors of *Hopscotch* are certainly to be identified as Picasso's wire constructions of the twenties—with perhaps a faint recollection of Mondrian's plus-and-minus pictures—the highly dispersed, seemingly random character of its articulation is without precedent in sculpture. *Hopscotch* is the only work of these years which is not painted, no doubt because Caro found the shiny surface of the aluminum appropriate to the bodiless, purely optical character of the configuration.

Early One Morning (1962, pp. 40, 41) was Caro's magnificent summation of three years' explorations. It combines the economy of *Midday* and *Sculpture 7* with the airiness of *Hopscotch*, achieving the stateliness and architectonic quality of the former with less insistent means. For the first time, in *Early One Morning*, Caro employs, albeit sparingly, a kind of drawing that is not confined to geometrical or parabolic curves. The inflections of the near-vertical pipes (at the "front" of the piece and roughly one-quarter and one-half way down the work's "spine") are modest. But the effect is stunning. All the "freehand" lines seem mysteriously responsive to forces exerted by the horizontal and vertical axes, especially insofar

SURVEY. *1971–73. Steel, rusted and varnished, 30″ x 7′ 6″ x 5′ 11″. Private collection, New York.*

Opposite: CREST. *1971–72. Steel, rusted and varnished, 4′ 1″ x 2′ 8″ x 4′. Guido Goldman Sprinkling Trust, Cambridge, Massachusetts.*

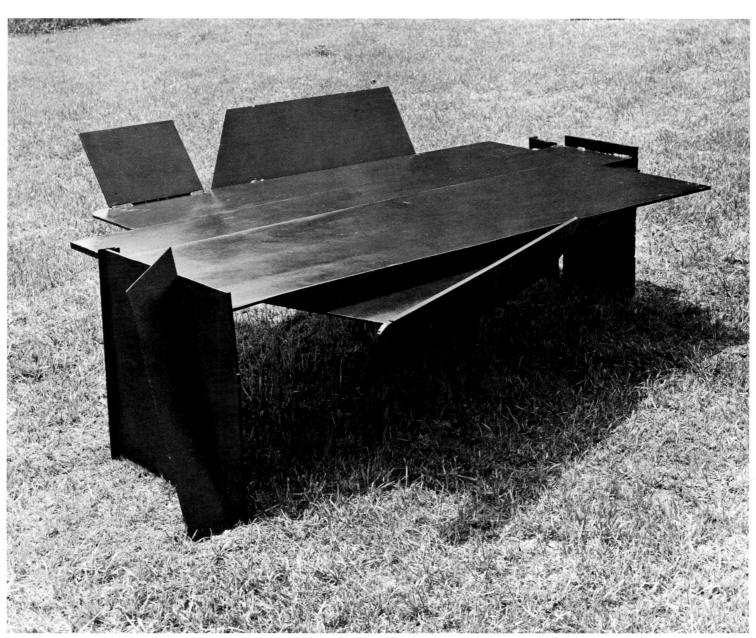

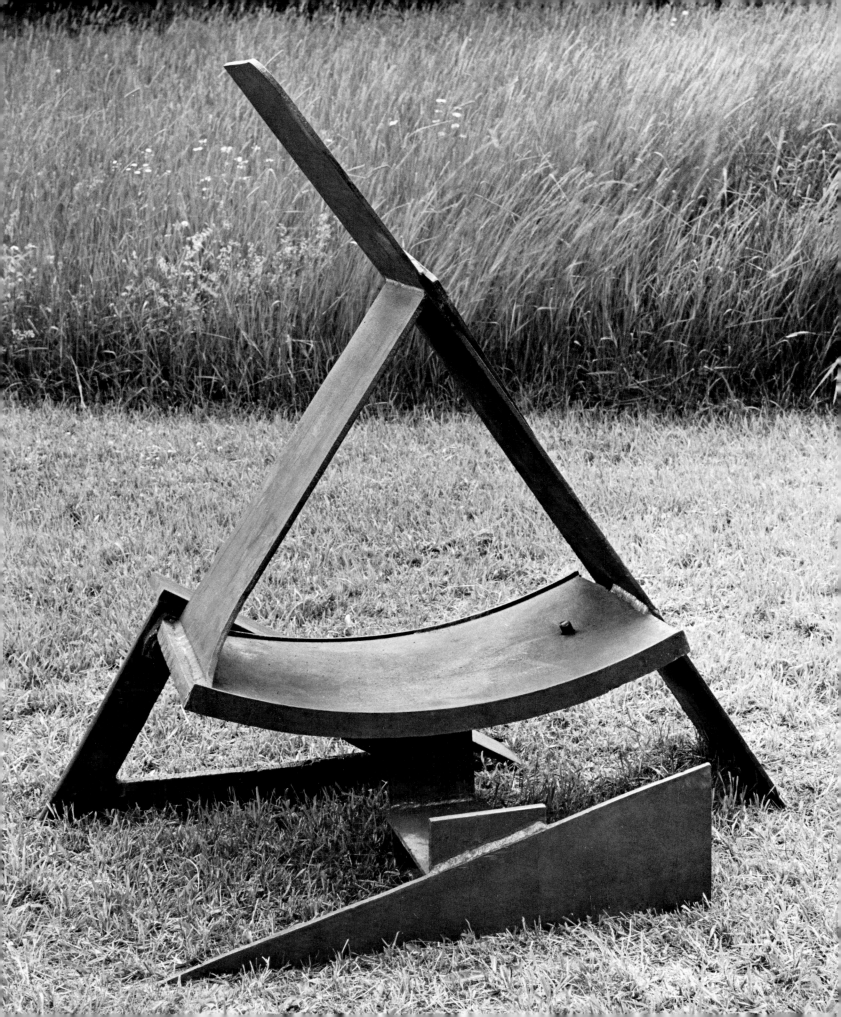

as these are embodied in neighboring members. Thus the heavy pipe rising at the front seems to straighten upward ever so slightly—to stiffen, as it were—just before it is traversed by the channel bar that forms a cross with it. Behind it, a narrower, more delicate pipe bends not only sideways toward the horizontal spine, but also forward toward the cross, as if attracted by the presence of the more dominant pipe. Its falling away just after crossing the spine (p. 40)—as if it had depended on that horizontal for support—provides a superb foil for the more rigid elements, and a touch of humor as well. The contrast of arabesque and straightedge is made explicit in the last two inflected lines—splayed tines that project upward (at an angle no photograph can clarify) with the resiliency and impudence of breast hairs in Miró.

The principle of contrast operates with equal simplicity and economy in regard to the other components of the sculpture. Two sections of steel beam are paired as vertical members, but one is cut from a horizontal girder, the other is a vertical channel section. The two rectangular planes that parallel the ground are contrasted with each other by their positioning vis-à-vis the spine, and each provides a foil, in terms of axis, for the vertical rectangle that rises like a great screen to "close" one end of the piece. This play of analogies unites *Early One Morning* and establishes a rhythm for the eye as it moves through the twenty feet over which its components are dispersed. We follow the play of curved pipes from

ORDNANCE. *1971. Steel, rusted and varnished, 4' 3" x 6' 4" x 11' 11". André Emmerich Gallery, New York.*

Below and opposite: CHERRY FAIR. *1971. Steel and Cor-ten steel, painted, 3′ x 7′ 3″ x 6′ 2″. Collection Professor Hanford Yang, New York.*

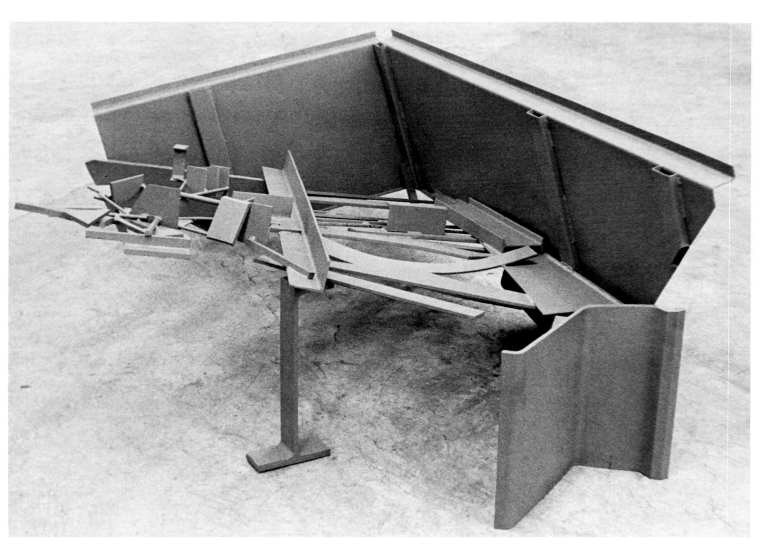

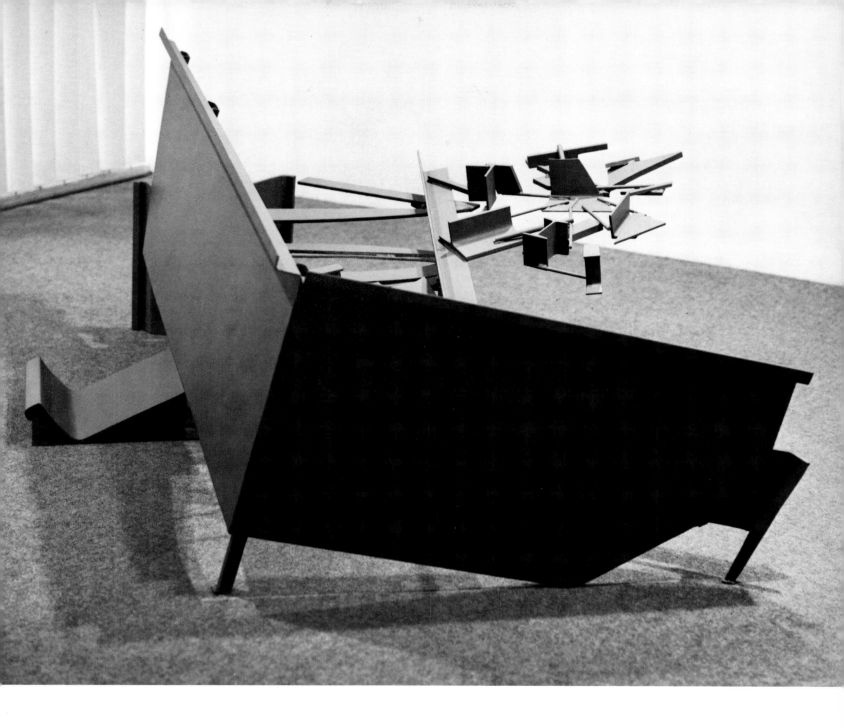

one to another along the horizontal bar; the nearer steel beam leads to the one farther down, which in turn adjoins the first horizontal plane, the motif of which carries us to the back of the piece.

I call this upright rectangle the "back" of the piece—and, thus, the cross its "front"—because its opacity effectively blocks a view of the work from a position behind it. In this sense—exceptionally for Caro's mature art—*Early One Morning* has a back in something of the same manner as *Twenty-four Hours*, though unlike the earlier piece it does not force a frontal position on the viewer. To be sure, *Early One Morning* is dramatic when viewed frontally, with the cross seen against the screen of the back plane in a manner that telescopes the immense distance separating the two (p. 41). The perspective is, nevertheless, inadequate for the perception of much that is important and expressive in the work, which can be assimilated only by moving around it. Because of its size and dispersed character, *Early One Morning*—like much of Caro's other work—resists being photographed in a way that corresponds to the actual experience of the work. This is to some extent true for all sculpture, owing to the camera's monofocal vision. But it is especially true of sculpture that is not organized in a pictorial manner (i.e., in relation to a plane at right angles to the spectator). As the camera does not have man's peripheral vision or his ability to rotate his view, a process essential to seeing Caro's sculpture, the

NIGHT ROAD. *1971–72. Steel, painted, 5' 3/4" x 7' 4" x 3'. The Museum of Fine Arts, Houston.*

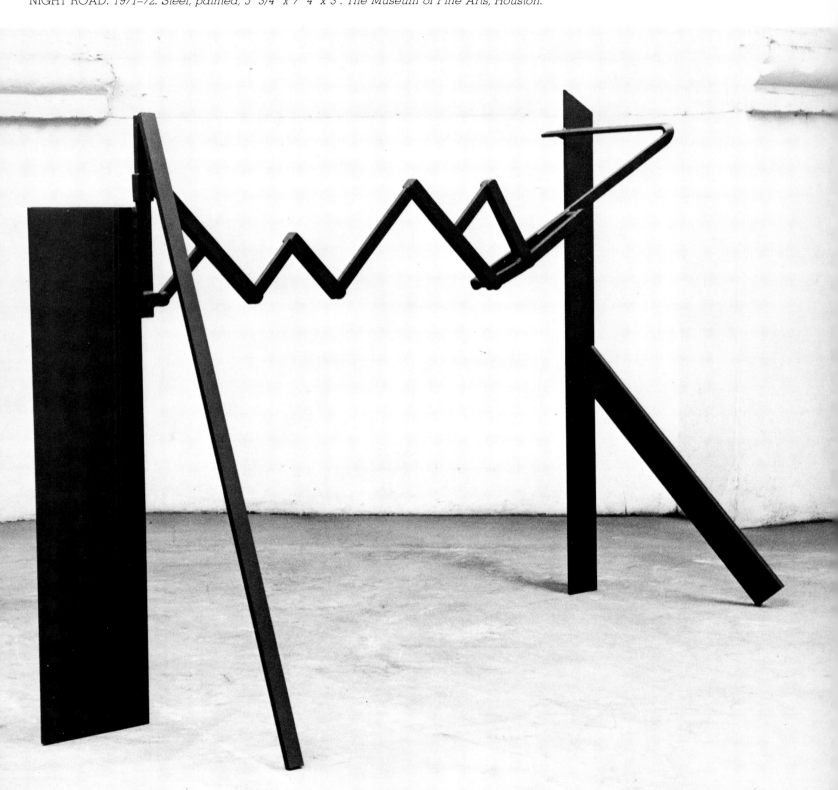

FENDER. *1972. Steel and Cor-ten steel, varnished, 21 3/4" x 34" x 8' 1". Collection Helen Frankenthaler, New York.*

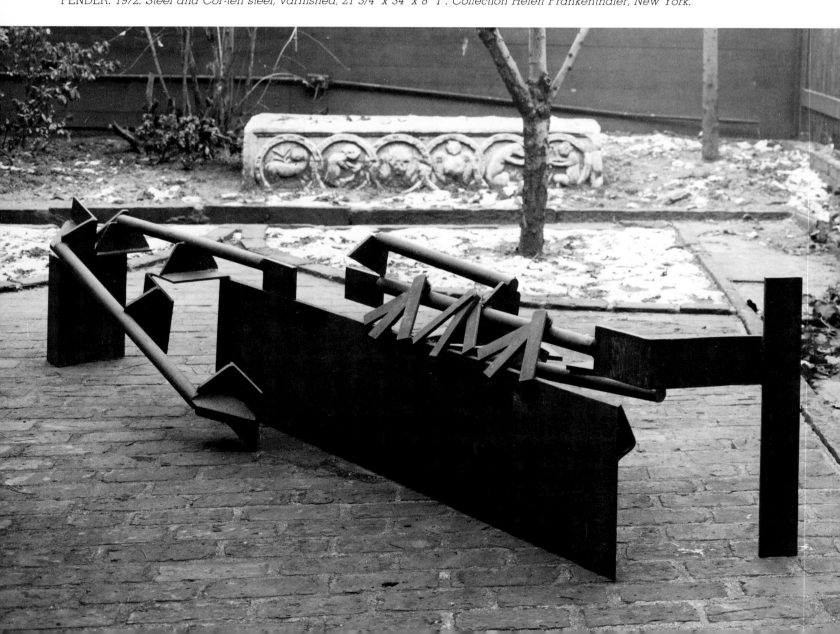

photographer must take a position farther from the work than would the spectator—with consequently greater falsification of the experience than is usually the case.

Even allowing for the mobility of the eye and the spectator's ability to retain visual facts while the retina is being imprinted with new ones, there comes a point at which the optical data of a truly three-dimensional work are too complex to cohere meaningfully. I believe this happens in *Month of May* (1963, pp. 44, 45). In this work Caro enlarged upon the possibilities of the kind of curvilinear drawing announced in *Early One Morning*, just as he had shortly before explored the implications of its vertical plane in *Pompadour* (1963, p. 42). And like *Pompadour*, *Month of May* suffers from too much of what had been a good thing in *Early One Morning*. The bent pipes produce too many twists, turns, and angles in three-dimensional space for their complications to be resolved satisfactorily from any single perspective, a problem intensified, I believe, by the work's polychromy.[47] *Month of May* suggests that complex drawing moving in and out of three-dimensional space may be beyond sculpture's possibilities. What this piece wants is precisely that ordering by an implicit picture plane that underlies Smith's "drawing in air."

Pompadour and *Month of May* suffer from an overstatement rare in Caro's work. They were followed by a break in his production occasioned by a trip to the United States in the fall of 1963, when he

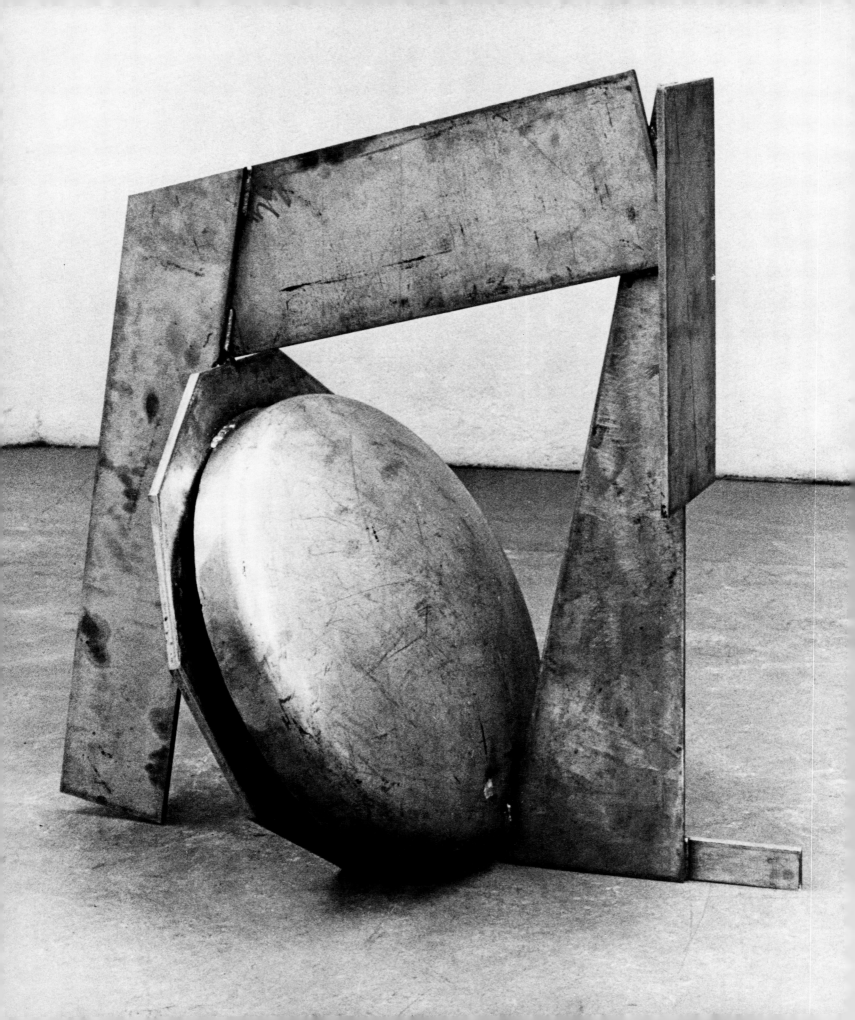

took up a teaching position at Bennington College. Perhaps the proximity of Kenneth Noland and Jules Olitski, with whom he spent a good deal of time during his Bennington stay, reinforced Caro's instinct for economy. In any event, an emphatic spareness marks the series of sculptures executed that winter in an abandoned garage where he was able to set up a welding studio.

Titan (pp. 46, 47), *Bennington* (p. 49), both 1964, and *Shaftsbury* (pp. 54, 55), executed in Bennington the following year, come as close to constituting a series as anything Caro had yet produced.[48] They hold in common primarily their exceptionally low centers of gravity—every component in them rests on the ground and none rises higher than 3 1/2 feet—and their use of I-beam segments arranged in relation to long, low panels of thin steel. In *Titan* and *Bennington* these low panels are set at right angles to the ground—in *Shaftsbury*, one of them is tilted obliquely—and they form, respectively, an "L" and a modified "T." *Titan* and *Shaftsbury* contain a characteristic three-panel shape like a Z pulled into right angles. The simple found version of this element is attached to one extremity of *Shaftsbury;* in *Titan,* two such elements are joined on a common plane to form what I earlier called a "swastika" shape.

Wide (1964, p. 51), executed after *Titan* and *Bennington,* shares with them only the low-lying panel. Three flattened tubes flare out from this, and one end of a long L-shaped bar lies across it. *Wide* is one

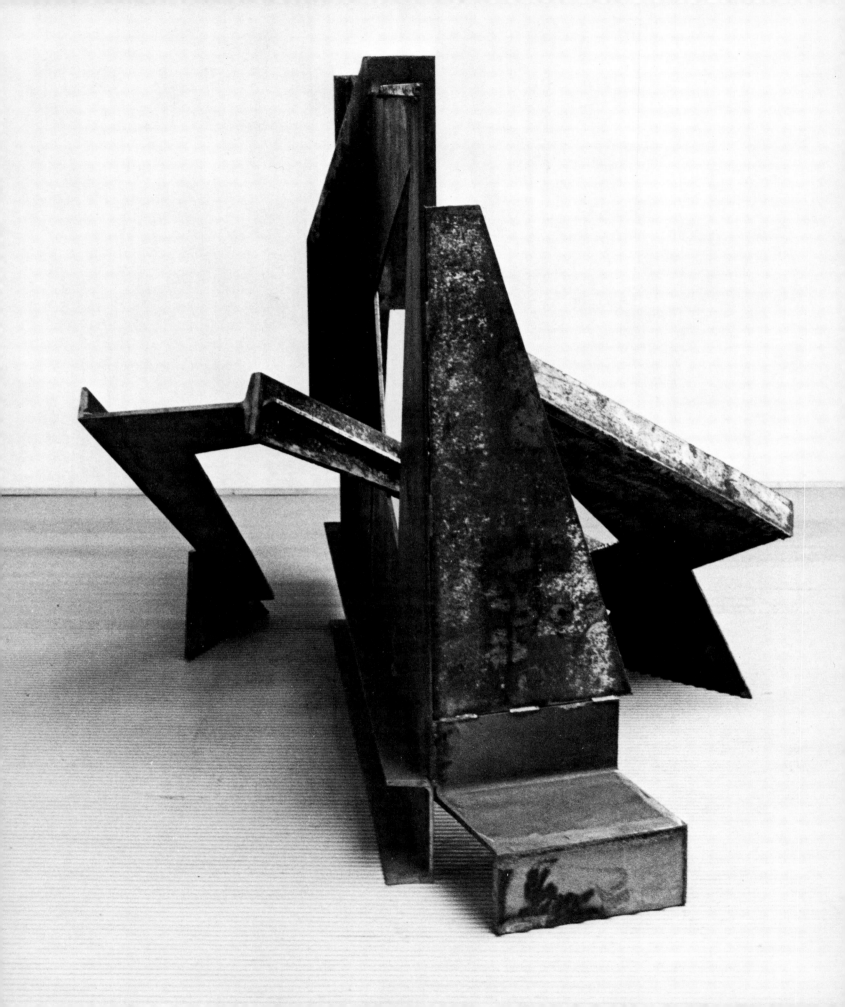

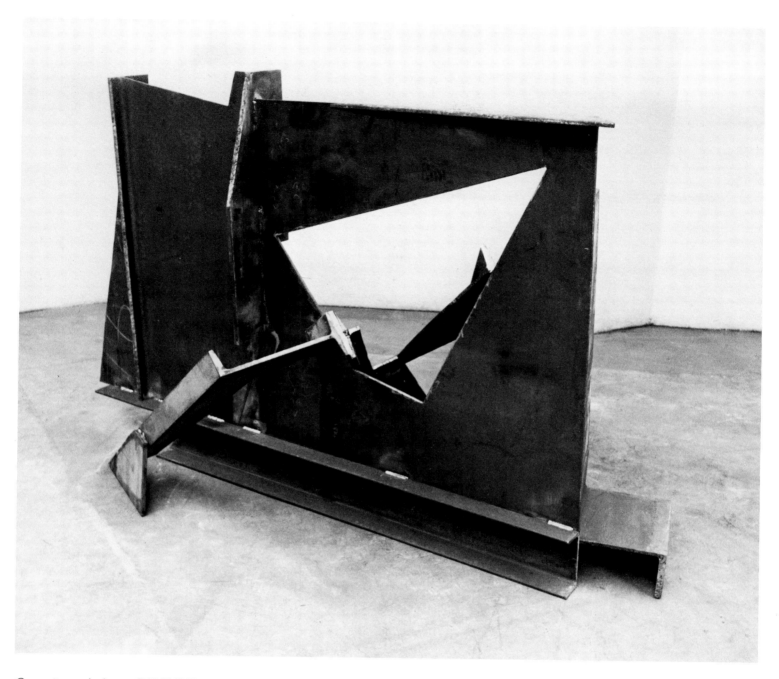

Opposite and above: STRAIGHT LEFT. *1972. Steel, 5' 1" x 4' 6" x 8' 2". The David Mirvish Gallery, Toronto.*

of Caro's freest and most unexpected compositions, and seems to have provided the impetus for a series of linear sculptures—including *Smoulder*, *Sight* (p. 57), *Sleepwalk* (p. 59), and *Farnham* (p. 58)—all executed in 1965. Motifs lead to one another in these sculptures as in a musical improvisation. *Sight*, the simplest of the group—which Caro refers to collectively as "naked" sculptures—consists of but a narrow angle-iron cantilevered upward from a shorter, heavier bar that establishes the ground. Except for its precise orientation, this flaring angle-iron is similar to the one of *Sleepwalk*, the other feature of which is a low-lying, almost horizontal "X." This "X" is, in turn, pushed upright at one end of *Farnham*, the other end of which is anchored by a short vertical, a motif picked up, in its turn, from *Smoulder.*

In the sculptures of 1966 Caro solved the "problem" of the opacity of vertical panels—such as that of *Early One Morning*—by introducing rectangular grids made of street gratings or expanded-metal mesh of the type used for reinforcing walls. These made possible compositions based on semitransparent upright planes dispersed through lateral space with an autonomy that Caro emphasized by making their linkages extremely tenuous. Only a narrow pipe, for example, connects the two quasi-independent sections of *Carriage* (1966, p. 81) and of *Source* (1967, p. 88). The relative transparency of the grids permits them to function almost as surrounding walls. Thus, instead of a solid sculpture that

Opposite: STRAIGHT UP. *1972. Steel, 4' 8" x 3' 7" x 5' 8". Collection Mr. and Mrs. Robert Geddes, Princeton, New Jersey.*

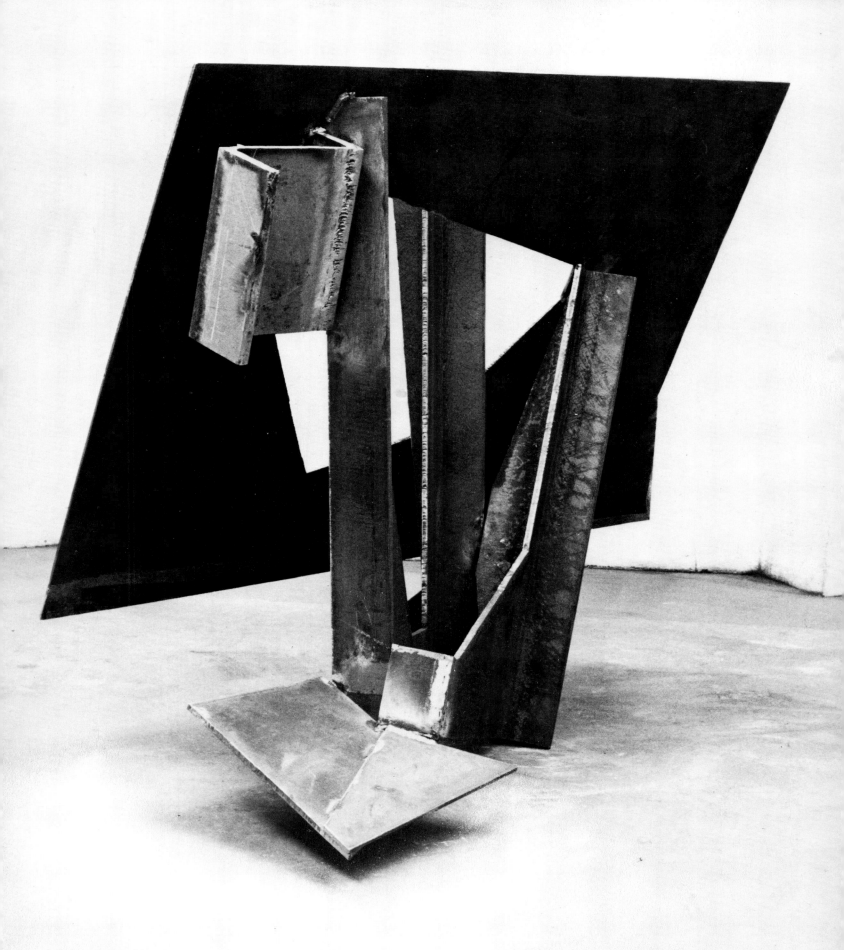

articulates the space into which it extends, Caro was now making works that, in effect, define an empty space at their center.

In these pieces, the semitransparent material is used to form rectangular planes. Never irregularly shaped, they sometimes provide a ground for arabesques (as in *Aroma*, 1966, p. 77) or for a small panel (as in *Red Splash*, 1966, p. 78, and *Source*), whose opacity reemphasizes the grid's transparency. In *Red Splash*, the mesh panels—known technically as "expanded metal"—are tilted at an angle and form an "X" that connects four posts whose differing heights and diameters almost constitute a parody of perspective. In other pieces the grid or mesh planes are absolutely vertical: in *Span* (1966, p. 82) the grid is very heavy, in keeping with the character of the solid elements in the work; in *Carriage*, two kinds of expanded metal overlap to produce a shaded effect.

Caro's mesh pieces are among his most successful. *Carriage* is distinguished by the simplicity of its conception and by the expressiveness of the oblique confrontation of its two parts. *Source* is the most sophisticated, most thoroughly distilled work of the group. Here the two space-defining elements that confront one another are made maximally contrasting. The low one is formed of opaque components of which the main constituent is a long rectangular panel angularly cantilevered away from the rectangle of expanded metal that it confronts, and to which it is connected by a gently curved pipe.

Some months before *Source* was completed, early in 1967, Caro began an extended series of small table pieces that represented a new departure for him in several ways. He had earlier shied away from making small pieces for fear they would seem like maquettes or models of larger ones. In an attempt to retain the kind of literal size that is measured in relation to the viewer himself (see above, p. 75), Caro executed his tabletop works mostly in units no smaller than those in the more intricate passages of the contemporaneous larger works, often emphasizing their human scale by incorporating an actual grip or handle. *Table Piece XXII* (1967, p. 171), one of the earlier of the small works (which Caro continues to make), sets out their premises with great clarity. A short segment of regularly curved wide-bore pipe is joined to a long segment of narrower bore by a metal handle. The hefty size of each element and, above all, the scale forced on us by the recognizable handle help assure that we will not see this as a reduced version of a larger conception; at the same time, the handle fixes our sense of the small size of the work by suggesting that it can be lifted from the tabletop. The descent of elements below the level of the tabletop, which precludes "its transportation, in fact or in imagination, to the ground,"[49] further prevents any mistaking it for a model of a larger work.

The tabletop is, in the first instance, the studio workbench on which the pieces are actually assembled. Its finiteness gave Caro the possibility of treating this support as an entity in itself and, at the

David Smith. VOLTRI XIX. 1962. Steel, 55 1/4" x 45" x 50". Estate of David Smith, Knoedler Contemporary Art, New York.

Alberto Giacometti. THE TABLE. 1933. Plaster, 57 1/2" h. Museé National d'Art Moderne, Paris.

same time, dropping below its plane. Thus the narrower pipe of *Table Piece XXII* is tilted so that it descends below the support's edge, while the rectangular plane of *Table Piece XVIII* (1967, p. 170) had been pushed even further in that direction insofar as it defines the *side* of the tabletop by pressing against it.

Not long after beginning his series of table pieces, Caro introduced broad horizontal planes reminiscent of tabletops into a few large pieces. *Trefoil* (1968), for example, is traversed by a horizontal panel placed a bit below half its height. Some elements rise directly or arch upward from this plane, and one swings down over the edge. The very points on which the work is actually supported give the illusion of having been "dropped" from the table plane (their forms suggest a bounding upward) rather than having been conceived as supports for it.

Neither in *Trefoil* nor in *Orangerie* (1969, p. 94), where the traversing table plane is inflected away from the horizontal by being joined to a slightly tilted one, did Caro allude to the tabletop idea descriptively—i.e., as the worktable—in the manner of Smith in certain of his sculptures. For Smith, the table had poetic and autobiographical implications which he wanted the viewer to share. His *Voltri XVI* is a workbench re-created in a formal manner as a work of art. The more surreal *Voltri XIX*—shown at the Tate Gallery shortly before Caro began his table pieces—contains a pair of steel forging tongs that spill downward over the edge of the

David Smith. VOLTRI XVI. *1962. Steel, 44" x 40" x 38". Estate of David Smith, Knoedler Contemporary Art, New York.*

TREFOIL. *1968. Steel, painted, 6' 11" x 8' 4" x 5' 5". The David Mirvish Gallery, Toronto.*

table in the manner of Dali's soft machines. Though not a direct influence on Caro's work and very different in character from it, the piece nevertheless provides something of a precedent for the descent of forms beneath the plane of the support.

The use of the tabletop not simply as a locus for sculpture but as a component of it was not entirely Smith's own idea. Like certain other aspects of his work, it was to some extent a gloss on the early Giacometti. Although the latter's *Table* (1933) is closer than Smith's to a Surrealist *objet trouvé aidé*, it was, nonetheless, entirely modeled, and the table section itself[50] is not a stand, but an integral part of the piece. Its surface supports full-scale carvings of a severed left hand, a bottle, an abstract sculpture, and the bust of a woman. In a note distantly foreshadowing both Smith and Caro, the folds of drapery from the woman's hood spill down below the level of the table. Taken in sequence, Giacometti's *Table*, Smith's *Voltri XVI,* and Caro's *Trefoil* constitute a study in the progressive reduction of the poetic and metaphoric implications of the tabletop motif in the interests of its purely abstract possibilities.

Table pieces *LXIV* (1968, p. 143, also known as *The Clock*) and *LXXXVIII* (1969–70, p. 143, subtitled *The Deluge*)[51] not only are among the best of Caro's smaller pieces, but are very revealing for the distinctions they clarify between Caro's personal draftsmanship and the "drawing in air" of Smith. Smith's *Timeless Clock*—which comes closer than any of his other works to being actually drawn

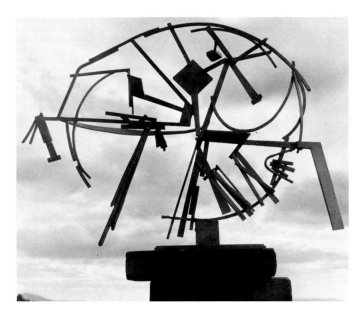

David Smith. TIMELESS CLOCK. *1957. Sterling silver, 21" x 27". Collection Mr. and Mrs. Harry W. Anderson, Atherton, California.*

with metal[52]—rises from a small stand and is deployed almost entirely within a single vertical plane that the viewer perceives at a right angle. Caro's *Clock,* on the other hand, is organized around an implied plane that tilts angularly in relation to the tabletop, and the integrity of that plane is much less respected than in Smith. By the standards of his work as a whole, Caro's *Clock* is intricate. But it has nothing of the linear complexity of Smith's *Timeless Clock.* Whereas the smaller accents of the Smith are sculptural counterparts of drawing devices (such as hatchmarks), those of the Caro are characteristically the actual underpinning of the construction process (the tack-bars) that have been allowed to remain.

The fact that Caro's line, even at its most elaborate, is additive—made up of simple, geometrical curves and straight edges, and not "freehand" arabesques as in Smith—is well illustrated by comparing his superbly stylized *Deluge* to Smith's *Timeless Clock.* Though the forms of *The Deluge* spill below the tabletop, many of them at oblique angles, its configuration rises essentially at right angles to the support and thus comes as close as anything in Caro's work to resembling the more draftsmanly intimate sculptures of Smith. In contrast with the latter's *Timeless Clock,* however, the lines of *The Deluge* are almost all regular arcs—segments of circles or parabolas. Nowhere does an individual contour break this continuity or change direction unexpectedly. The intricacy and the inventiveness of the configuration derive from the way in which the

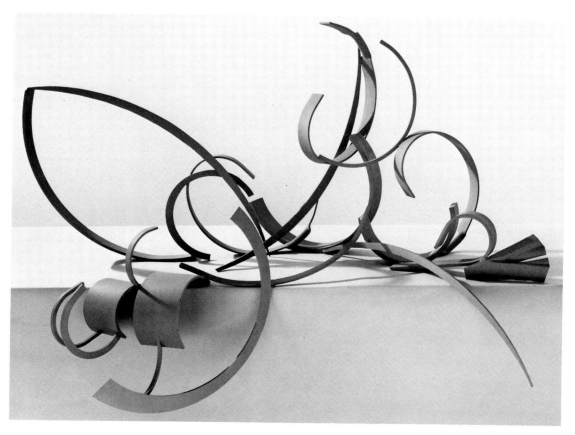

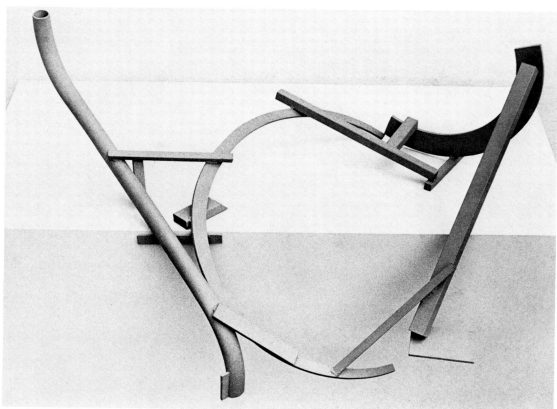

Top: TABLE PIECE LXXXVIII (THE DELUGE). *1969–70. Steel, painted, 40" x 63" x 38". Guido Goldman Sprinkling Trust, Cambridge, Massachusetts.*

Bottom: TABLE PIECE LXIV (THE CLOCK). *1968. Steel, painted, 30" x 51" x 32". Collection Mr. and Mrs. Clement Greenberg, New York.*

143

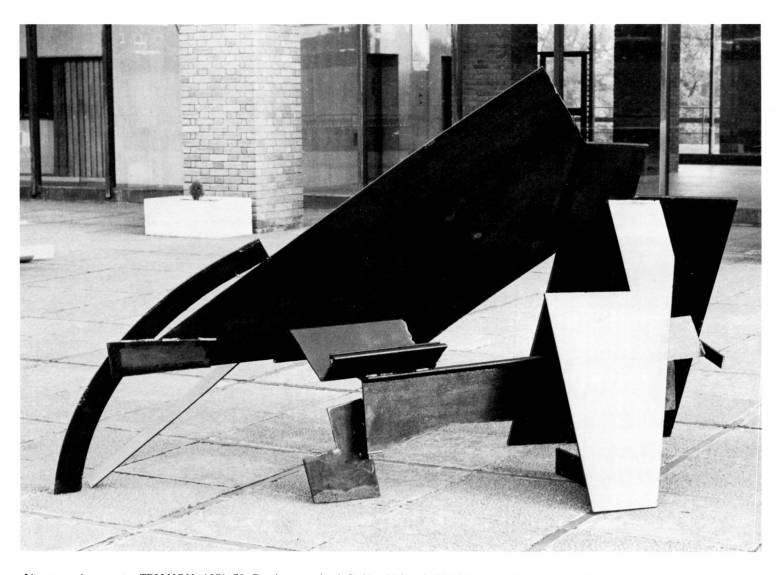

Above and opposite: TRIANON. *1971–72. Steel, varnished, 5′ 3″ x 3′ 6″ x 8′ 11″. Private collection, London.*

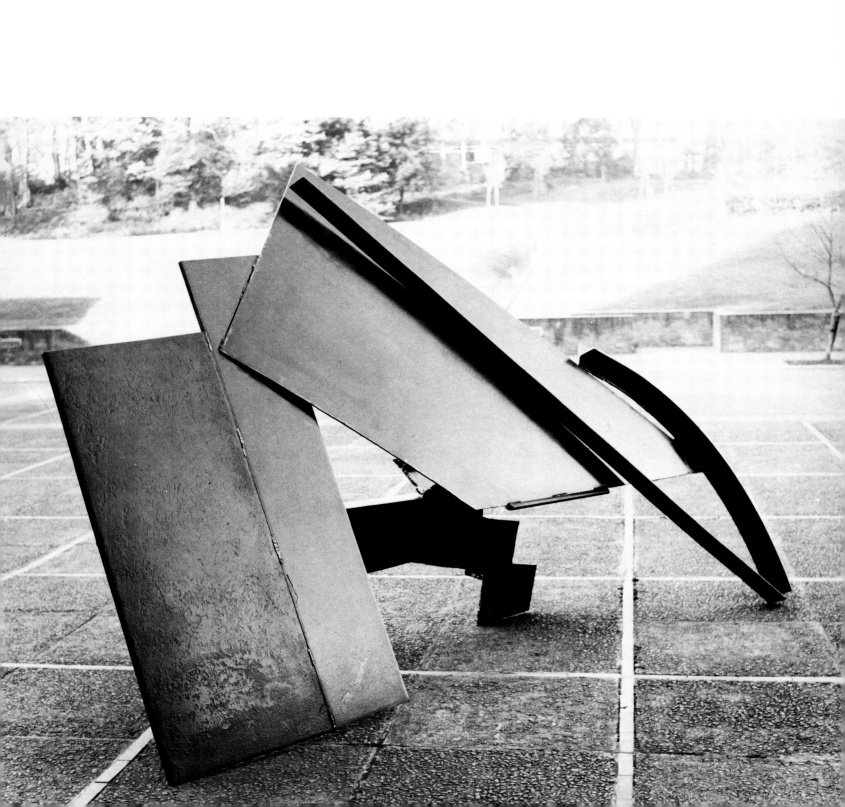

linear components are multiplied and the manner in which they are juxtaposed, rather than from inflections within any single one of them.

We have seen that in some of the grid and mesh pieces of 1966–67, Caro tended to define an empty space by flanking it, sometimes with transparent units that rise above the viewer's line of sight. In *Prairie* (1967, pp. 86, 87), he defined space in precisely the opposite way, by measuring it from within. *Prairie* confronts us for the first time with a work that appears to occupy its lateral space fully, rather than zigzag through it or reach into it from one or more axes. And, though *Prairie* is only slightly over a yard high, it involves a dividing or measuring of vertical space that is just as sophisticated as its organization of horizontal space, with which it is rhythmically interlocked. Indeed, the piece is Caro's most extraordinary essay in the direction of very low-lying, lateral sculpture.

Prairie measures its space by articulation rather than by displacement. The sculptor David Annesley put it well when he said: "I'm aware of the volume in *Prairie;* I find *Prairie* has a very specific volume. But I'm not aware of the mass any longer . . . What has happened is he's taken weight from mass and left us with a kind of volume. And it's not that it's light; it's weightless. I think *Prairie* [has] achieved [a] weightless state visually, and yet we know it's made of steel and it's there and its physicality is as real as any of the [other sculptures]."[53]

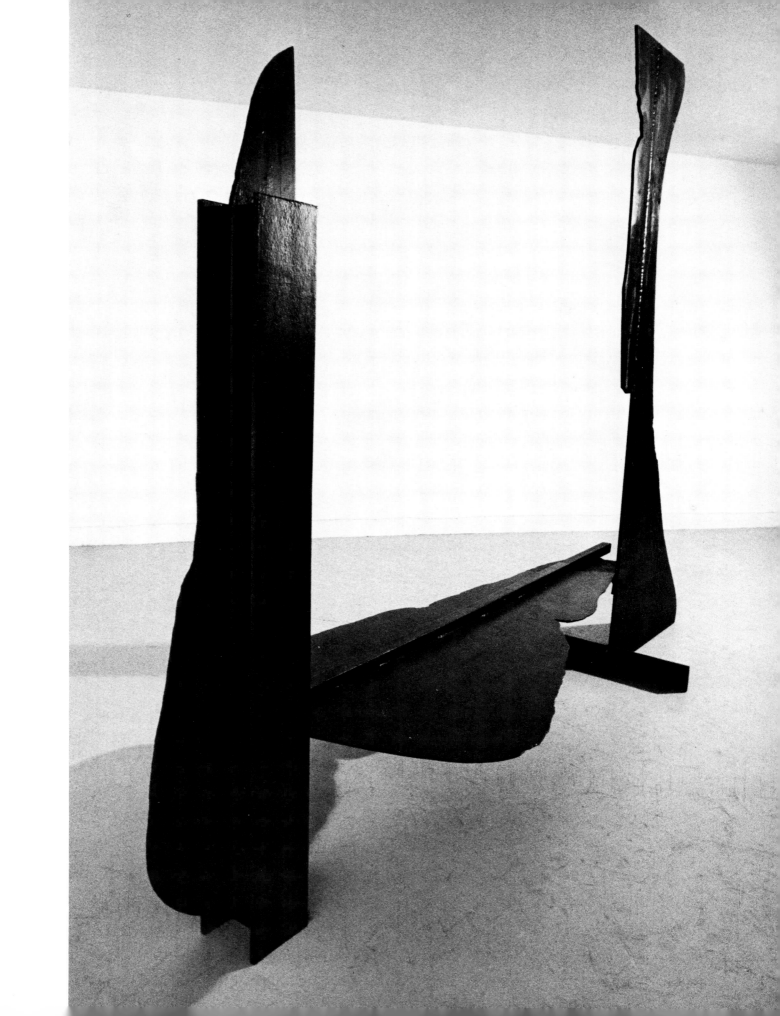

So convincing is the sense of weightless extension in *Prairie* that one almost loses sight of the frankness with which its mechanics are avowed. A stroll around the sculpture makes the workings of the entire support system manifest. The central element in *Prairie* is a rectangular steel form containing four corrugations. By the way it is jacked up from the ground, the motif of the floating element is established and then reiterated in the rods passing at right angles above; the analogy of the rods to the corrugated panel is further developed by their convex contours, which appear as "positive" counterparts of the "negative" channels of the corrugations. The fact that two of the corrugations are at the outer edges of the sheet—thus defining its limits—and that they are all equidistant from one another completes the analogy to the implied plane of the rods.

Prairie's corrugated panel constitutes its second lateral plane, the lowest being the ground itself, which is forced into our cognizance by the flangelike units that traverse it. The third lateral level is determined by the horizontal rods, whose illusory weightlessness Caro emphasized by painting them a slightly lighter yellow ocher than the rest of the piece. Only one of these rods is supported in two places (by the diagonally rising planes that also serve to jack up the corrugated panel). The other three rods are held by a single weld near one end and cantilevered—two from the diagonal planes and the third, slightly longer one from a free-standing rectangular

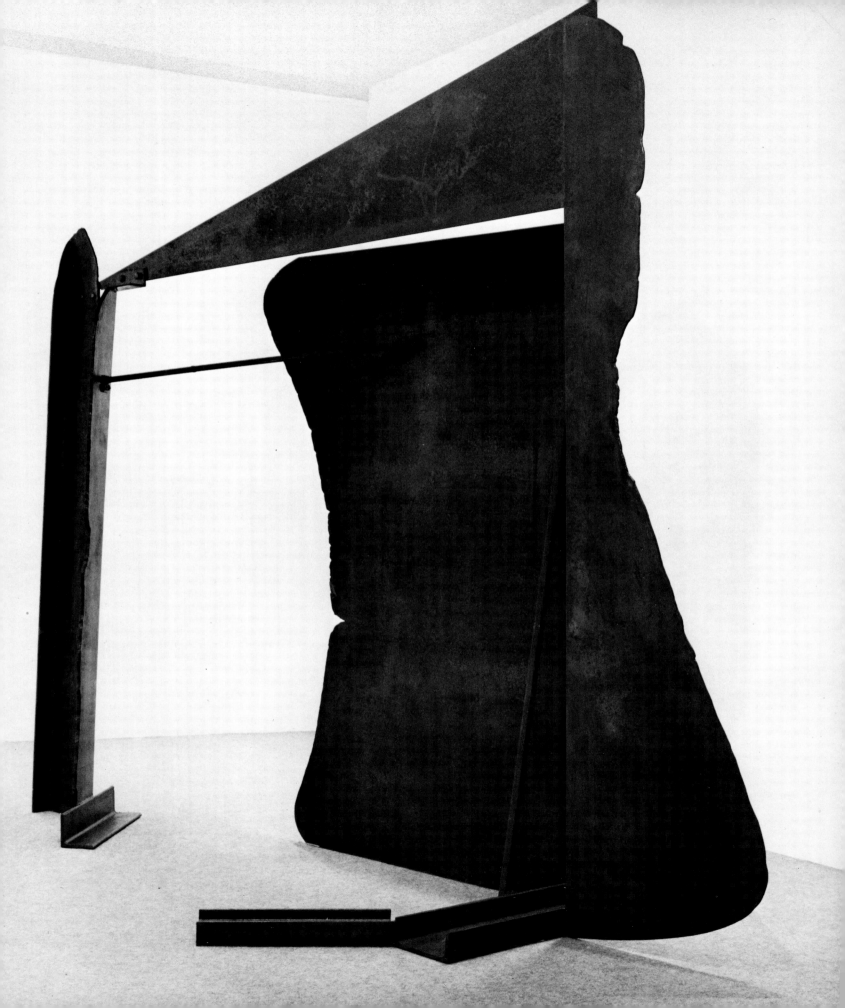

COCAINE. *1973. Steel, 24" x 13' 4" x 30". Kasmin Limited, London.*

panel. This panel is, in turn, assimilated to the main body of the piece through the rhythm of the rod it supports, and its opacity establishes a boundary of *Prairie* by implying a space-delimiting "corner."

This description of the "rationale" of *Prairie*'s construction risks giving—as was the case with my earlier remarks on *Titan*—the sense of a cerebral, highly planned sculpture, when in fact the piece was intuitive and entirely improvised.[54] Despite our confrontation with the frankly avowed mechanics of support, the initial illusion of *Prairie*'s weightlessness holds. The rods, for example, seem only to touch, rather than to be cantilevered from, the panels that in fact support them. ". . . grasping exactly how *Prairie* works as a feat of engineering," wrote Michael Fried,

does not in the least undermine or even compete with one's initial impression that the metal poles and corrugated sheets are suspended, as if in the absence of gravity, at different levels above the ground. Indeed, the ground itself is seen, not as that upon which everything else stands and from which everything else rises, but rather as the last, or *lowest*, of the three levels. . . . (In this sense, *Prairie* defines the ground, not as that which ultimately supports everything else, but as that which does not itself require support. It makes this fact about the ground both phenomenologically surprising and sculpturally significant.) The result is an extraordinary marriage of illusion and structural obviousness. . . . More explicitly than any previous sculpture, *Prairie* compels us to believe what we see rather than what we know, to accept the witness of the senses against the construction of the mind.[55]

Caro's sculptures of 1968–70, the years following *Prairie*, reflect a

DURHAM PURSE. *1973–74. Steel, rusted and varnished, 4' x 12' 3" x 30". Collection Joanne du Pont, New York.*

Opposite: DURHAM STEEL FLAT. *1973–74. Steel, rusted and varnished, 9' 4" x 8' 3" x 5' 11". Guido Goldman Sprinkling Trust, Cambridge, Massachusetts.*

SILK ROAD. *1971–74. Steel, rusted and varnished, 5' 2 1/2" x 12' 7 1/2" x 33". The David Mirvish Gallery, Toronto.*

DARK MOTIVE. *1971–74. Steel, rusted and varnished, 5' 1" x 11' 3" x 26". The David Mirvish Gallery, Toronto.*

détente; rigor gave greater way to fancy, and a variety of sculptural possibilities hitherto little developed began to make themselves more explicit. *Prairie* constituted the summary of Caro's explorations in large low-lying sculptures composed of simple constructivist-type elements. Such new works as his *Orangerie* (1969, p. 94), *Sun Runner* (1969, p. 93), *Deep North* (1969–70, pp. 104, 105), and *Crown* (1970–71, p. 114) witness a greater interest in vertical movement and in a kind of drawing that involves the free contouring of individual units. I use the phrase "vertical movement" because, even though the prevailing inner articulation was no longer lateral, most of the sculptures did in fact remain wider than they were high. In *Sun Runner,* for example, one end of the piece is composed of vertical elements, and as the eye reads the work its forms seem to spill downward. In *Deep North,* the most stable, most "architectural" element is a rectangular grill poised horizontally eight feet off the ground. This establishes for the structure a kind of firmly fixed "roof" from which more freely shaped forms descend, one of them seeming almost to rebound from the ground.

Caro's new inventiveness with nongeometrical shapes is at its best in the Matisse-like *Orangerie.* Even here, of course, most of the forms are "found"—in the sense that they are segments of plowshares purchased as scrap metal. The choice and the segmentation of the particular pieces constitute the whole of the "drawing." Yet so beautifully arabesqued and turned are they that they give the

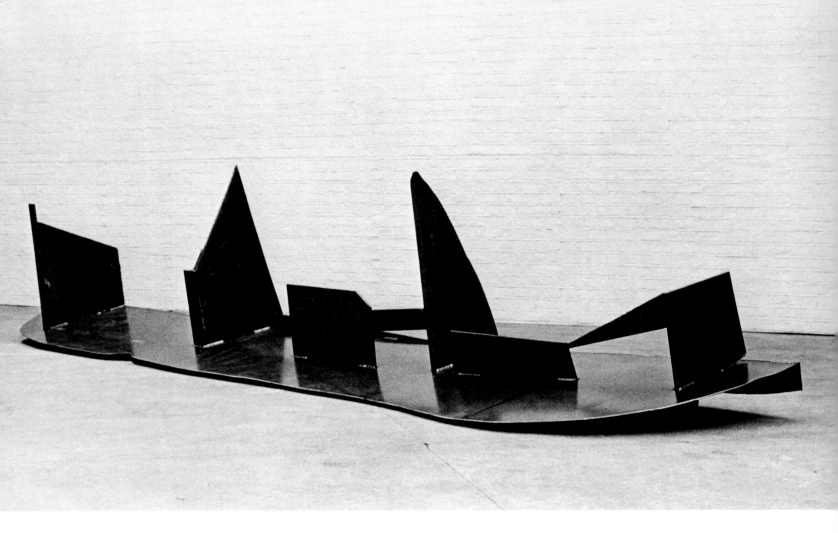

FIRST WATCH. *1974. Steel, rusted and varnished, 3′ 5″ x 15′ 8″ x 3′ 6″. André Emmerich Gallery, New York.*

impression of having been entirely shaped by the sculptor's hand—cut out, as it were, like the shapes of Matisse's *découpages*. Caro's intense interest in drawing gives *Orangerie* a more pictorial appearance than his earlier works present, though it remains true to his anti-pictorial premises in the way the individual shapes—and the sculpture as a whole—turn in space. Slightly wider than it is high, *Orangerie* nevertheless gives the impression of being a vertical sculpture. But Caro offset the sense of weight inherent in a vertical configuration by having the forms below the "tabletop" seem to spill down from it rather than support it.

Caro's output during the three years 1969–71 was marked by a greater internal variety than ever before. While employing vocabulary elements of *Orangerie* in a less decorative manner in *Georgiana* (1969–70, p. 103) and *Sun Feast* (1969–70, pp. 96, 97), he continued to work with linear components in *Serenade* (1970–71, p. 112), *Cool Deck* (1971, p. 110), and *Air* (1971, p. 117)—the last notable for the extremely casual, almost accidental manner in which its struts and sections of grill appear scattered on the ground. *Air*, as low and lateral a work as Caro ever constructed (the average height of its units is no more than four inches), was made in the same year as the vertical *Box* (1971, p. 119), whose dominant form is uncharacteristically supported, as if on a tripod, above eye level. Although most of the sculptures of this period were painted, an important shift was anticipated in the treatment of the steel sheets

DOMINION DAY FLATS. *1974. Steel, rusted and varnished, 7' 1" x 15' 1" x 6' 1". Collection Kenneth Noland, Shaftsbury, Vermont.*

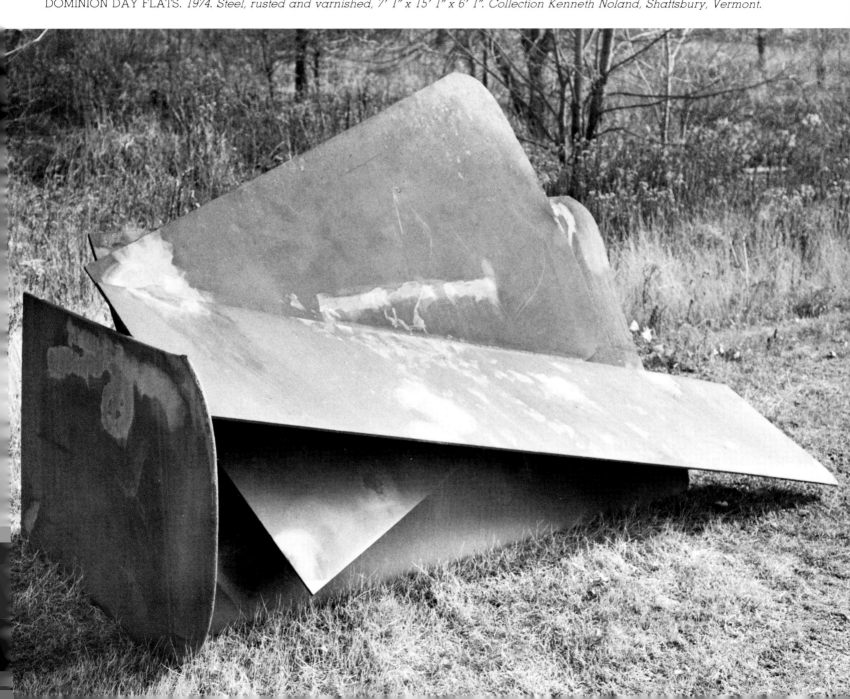

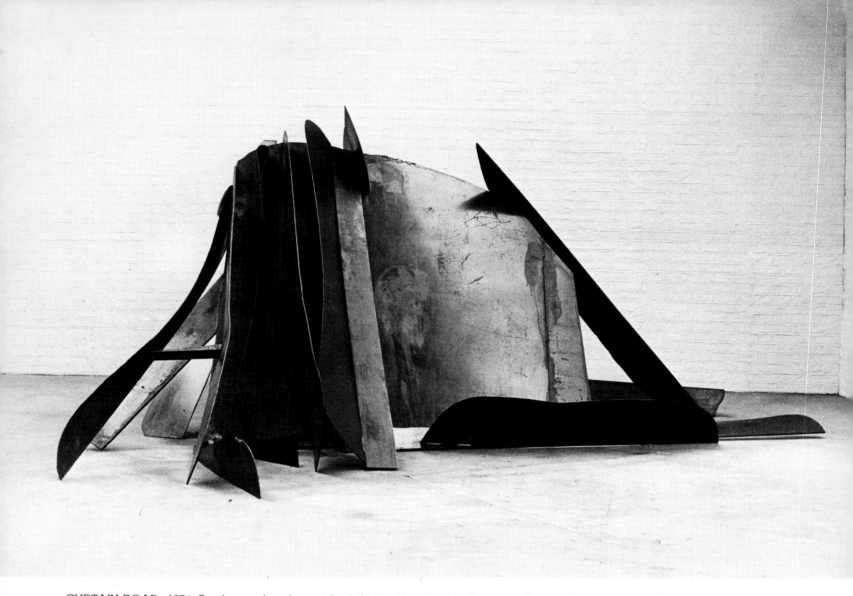

CURTAIN ROAD. *1974. Steel, rusted and varnished, 6' 6" x 15' 8" x 9' 1". Private collection, London.*

and sections of *The Bull* (1970, p. 107), which were left their natural color, then varnished to protect the surfaces against weathering.

Caro's subsequent acceptance of the surface of raw steel, with its discolorations and fragmentary patina of rust, marked a significant redirection in his work. By ceasing to "disguise" the material substance of the forms in his sculpture, he in effect affirms their great weight, and thereby invites a response to structure very different from that elicited by his works of the sixties. It is not accidental that Caro's use of unpainted steel became virtually exclusive with a series of works that represents, in other respects as well, a new departure for him—the monumental, almost baroque, vertically oriented sculptures of 1972, of which *Straight Up* (p. 137) and *Straight Left* (pp. 134, 135) are the most impressive. The forms of these compositions are adjusted in relation to a dominant vertical or diagonal steel plate that functions analogously to a picture plane. Most of the smaller elements in *Straight Left,* for example, project forward and backward from this plane, which is itself cut open to let still other forms traverse it, in a manner foreshadowed in certain of David Smith's *Zigs.*

Having accepted steel as steel—not simply as a necessary means to structural ends—Caro soon found himself interested in types of milling and factory scraps that he would earlier have rejected. The irregular, "drawn" edge of steel rollings, for example, became central to a series of sculptures executed in Veduggio, Italy, in the

winter of 1972–73 (pp. 147, 149). The Veduggio series, the Durham sculptures made subsequently in England, and those executed in Toronto in the summer of 1974 are pivotal to Caro's latest period. Whereas his earlier sculptures frankly invade and occupy the space of the viewer, these recent works often seem to have been flattened back into themselves so that they have an almost pictorial quality. Because the rolled, curled edge of the steel sheets is already in itself so decorative, Caro found that it became impossible for him to add the painted hues—decorative as well as expressive in function—which he had been using for a decade. Thus the steel scraps are fixed against further rusting by transparent varnish coatings but are otherwise left with their accidental "imperfections" entirely visible.

Having already explored the possibilities of unpainted steel in a frank and direct way in *The Bull* and the Straight series, Caro has begun in his latest works to consider once again the possibilities of illusion (a persistent concern in the work of the early sixties). This time, however, he goes about it in quite a different way—by making sculpture that is, as noted above, much more flattened, almost painting-like in character. Despite its planarity and pictorial "flatness," however, it reads like free-standing sculpture, not bas-relief. The different—sometimes startling—surprises that the viewer gets on moving around the recent, often immense sculptures indicate that Caro is still interested in a perceptual experience that is

CRISSCROSS FLATS. *1974. Steel, rusted and varnished, 9' 8" x 13' 1" x 4' 1". The David Mirvish Gallery, Toronto.*

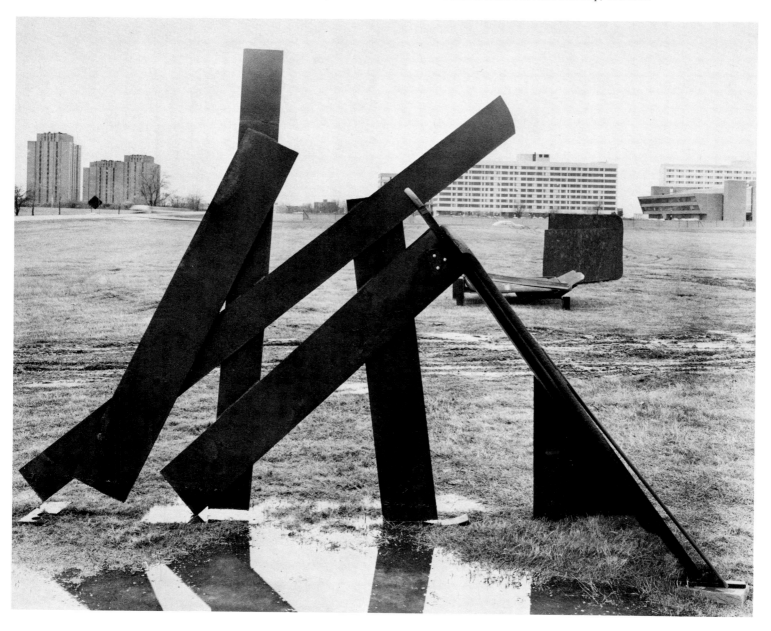

aggregate in character and that unfolds non-holistically in time. The quasi-"narrative" aspect of the earlier sculptures depended on continual inflections and on arrival and departures of subordinate elements along the main axes of a piece (as along the spine of *Early One Morning*). In the new sculptures we are prevented from grasping the works in an immediate single perception more by the fact that the back, front, and/or side views will be shut off from one another by the very panels of which they are formed.

The rolled steel which Caro had used in Veduggio continued to interest him on his return to England, where he found rolled steel plate with a different kind of edge (due to the difference in thickness of the English manufacture). Caro used these new plates—as he had in Veduggio—largely as vertical planes anchored and supported by straight-edged beams and panels. The most arresting work in this second series is the superb *Durham Steel Flat* (1973–74, p. 153), which is dominated by an immense plate of rolled steel that rises at a near-vertical and is supported by a network of rectilinear girders behind and to its side. *Durham Steel Flat*, while reversing many of the premises of Caro's earlier mature work, nevertheless recaptures in a new form that abrupt and stark monumentality peculiar to such works of 1960–61 as *Midday* (p. 25), *Sculpture 2* (p. 24), and *Sculpture 7* (p. 28)—a raw bigness that was "refined out" of his work, as it were, in 1962. In the thirty-seven very large sculptures that Caro made in Toronto in the summer of 1974, the titles of which

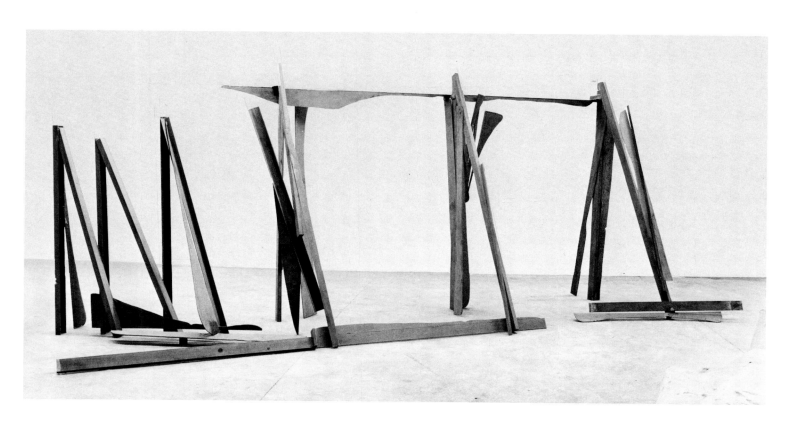

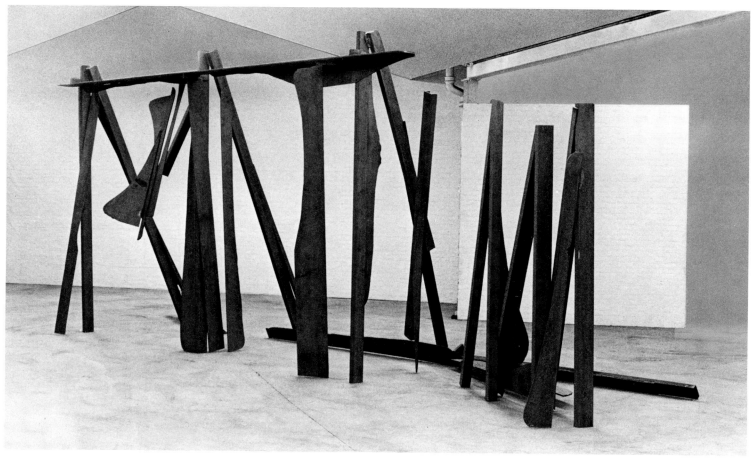

Top and bottom: RIVIERA. *1971–75. Steel, varnished, 10' 7" x 27' x 10'. André Emmerich Gallery, New York.*

all contain the word "Flat" or "Flats," he takes that raw bigness one step further. Working for the first time in a steel yard, with the cranes and other handling equipment as well as the workmen of the factory available to him, he was able to manipulate massive sheets of steel weighing sometimes thousands of pounds and treat them as loosely and freely as if they were as light as the steel he works with in his own studio. Caro made a point in these works (as in the Veduggio pieces) of making fairly quick decisions so as to maintain the freshness and life of the conceptions, leaving the process of review and editing to a return visit. This procedure differs from the more considered method used in the making of such works as *Midday* and *Prairie* or yet a recent work, the startling *Riviera* (1971–75, p. 165). Though executed in London, *Riviera* is a brilliant and extended gloss on sculptures Caro had been working on intermittently in Bennington since 1971. As he had throughout the sixties, Caro spent at least a short period each year working in Bennington. There, during the same years that saw the Veduggio and Durham series, he elaborated a remarkably inventive series of sculptures that appear to originate with the motif of the saw-horse—for example, *Silk Road* (1971–74, p. 154) and *Dark Motive* (1971–74, p. 155). At the same time, he also executed in Bennington a number of works that enlarge upon the configurations of the sixties—the low-lying and seemingly random *Cocaine* (1973, p. 150) and the tablelike *Survey* (1971–73, p. 122), for example. Caro's

varying of his work processes had no doubt a bearing on the range, variety, and flavor of his sculptures. At all events, the achievement represented by the thirty-seven large Toronto pieces, all created in a limited period of the summer of 1974, confirms that his energy and inventiveness continue at a high pitch.

Caro's sculptures of recent years represent in some respects a development against the grain of his own earlier work. It is as if he had not only refused to be locked into a style but wished, now that he was well established as a sculptor, to go back and pick up options that he had let pass at the beginning of his mature career. Insofar as Caro in the new work eschews painted surfaces and regular contours for the look of raw steel and the irregular edge of rolled plate, he turns away from the vocabulary elements he had shared in the sixties with the younger generation of British sculptors on the one hand and—to a more limited extent—the American Minimalists on the other. What may be on Caro's part a quite unconscious renewed interest in the sculpture of the forties and fifties—Smith especially—is further underlined by his more frequent use of configurations built around dominant verticals.

Caro's participation in this new-old vocabulary, however, does not signal a rejection of earlier ideas. Indeed, his recent sculpture constitutes less a reversal of his earlier premises than a confirmation of the fact that he has all along subscribed to a line of thought

at odds with the Minimalist reductionism that dominated sculpture in the sixties, particularly in America. Though not infrequently grouped with Minimalist sculpture in that decade, Caro's work is in fact utterly different in derivation and character. Not only did it emerge from sculpture (the constructionist work of the forties and fifties), but Caro found his personal role in expanding the purely sculptural (i.e., integrally three-dimensional) possibilities of that heritage. Minimal art, though resolutely anti-illusionist, emerged not from sculpture, but from painting—the painting (and concomitant criticism) of the late fifties. Its methods—objects are machine-made, not constructed by the artist—and its aesthetic involved a rejection of most of what constructed sculpture had been about (see above, p. 43). Indeed, Minimal art's holistic structures—the so-called "non-relational" configurations—its Spartan means, and serial progressions reflect a direct filiation with the late-fifties work of such painters as Noland and Stella. Some of the Minimal sculptors themselves conceived of their art as the logical—if not inevitable—evolution of the same set of concerns that had governed much of the advanced painting of the late fifties.

Since David Smith's death, construction sculpture has been pursued by a number of sculptors of Smith's own generation. But more than they, it is Caro who has gained it adherents among younger sculptors and kept its tradition alive during a decade in which Minimalism counterposed itself as the embodiment of the

avant-garde. Caro has done this without committing himself to any particular critical or art-historical position. His intuitive, improvisational approach is at odds with the theory and methods that characterize much avant-garde sculpture in the sixties.[56]

It is in the framework of this sense of the last decade that we can best understand an aspect of Caro's enterprise which I cited at the outset of my discussion—its relative traditionalism. By this I do not mean to imply that he was unconcerned with the development of new forms. On the contrary, I have tried to emphasize the radically new plastic possibilities that his lateral, altogether abstract and integrally three-dimensional sculpture opens. Caro's traditionalism is of the nature of Cézanne's and Matisse's. He was and is concerned with conserving and proving viable certain conventions of the art of sculpture presumed dead by his most radical contemporaries. But most of all, he has shown that through his intervention these conventions are capable of begetting yet newer conventions, which expand the tradition of sculpture without sacrificing its roots.

Top: TABLE PIECE XVII. *1966. Steel, polished and lacquered, 35" x 21" x 5 1/2". Collection J. Kasmin, London.*

Bottom: TABLE PIECE XVIII. *1967. Steel, polished and lacquered, 10" x 21" x 20". Private collection, New York.*

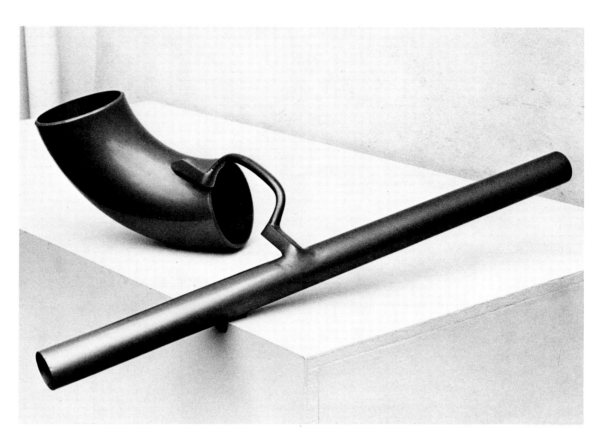

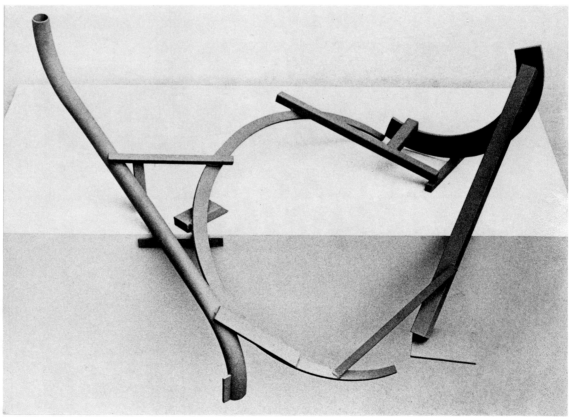

Top: TABLE PIECE XXII. *1967. Steel, painted, 10" x 31 1/2" x 27". Private collection, London.*

Bottom: TABLE PIECE LXIV (THE CLOCK). *1968. Steel, painted, 30" x 51" x 32". Collection Mr. and Mrs. Clement Greenberg, New York.*

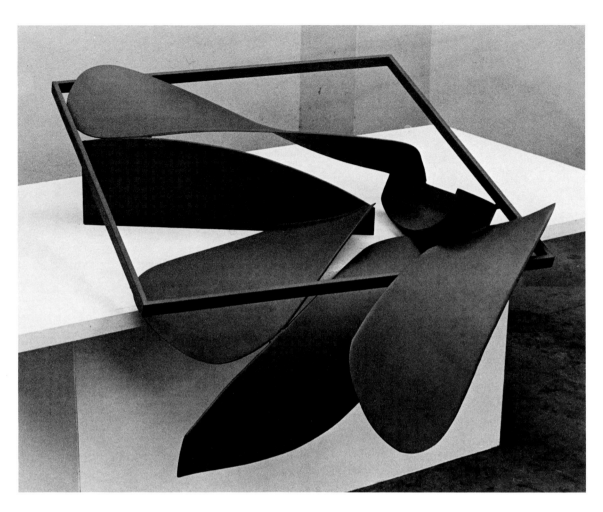

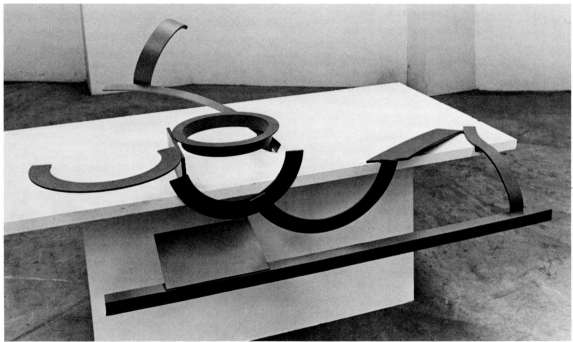

Top: TABLE PIECE XCVII. *1970. Steel, 25″ x 53″ x 44″. Private collection, London.*

Bottom: TABLE PIECE C (CENTURY). *1969–70. Steel, painted, 24″ x 67″ x 52″. Private collection, New York.*

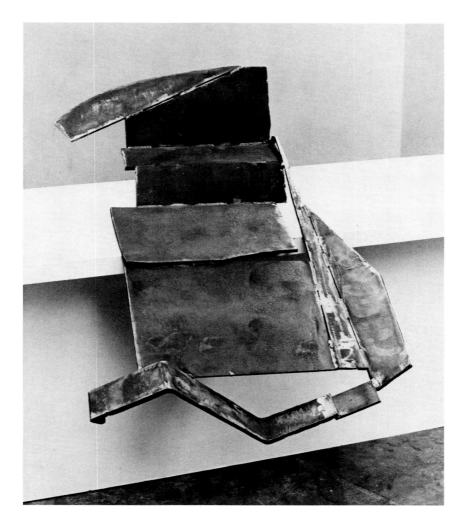

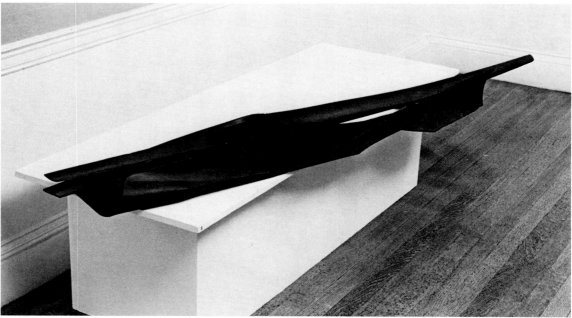

Top: TABLE PIECE CXVI. *1973. Steel, rusted and varnished, 32" x 25 1/2" x 36". Collection Leslie Feely, New York.*

Bottom: TABLE PIECE CLXVII. *1973. Steel, rusted and varnished, 8" x 21" x 6' 11". Kasmin Limited, London.*

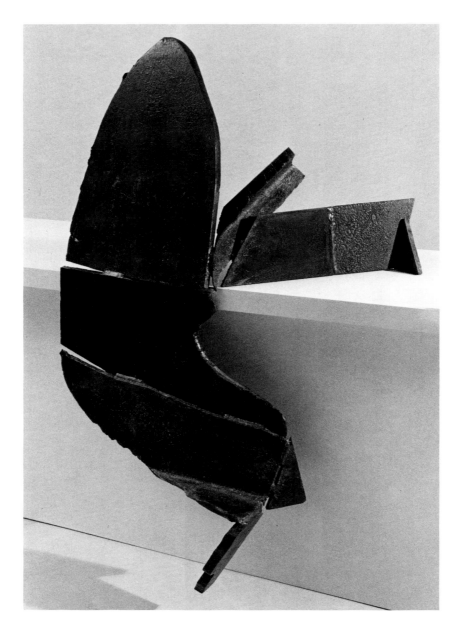

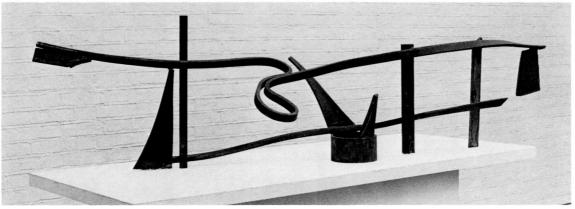

Top: TABLE PIECE CLXVIII. *1973–74. Steel, rusted and varnished, 49" x 30" x 18". Private collection, London.*

Bottom: TABLE PIECE CCIII. *1974. Steel, rusted and varnished, 1' 11" x 7' 6" x 1' 5". Acquavella Contemporary Art, Inc., New York.*

NOTES

1. I use the word "realize" here in relation to the way sculptors have become aware of the avenues Picasso opened. Criticism, even among Picasso specialists, has been somewhat slow in recognizing the revolutionary character of his sculpture. Douglas Cooper, for example, largely dismisses the importance of Picasso's Cubist constructions and concentrates on the 1909 *Head* and Picasso's "only other Cubist sculpture . . . the *Absinthe Glass* of 1914." He wholly misses the point of Picasso's constructions, which "because of the materials of which they were made, and their lack of mass . . . became important," as far as Cooper can see, only "as forerunners of *papiers collés*" and for giving "reality to the tableau-object." (*The Cubist Epoch* [London: Phaidon Press, 1970], pp. 232, 234.) For a critical discussion of this view, see Hilton Kramer, "The Cubist Epoch," *Art in America* (New York), Mar.–Apr. 1971, pp. 56–57.

2. Insofar as the earliest construction sculpture was indebted for its motifs, morphology, and syntax to Cubist painting it was, of course, anticipated by Braque's work as well as Picasso's own. But Braque had always been a less sculptural Cubist painter than Picasso (this undoubtedly influenced Picasso in the change his painting underwent between late 1909 and 1912) and seems to have had no interest in literally three-dimensional exploration. Cooper (*The Cubist Epoch*, pp. 58, 234) says that Braque made some cardboard models of objects in the summer of 1912 for the purpose of study. Evidently Braque considered them only as a function of his painting and was blind to their sculptural implications. By 1913 Cubist painting itself had taken on certain potentially sculptural aspects that had been anticipated in Picasso's constructions of the year before.

3. At the risk of appearing chauvinistic, I must observe that little metal sculpture of any interest appeared elsewhere in the forties and early fifties. Two Continental sculptors who held some interest for Caro were Robert Jacobsen and Robert Müller, both of whom began to make welded metal pieces after arriving in France—Jacobsen in 1948 and Müller in 1949. Mention should also be made of Eduardo Chillida, possibly the best artist working directly with metal in Europe. Little influenced by the constructivist aesthetic, Chillida is as authentically attached to the great Spanish tradition of forged ironwork as Smith was to American industrial welding.

4. "The New Sculpture," *Partisan Review* (New York), June 1949, p. 641. Italics mine.

5. "Sculpture in Our Time," *Arts* (New York), June 1958, p. 25. This article is a revision of Mr. Greenberg's "The New Sculpture" (see note 4 above) and is reprinted in his *Art and Culture* (Boston: Beacon Press, 1961), pp. 139–45.

6. Unlike the 1947–50 Pollock, for example, where elements of Impressionism and Cubism were subsumed in a new and original style, Guston's work of the fifties amalgamated the color and flickering light of Monet—in particular, *Impression, levée de soleil*—with the High Analytic lattices of the 1913 Mondrian in a manner that is easily parsed. Many of Guston's early fifties pictures are, nevertheless, very beautiful in the way they suspend sensations of light in an architectonic armature through a quasi-Impressionist rendition of "plus and minus" brushwork. Lassaw, in effect, three-dimensionalized these High Analytic Cubist lattices, and the "painterly" surfaces and edges of his lines in such works as *Nebula in Orion* of 1951 approximate in sculptural terms the effects of Guston's paintings.

7. These early works of di Suvero are an almost mimetic translation of painting aesthetics into the unavoidably more literal domains of sculpture. While they were, I think, overly admired in certain quarters at the time, they did attest to a large talent, which has been much more fully realized in di Suvero's work of the last five years.

8. Certainly David Smith was then the only "towering figure" on the American sculptural scene. But even Smith—despite his influence on some other sculptors—did not at the time have the historical impact (nor did he enjoy the notoriety) of such artists as de Kooning or Pollock.

9. See below, p. 43 and note 56.

10. I am here paraphrasing ideas expressed by Clement Greenberg in "Modernist Painting," *Arts Yearbook 4,* 1960 (New York: 1961), pp. 103–8. Reprinted in *Art and Literature* (Lausanne), Spring 1965, pp. 193–201. (Written in Feb. 1960 and shortly thereafter broadcast by Greenberg on Voice of America.)

11. Caro says that Noland influenced him through the idea of working in series, but there is nothing in Caro's oeuvre resembling series as we see them in the work of Noland—or other abstract painters of his generation such as Stella. Sometimes, as in the sculptures executed in 1964–65 during Caro's stays in Bennington, Vermont—*Titan, Bennington,* and *Shaftsbury*—the pieces have a closer family resemblance to one another than elsewhere. But even in these Bennington sculptures, all of which contain I-beams and hug the ground, the configurations are very different from one another. Caro, in fact, worked much less "in series" than Smith, and such groups of sculptures as one can isolate in his work only occasionally exceed four or five in number.

12. Caro has, indeed, gotten away from the traditional use of found objects—that is, the incorporation of found elements in such a way that they remain recognizable (as in certain sculptures of Picasso and Smith). Nevertheless, a great many constituents of Caro's sculptures are literally found (he is a relentless scavenger). But Caro disguises the adapted elements so that we no longer recognize them or—except in the case of the I-beams, which are hardly "objects"—even know that they are there. Thus, while Caro is quite right in saying he got away from "found objects," it is necessary to qualify his observations by speaking of his "found forms."

13. Particularly in his pastels, Degas favored perspectives whose unusual angles not only deformed or denatured the motif but, in representations of the

175

female figure especially, involved the further aggression of an implied invasion of privacy. In his lectures at Columbia University, Meyer Schapiro has eloquently discussed this both as a formal innovation and as a projection of Degas's particular psychological makeup. As the angle of the viewer cannot be controlled in regard to sculpture in the manner that it is automatically fixed by pictorial illusion, the effects of Degas's interest in oblique perspectives were less acutely felt in his sculpture than in his painting.

14. There is, of course, an historical precedent for low-lying, horizontal sculpture in various tomb sculptures beginning in the ancient world, and most notably in the late medieval *gisants*. These, however, are associated not only with given sepulchral contexts of an architectural and often sculptural order, but also specifically with the idea of death and, hence, inertness. Caro has been able to invest his horizontal sculpture with a vital character previously expressed through the idea of rising upward.

In addition to Degas and Giacometti, I must mention the tablelike pieces of Isamu Noguchi as well as certain of his low-lying dispersed garden ensembles, although I believe both these typologies in his work to have been influenced by Giacometti, the latter group by such works as *Project for a Square*. Closest to Caro in time and concept are George Sugarman's series of carved wooden sculptures snaking across the floor, executed in the early 1960s. These very fine pieces were, however, unknown to Caro.

Isamu Noguchi. NIGHT LAND. *1948. Marble, 45 1/4"l. Collection Madelon Maremont Falxa, Cambridge, Massachusetts.*

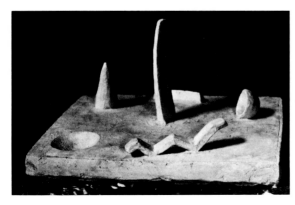

Alberto Giacometti. PROJECT FOR A SQUARE. *1931. Plaster, 7 1/8" x 10 1/4" x 6 1/4". Galerie Maeght, Paris.*

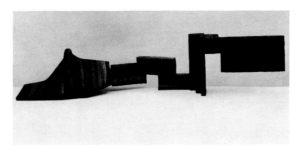

George Sugarman. FOUR FORMS IN WALNUT. *1960. Laminated walnut, 19" x 7' 2" x 20". Collection of the artist.*

15. This has been observed by Gestalt psychologists and can be confirmed by an experiment of a type I conducted some years ago with my students. Viewing the three simplest, most common geometric forms, the square, the circle, and the triangle, arranged in any combination contiguously along a vertical axis, the students have consistently read the forms more anthropomorphically than the same groupings arranged horizontally.

16. Despite Caro's use of construction materials, his sculpture has little resemblance to architecture. He himself considers associations of his configurations to the cityscape as wholly alien to the work.

17. *Anthony Caro.* Catalog of an exhibition produced by the Arts Council of Great Britain at the Whitechapel Gallery, London, Sept.–Oct. 1963. Reprinted in *Art International* (Lugano), Sept. 25, 1963, p. 70.

18. "Anthony Caro," *Arts Yearbook 8: Contemporary Sculpture* (New York), 1965, p. 106.

19. *Anthony Caro.* Exhibition catalog, Hayward Gallery, London, Jan. 24–Mar. 9, 1969, p. 10.

20. "Questions to Stella and Judd," Interview by Bruce Glaser. Edited by Lucy R. Lippard. *Art News* (New York), Sept. 1966, pp. 56, 57. Reprinted in *Minimal Art: A Critical Anthology*, ed. Gregory Battcock (New York: E. P. Dutton, 1968), pp. 150, 151, 154. (Originally broadcast on WBAI-FM, Feb. 1964, as "New Nihilism or New Art?")

21. *The Telegram* (Toronto), May 21, 1966.

22. "English Sculptors Outdo Americans," *Washington Post*, May 8, 1966.

23. "Caro and Gravity," foreword to exhibition catalog *Antony Caro*, Galleria del Naviglio, Milan, Mar. 19–28, 1956, n.p.

24. Cited by Phyllis Tuchman in "An Interview with Anthony Caro," *Artforum* (New York), June 1972, p. 56.

25. Hayward catalog, p. 10.

26. See note 12 above.

27. "How Caro Welds Metal and Influences Sculpture," *New York Times*, July 18, 1971.

28. Hayward catalog, p. 8.

29. See the author's *Frank Stella* (New York: MoMA, 1970), pp. 68–70.

30. Moore and Smith, both of whom were formed

as artists in the thirties, owed a profound debt to Surrealism and always remained committed in their different ways to a metaphoric "totemic" conception of sculpture. Among Surrealist sculptors, Arp had the major influence on Moore, Giacometti on Smith. Picasso's influence was greater on Smith than on Moore, while Smith remained relatively untouched by Brancusi, a major influence on Moore.

31. The light in a painting is fixed by the artist, whereas that in sculpture depends to a great extent on the installer. Refined chiaroscuro in painting allows a minute subdivision and nuancing of values beyond the possibilities of even the most sophisticated "painterly" sculptural surface. Chiaroscuro can also be manipulated—as was the case in Analytic Cubism—in terms of warm and cold. The effects achieved can be approximated in sculpture only through tonally varied patina—which one can hardly imagine operating in concert with the surface "chiaroscuro" in a way to rival the delicacy of painting.

32. There are, in fact, two minor uncompleted essays in this direction. See the author's *Picasso in the Collection of The Museum of Modern Art* (New York: MoMA, 1972), p. 61 and note 2, p. 203.

33. For a discussion of *The Absinthe Glass* as the exception that proves the rule see the author's *Picasso in the Collection of The Museum of Modern Art*, p. 95.

34. *Monument* is the full-scale realization executed in 1971–72 of a wire maquette made by Picasso forty-four years earlier and submitted at that time to a committee formed to erect a monument in memory of Guillaume Apollinaire. The committee rejected it, along with two other Picasso maquettes. *Monument* was executed in New York on the basis of an intermediate-size maquette (six feet high) provided the Museum by Picasso. The particular kind of steel (Cor-ten), the rod thicknesses, and the precise height of the work were all determined by Picasso, who was provided the steel samples. He was kept informed of the work in progress by means of photographs.
The immediate point of departure for the style of *Monument* is to be found in the simple arabesques and basic geometrics (triangles, rectangles, circles, and ovals) that make up such paintings of 1927 as *The Studio.* Nevertheless, the effect of a transparent structure, a scaffolding perceived in space, has its origin in the Cubism of 1911–12.

35. Cited in Tuchman, p. 58.

36. Ibid.

37. Fried: ". . . each of Caro's sculptures establishes a structure of mutually reinforcing norms, against which various inflections make themselves felt . . ." and ". . . rectilinearity is a fundamental norm of Caro's art . . ." Hayward catalog, pp. 8, 9.

38. The principle of constancy refers to the process through which essential structural relationships are perceived even as these are distorted by the optical image. This kind of perceptive compensation obviously operates with greater force in regard to such objects as chairs, tables, buildings, etc., whose basic structure is known and familiar, than it does in regard to a modern sculpture that conforms to no previously experienced pattern and

whose support and syntax may appear contrary to structural logic.

39. Cited in Tuchman, p. 57. Caro adds that this is true "up to now," but he does not rule out the possibility of making public sculpture in the future.

40. Fried, Hayward catalog, pp. 14, 11.

41. It would be a mistake to attribute particular significance to Caro's engineering studies in the formation of the constructivist style he adopted many years later. In the work of certain sculptors, Kenneth Snelson, for example, a knowledge of engineering is required for the very construction of the work, whose aesthetic structures are determined within an a priori set of engineering possibilities. Artistic decisions in Caro's work are always purely intuitional. The manner in which his provisionally improvised structures are engineered is determined after the configuration is settled upon. Ironically, some of Caro's sculptures of the early and middle sixties sometimes tended to be badly engineered (*Titan,* for example). These and some other works have had to be restudied from the purely engineering point of view after being exhibited.

42. "The Master Sculptor," *The Observer* (London), Nov. 27, 1960.

43. "Portrait: Anthony Caro," *Art in America* (New York), Sept.–Oct. 1966, p. 83.

44. Richard Whelan, *Anthony Caro* (Harmondsworth, Middlesex: Penguin, 1974), p. 24.

45. Cited by Lawrence Alloway, "Interview with Anthony Caro," *Gazette* (London), no. 1, 1961.

46. In this regard Hilton Kramer has written: "Mr. Caro's first sculptures in the new mode were exceedingly 'tough.' He seemed intent on placing the greatest possible distance between his new work and the genteel styles which were then prevalent even among the most advanced artists in London." "A Promise of Greatness," *New York Times,* May 17, 1970.

47. Caro polychromed *Month of May* in an attempt to clarify what he realized were its visually complicated configurations. He intended the three colors to emphasize the structural characteristics of its various components—magenta for its straight-edged members (the I-beams on the ground and the cantilevered diagonals); orange for the randomly bent and angled pipes; and green for the longest, cursively extended pipe. For my eye, however, the colors are more distracting than helpful, especially as the orange and green are both used for "drawn" elements.

48. Though Caro never made serial sculptures, nor even worked in series, in the manner that Stella and Noland made paintings, he has occasionally produced works that are closely enough related by a common motif to be called a series. The photograph of Caro with his work in Bennington (p. 8) shows one of the most extensive of these series, of which *Kasser* (1965, p. 73) is representative.

49. Fried, "Caro's Abstractness," *Artforum* (New York), Sept. 1970, p. 32.

50. The variously styled legs recall the furniture Giacometti designed for the decorator Jean-Michel Frank beginning in 1930.

51. This title was suggested by the author when he saw the work in Caro's studio, as its configurations seemed reminiscent of the more stylized of Leonardo's drawings of deluges. The title has been incorrectly attributed to a visit by Caro to an exhibition of Leonardo's drawings at the Queen's Gallery in 1969. "The subtitle of the piece, *Deluge*, refers as John Russell has suggested, to the Leonardo drawings of deluges that were exhibited at the Queen's Gallery in London in 1969." (Richard Whelan, *Anthony Caro* [see note 44 above], pp. 79–80.) "During the year in which Leonardo's drawings were on view in great numbers at the Queen's Gallery in London he made a piece . . . which to my eye came very near to paraphrasing one of Leonardo's Deluge drawings . . ." (John Russell, "Closing the Gaps," *Art News* [New York], May 1970, p. 39.) Caro did, in fact, see the Leonardo drawings, but only after the piece was finished and had been titled.

Such descriptive titles as *Deluge* have proved useful in avoiding the problems posed by Caro's use of Roman-numeral titles for his table pieces. Certain of these "substitute" titles are acceptable to Caro; others—*The Clock*, for example—he profoundly dislikes.

52. Even in Smith's most seemingly spontaneous and lyrical "drawings in air," such as *Australia* (1951) and *Hudson River Landscape* (1951), the actual execution was extremely arduous because of the resistance of the steel. The arabesqued *Timeless Clock* (1957) is made of silver, which when heated is relatively easy to manipulate, and Smith was able with this material to attain an ease of execution that can legitimately be likened to the freedom and fluidity of drawing.

53. In "Anthony Caro's Work: A Symposium by Four Sculptors: David Annesley, Roelof Louw, Tim Scott, and William Tucker," *Studio International* (London), Jan. 1969, p. 16. Tucker's reply to Annesley's comment was: "I liked that sculpture because it was very economical. Everything in it had equal importance. There weren't that many elements in it, but everything was to do with establishing levels or transferring from one level to another. And it seemed to be beautifully economically done."

54. The following exchange took place (ibid.) between David Annesley and William Tucker regarding the execution of *Prairie:*

Tucker: . . . Caro denied it when I asked him about it but it seemed to me a very planned sort of sculpture, rather than spontaneously-made and intuitive.
Annesley: No, I thought the planning was an afterthought. I thought that it looked like he'd put up a whole lot of these things across benches or something, and then he'd thought, "That's nice, having a whole lot of those on benches, establishing a horizontal plane with poles instead of with a big sheet." And then he thought, "But we could put the big sheet somewhere else and establish another plane with the big sheet, and then finally we could have something on the ground." And finally just fixing it. The working-out bit only comes right at the end where he says, "We'll shift that a bit; we'll have to get rid of that; and finally I can hold it up. Then what I can do is have all these poles that I had on the benches, just *there*, and that big thing which I had stuck on the block of wood—I can take the block of wood away and that will be just there." So it's really done by intuitively setting it up very roughly and then kind of taking the world away. Taking away the benches and props and bits of string, until there it is again.

Tucker: He's very cunning. He has this general appearance of doing everything off the top of his head, but I think he knows what he's doing to such an extent that it's very hard to break down the distinction between spontaneous instinctive behaviour in his work, and very high and aesthetic behaviour.
Annesley: I don't accept that he's more cunning than he makes out to be. Because I think the cunning is actually intuitive. Of course he knows what he's doing, he sure as hell knows what not to do, but he, as it were, invents procedures for himself which keep the knowledge at an intuitive level, so that it is into the dark every time, to lighten it. In *Sill* he's lined up these things and he's maybe had five or six and he sort of likes four, and he puts that line across it. And then he maybe could take the line off again, or put another line, but he says, "Yea, that's it." And he stops there, because he seems to know when to stop at the earliest possible moment that he could stop, which is rather amazing. Sculptures like *Sill* are so economic and yet they're really doing it for him. It's done that reality change sufficiently. Why does one addition make it better, but then seem as if that's enough?
Tucker: Because he knows what he's doing. The point I was trying to make was that he's a far more accomplished and sophisticated artist than he gives the impression of being.

55. "Two Sculptures by Anthony Caro," *Artforum* (New York), Feb. 1968, p. 25.

56. In their writing and public statements the Minimal sculptors, for example, have implemented a critical apparatus more complex than that of any previous group of plastic artists. The Abstract Expressionists spoke and wrote less about their work, and their language tended toward the personal and poetic. This difference may reflect the fact that more of the Minimalists have been educated not only in college but in graduate school, some of them—such as Judd and Morris—specifically in art history. Further, whereas the vogue of so-called "formalist" criticism *followed* the establishment of the major Abstract Expressionist styles, it immediately *preceded* the emergence of Minimalism. And however much the Minimalists have reacted against this mode of criticism—or at least certain of its conclusions—many of them appear to have been influenced by its dialectical system. There is no little irony in the fact that Minimalist "specific objects" go far toward fulfilling Clement Greenberg's 1949 prophecy (p. 17 above) of "new objects . . . [which have a] self-evident physical reality, as palpable and independent and present as the houses we live in and the furniture we use." As Minimalist art sometimes suggests commitment to an a priori theory, of which the work itself constitutes the literal embodiment, it is not by accident that Conceptual art—which took the next step in a logical scenario by dismissing such literalization as vestigial—should have followed hard upon Minimalism.

Caro and the other constructionist sculptors of his generation relate to the materials of their art in a more direct and traditional way. The radical posture proposed by Minimalism evolved as much from a perception about art history as from an immediate experience of art itself. From Manet through Abstract Expressionism, the identification of an avant-garde had resulted from the relation of new work to existing societal and critical conventions. Minimalism's conscious attempt to create itself as avant-garde produced a situation in which, for the first time since the advent of modern art, the very concept of the avant-garde has been called into question.

CHRONOLOGY

Compiled by Elinor L. Woron

1924

Anthony Alfred Caro born, March 8, in New Malden, a suburb of London, England. A Jewish family, the Caros can be traced back to the sixteenth-century Talmudic scholar Rabbi Joseph Caro. Father is Alfred Haldinstein Caro (born December 18, 1885), a stockbroker; mother is Mary Rose Edith Caro, née Haldinstein (born December 20, 1896). Anthony is the youngest of three children; brother Peter Jack and sister Rachael Alice.

1927

Family moves to Churt, near Farnham, where father purchases a farm.

1933–37

Attends Pinewood School, a preparatory school in Farnborough, Hampshire.

1937–42

Attends Charterhouse School, Godalming, Surrey. Sculpts in clay for the first time at age fifteen. At Charterhouse, Housemaster introduces Caro to his friend, the sculptor Charles Wheeler, who later becomes President of the Royal Academy (1956–66). Caro is offered opportunity to work with Wheeler during vacations and holidays, and becomes acquainted with the general operation of a studio. Learns techniques, including making armatures for clay models, and gains experience in enlarging small-scale models.

1942–44

Attends Christ's College, Cambridge. Obtains M.A. degree in engineering.

Studies sculpture at local Farnham School of Art during vacations and holidays. Concentrates on modeling clay figures and portrait busts from life.

1944–46

Serves with Fleet Air Arm of Royal Navy as Sub-Lieutenant.

Utilizes every opportunity during furloughs and leaves to work at Farnham School and at Wheeler's studio. Decides to make sculpture a career.

1946–47

Enrolls full-time at Regent Street Polytechnic Institute. Studies sculpture with Geoffrey Deeley.

1947–52

Attends Royal Academy Schools, London, where he receives a strict academic training. Studies under Charles Wheeler and other visiting teachers, including Siegfried Charoux, Alfred Hardiman, Arnold Machin, and Maurice Lambert. Rotation of teachers each term provides opportunity to gain technical mastery in a variety of traditional sculptural materials, including ivory, stone, wood, terra-cotta, and plaster. Fellow students include Frank Martin, Peter Lowe, and Peter Smithson.

Sculpting from the model or from antique casts,

Caro works daily at Burlington House. Studies and copies Greek, Etruscan, Romanesque, and Gothic sculpture.

1948

Receives Royal Academy Schools awards: two silver medals and three bronze medals for clay figure models, carving, and composition.

Travels to France in summer. Spends a month drawing, photographing, and studying Chartres Cathedral.

1949

Receives Landseer Scholarship and First Landseer award at Royal Academy Schools.

Marries Sheila Girling (December 17), a fellow student at Royal Academy Schools. They move to small apartment with adjacent studio at 416 Fulham Road, London. Throughout his career Caro has worked closely with his wife, whose criticism and support have been of great help and importance to him.

1951

Desiring to expand his experience beyond traditions of Royal Academy Schools, Caro applies for assistantship with Henry Moore.

Purchases home in Hampton Court. Lives there for only a few months. First son, Timothy, is born July 6.

July: Caro accepted by Moore as part-time assistant, and works with him until August 1953. Family moves to Much Hadham, Hertfordshire, near Moore's studio.

1951–53

Caro enlarges Moore's small-scale models to final sculptures. Among other projects, Moore is working on large sculptures for Time-Life Building on Bond Street, London. Caro helps with carvings for facade and works on enlarging *Draped Reclining Figure* for interior court of Time-Life Building.

Lost-wax process of bronze casting interests Moore, and under his guidance Caro helps to build bronze foundry and to cast small sculptures. Moore's experiments with sculptures executed directly in wax stimulate Caro in the use of new materials.

Discussions with Moore and loan of art books introduce Caro to aspects of art not studied at Royal Academy and expand his knowledge of twentieth-century painting and sculpture as well as African art. Caro continues to draw at Royal Academy Schools two days a week, often bringing his work back to Much Hadham for criticism.

1953

Becomes interested in Picasso's expressionistic animal images as possible alternatives to Moore's influence. Creates sculptures of warriors and bulls in an expressionist manner. In an attempt to find new and freer ways of working, Caro uses found objects, including pieces of tree trunk, as beginnings for sculptures. Also experiments by dropping pieces of soft clay on tables, chairs, floor. He hits, tosses, punches, punctures the clay, then reworks it as shapes suggest themselves.

Meets Peter King, Surrealist sculptor who also works at Moore's studio. King acquaints Caro with American Abstract Expressionism and the paintings of Jackson Pollock.

Teaches sculpture two days a week at St. Martin's School of Art, London, where he continues to teach until 1973. Joins Frank Martin, head of sculpture department, in organizing the department and developing curriculum. Integrates sculpture and drawing into a single class with a view to understanding rather than copying the subject.

1954

Moves with family to coachhouse in Hampstead, London. Works in adjacent one-car garage.

Completes first important figurative sculpture, *Man Holding His Foot* (p. 18). Works on heavy expressionistic clay sculptures in which figure is distorted and surface is roughly rendered. Sculpts figures engaged in simple physical actions, such as bending, reaching, twisting, and stretching.

During summer vacations at Porlock Weir, Somerset, Caro makes molds of rocks and cliff outcroppings that he incorporates along with actual stones into figurative sculptures of clay. These are later cast in plaster or bronze.

1955

Sees Dubuffet exhibition at Institute of Contemporary Arts, London, and is especially interested by Corps de Dames series. His sculptured forms become more complex; texture, weight, and quality of the medium are emphasized. Expressive intensity of work also reflects Caro's interest in de Kooning and Bacon. Experiments with composite figurative sculptures made of plaster, stones, and clay; all ultimately cast in plaster.

August 11–September 3: First works exhibited in London are shown in "New Sculptors and Sculptor-Painters," group exhibition at Institute of Contemporary Arts, London. Caro exhibits *Man Holding His Foot* and *Seated Figure* (1955). Other participants include William Scott, Hubert Dalwood, Jack Smith, Ralph Brown, and Peter King.

[Caro's] enormous *Man Holding His Foot* is a most impressive figure whose bloated forms are modelled with considerable power. His smaller *Seated Figure,* less sensational, is even more successful because of the real beauty of its swelling and sensuous shapes. —*The Times* (London)*

Only in the case of Anthony Caro is the forcefulness of method matched by a similar violence of form, and in his case, the distortions are not convincingly related to the human actions from which they derive.—Basil Taylor, *The Spectator*

Of the new "sculptors" the most impressive on this showing seems to me to be Anthony Caro, whose hideous and rather silly "Man Holding His Foot" (picking his toes) . . . reveals, besides the influence of Picasso and Henry Moore, a sheer sculptural power indicative of rare promise. —David Sylvester, *The Listener*

November 30–December 31: Participates in "Contemporary Painting and Sculpture," City Art Gallery, Leeds. Works include *Woman Waking Up*

*Reviews quoted in the Chronology are documented in the Bibliography, pp. 191–96.

(1955, p. 19), *Seated Figure, Man Holding His Foot.*

1956

March 19–28: First one-man exhibition is held at Galleria del Naviglio, Milan. Twenty sculptures are shown, including *Portrait of Sheila* (1954), *Woman Arranging Her Hair* (1955), *Portrait of Sheila 2* (1955), *Woman in Pregnancy* (1955–56, p. 20), and *Woman Waking Up.* In catalog essay Lawrence Alloway writes:

Caro's rugged surfaces record the parodoxical fight of the sculptor, any sculptor, to make raw matter expressive. In Caro's sculpture the new solidity is at its most massive. His sculptures, compact yet tense with action, show a sense of the world. He has an acute feeling for the force of gravity and its operation.

The sculptures in the present show are those of a young man—there are unresolved passages here and there. His habit of incorporating pebbles and suchlike objects, not for their subjective qualities, but for their form makes for an irresolution and ambiguity in the figure. It is significant that this relic of Moore's methods is missing in later sculptures. But the work is serious and his future position may well be important. —Theo Crosby, *Architectural Design*

1957

January 8–26: First one-man exhibition in London is held at Gimpel Fils. Comprises sixteen sculptures of bronze, plaster, or lead, two sculptural reliefs, and five ink drawings; works executed between 1954 and 1956.

Unless one grasps what Caro is after, his bronzes must seem perversely repellent. . . . His uncouth figures struggle out of or threaten to relapse into the clay from which they sprang . . . He is a sculptor to be marked. —Nevile Wallis, *The Observer*

[In Caro's sculptures] modelling and surface are called to a new life . . . to counterbalance this sensuous violence of outer planes, Caro overemphasizes with obsessive insistence the ponderable mass of his work. It is a powerful blend of mass and touch from which the case for telling volumes is almost excluded. This sculptural compound is perhaps the most impressive feature in Caro's initial quests. . . . His road leads in other directions: toward the reevaluation of the very components of the essence of sculpture. —Pierre Rouve, *Art News and Review*

A young sculptor, Anthony Caro, is having his first exhibition at the Gallery of Gimpel Fils. As an exhibition it is a *tour de force.* . . . His figures are like Golems, black snowmen. —Andrew Forge, *The Listener*

May 25–October 12: Exhibits bronze *Seated Figure* in "Contemporary British Sculpture," touring exhibition of sculptures in the open air, organized by Arts Council of Great Britain.

July–August: Participates in group exhibition at Gimpel Fils, London.

Autumn: Shows in "Rome–New York Art Foundation Exhibition," Rome, of new trends in British art, presented by Sir Herbert Read and selected by Lawrence Alloway in cooperation with the Institute of Contemporary Arts, London. Caro exhibits three ink drawings: *Figure Walking* (1955), *Head* (1956), and *Head* (1956).

1958

May–September: Exhibits *Cigarette Smoker 1* in "Sonsbeek '58, International Exhibition of Sculpture in the Open Air," Sonsbeek Park, Arnhem, Holland.

June 14–October 19: Exhibits in the Central Pavilion, XXIX Venice Biennale, in international show of works by artists under the age of forty. Other British entries include paintings by Sandra Blow and Alan Davie. Caro exhibits *Man Taking Off His Shirt* (1955–56, p. 19), *Cigarette Smoker 1,* and *Woman Standing* (1957).

Son Paul is born (September 9).

December 5–February 8, 1959: Exhibits in Pittsburgh Bicentennial International Exhibition of Contemporary Painting and Sculpture, sponsored by the Carnegie Institute, Pittsburgh. Exhibits *Cigarette Smoker 1* (1957).

1959

Spring: Seats plaster figure on a steel bench set directly on the ground, thereby attempting to eliminate traditional pedestal.

May: Tate Gallery, London, purchases *Woman Waking Up.*

May–September: Exhibits *Man Holding His Foot* in Fifth Biennial of International Sculpture, Middelheim Park, Antwerp.

Becomes increasingly aware of restrictions of clay. Seeks a material that is less responsive and offers more resistance.

Summer: Participates in Biennial Exhibition of Open-Air Sculpture in Carrara, Italy. Exhibits *Woman in Pregnancy* and *Woman Standing.*

Awarded a Ford Foundation–English-Speaking Union Grant in the Field of Arts for travel to U.S.

American critic Clement Greenberg visits Caro's studio in London. Their discussion stimulates Caro to rethink his attitudes toward sculpture. Greenberg's criticism and friendship continue to be of lasting importance to Caro.

September: Attempts to condense expression directly into form, eliminating the figure. Makes nonfigurative abstract sculptures directly in plaster, sometimes incorporating objects such as trash-can lids or car fenders. These works are subsequently destroyed.

October 2–25: Wins prize for sculpture at First Paris Biennial. Exhibition comprises paintings, drawings, and sculptures by artists under the age of thirty-five. Caro exhibits *Woman Standing, Woman on Her Back* (1957), and *Woman with Flowers* (1958). Awarded a prize for sculpture. Award jury includes Will Grohmann, Porter A. McCray, Rufino Tamayo, and Ossip Zadkine.

October–December: Visits United States and Mexico. Spends two months traveling, meeting artists and critics, and visiting museums, art galleries, and art schools in New York, Washington, Chicago, San Francisco, Los Angeles, the Southwest, and New Orleans. Meets Kenneth Noland in Washington; spends time with Clement Greenberg. Makes acquaintance of Robert Motherwell, Helen Frankenthaler, Adolph Gottlieb, David Smith, Ray Parker, and Anne Truitt. At French and Co. Caro sees exhibition of early circle paintings by Kenneth Noland, works by Morris Louis, and *Sentinel* by David Smith. Admires Jackson Pollock's

paintings at Museum of Modern Art, New York.

December: Returns to London with new insights and enthusiasm. Visits scrap yards at docks in Canning Town and collects an assortment of steel pieces. Purchases oxyacetylene welding gear. Works at home in his garage-studio.

Breaks away completely from previous figurative style. Makes sculptures out of scrap steel, girders, and sheet metal, crudely welded and bolted together. Paints sculptures with brown or black household or industrial paints. For the first time sculptures eliminate the base, occupying the same ground as the viewer.

1960

March: First abstract steel sculpture, *Twenty-four Hours* (p. 23), is completed.

Radical change in his ideas forces him to rethink his teaching methods. A welding shop is set up at St. Martin's. Experimental atmosphere in school and working relationship with students provide a forum for stimulating exchanges. Students since 1960 include David Annesley, Michael Bolus, David Evison, Brower Hatcher, Peter Hide, Phillip King, Ron Robertson-Swann, Tim Scott, William Tucker, and Isaac Witkin.

May–September: Exhibits plaster sculpture, *Woman's Body* (1959, p. 20), in "Sculpture in the Open Air," Battersea Park, London County Council's Fifth Triennial Exhibition of Sculpture. Contributors to the exhibition include Arp, Hepworth, Chadwick, Picasso, and Epstein.

Summer: Studies the primitive menhirs and dolmens in the area of Carnac in Brittany, France.

To reinforce mood, sculptures are now painted in bright colors, e.g., red lead, reds, yellows, and greens. *Midday* (p. 25) completed.

Purchases heavy steel girders of ten- and twelve-foot lengths, to be used in *Sculpture 7* (1961, p. 28). Works without preliminary drawings or sketch models. Elements of sculpture are propped on blocks of wood, then welded, bolted, and assembled. Assistance given by David Annesley, Michael Bolus, and Isaac Witkin.

1961

April 14–May 18: Exhibits *Man Holding His Foot, Fighting Bull* (1954), and *Cigarette Smoker 1* in "Ten Sculptors," at Marlborough New London Gallery, London.

April 22–September 30: *Woman with Flowers* is shown in "Contemporary British Sculpture," open-air touring exhibition organized by Arts Council of Great Britain.

Summer: Makes his first polychrome sculpture, *Sculpture 7*.

Meets Michael Fried, then London correspondent for *Arts Magazine*. Fried's enthusiasm and insights are a source of encouragement for the artist.

August–September: *Sculpture 1* (p. 27), later renamed *The Horse*, is only sculpture selected by Lawrence Alloway in "New London Situation," an exhibition of British abstract art at Marlborough New London Gallery, London. Paintings shown include works by Bernard and Harold Cohen, John Hoyland, William Turnbull.

October–November: Exhibits *Capital* (1960) in International Union of Architects Congress Exhibition, London, organized by Theo Crosby.

1962

Caro begins to use aluminum tubes and sheets supplied by British Aluminium Co., Ltd. Works include *Hopscotch* (p. 39) and *Early One Morning* (pp. 40, 41).

March 2–20: Exhibits *Woman Standing* and *Cigarette Smoker 2* (1957) in "Young English Sculptors," Ateneo de Madrid.

1963

May–September: Exhibits *Midday* in London County Council's Open-Air Exhibition of Contemporary British and American Works, Battersea Park, London.

August 9–September 21: Exhibits *Sculpture 3* (1961) in group exhibition, "118 Show," Kasmin Limited, London, now Caro's dealer.

Caro is invited to teach studio course at Bennington College in Vermont. Art faculty will include Paul Feeley and Jules Olitski.

September–October: First one-man exhibition of steel sculpture is held at Whitechapel Art Gallery, London. Comprises fifteen sculptures executed between 1960 and 1963. Exhibition is organized by director Bryan Robertson, and catalog essay written by Michael Fried.

What these sculptures seem to lack is just that feeling for materials which Caro is at pains to disguise, principally by painting them. For one thing, to disguise a girder is really not possible. It merely adds an air of the phoney. . . . The result is much of Caro's work has a synthetic feeling about it, its impact depending too much on merely being bigger than we are. All the same, this is an important exhibition. Caro has shown most impressively that sculpture need not be dependent on the human figure. And that not all roads lead to Moore. —Edwin Mullins, *Sunday Telegraph*

Caro aims . . . to open up areas of awareness which have not previously been dignified by art. This is a painful process: we do not always care to have those areas brought into the open and we prefer the experience of art to relate to and clearly illumine other forms of experience. For these reasons many people will simply shut down when faced with Caro's sculptures. —John Russell, *Sunday Times*

October: After a delayed arrival due to Whitechapel exhibition, Caro begins teaching at Bennington College, where, except for a break in the fall of 1964, he continues as visiting faculty member until 1965. Before Caro's arrival David Smith equips and organizes welding shop at college.

Visits Smith's studio at Bolton Landing, ninety miles north of Bennington. Impressed by Smith's direct, spontaneous approach to work and materials.

A large garage belonging to Bennington Fire Department is made available for Caro's use; this provides excellent working space with parking area where sculptures can be placed outdoors.

Because of skiing accident, Caro is unable to fabricate elements freely; engages local welder, Shorty Griffen, who brings portable welding

equipment; machine screws replace bolts.

Caro is stimulated by association with Noland, Olitski, and visiting artists and critics. Noland interests him in working in series. Makes *Flats, Rainfall, Titan* (pp. 46, 47).

1964

April 22–June 28: Exhibits *Pompadour* (1963, p. 42) in "1954–1964: Painting and Sculpture of a Decade," exhibition organized by the Calouste Gulbenkian Foundation at the Tate Gallery, London. Works selected by Alan Bowness, Lawrence Gowing, and Philip James.

Sculptures now consist of isolated elements joined by long, low steel panels. Works include *Titan* and *Bennington* (p. 49).

June 27–October 5: Exhibits *Hopscotch* and *Month of May* (1963, pp. 44, 45) in Documenta III, Kassel, Germany.

July: Returns to London. *Wide* (p. 51), made of aluminum in combination with interlocking steel parts, is fabricated at Aeromet, a small London factory. An employee at the factory, Charlie Hendy, later joins Caro as technical assistant on a full-time basis.

December 2–19: First one-man exhibition in United States is held at André Emmerich Gallery, New York. Five sculptures of 1964 are shown: *Bennington, Titan, Lal's Turn, Wide,* and *Prospect.*

Using sections of I-beams and other structural steel members as his material, Mr. Caro dramatizes their geometrical shapes in structures of stark elegance. One feels that this is an art of reduction by distillation, but there is no loss of force in his spare purity. —John Canaday, *New York Times*

Caro's work is between ordinary sculpture and something new without sculpture's structure and qualities. The work should be stronger and more complex in quality; it's a little simple, aside from its intentional simplicity. As good as the work is, Caro's interests should be stated more clearly. —Donald Judd, *Arts Magazine*

1965

February 24–March 28: Exhibition at Washington Gallery of Modern Art, Washington, D.C., under direction of Gerald Nordland. Comprises sculptures from the years 1960–64: *Twenty-four Hours, Midday, Sculpture 7, Prospect, Flats, Pulse* (1964), *First National* (1964), *Rainfall, Sunshine* (1964), *Wide,* and *Bennington. Midday* and *Sculpture 7* remain in the United States on extended loan to the Fogg Art Museum, Cambridge, Massachusetts.

February 25–April 4: Exhibits *Early One Morning* in "British Sculpture in the Sixties," an exhibition organized by the Contemporary Art Society and held at the Tate Gallery, London. Sculpture is later purchased by the organizers and presented to the Tate Gallery.

... only three sculptors of the thirty included in the exhibition show real signs of having moved from the Fifties into the Sixties: Turnbull, Paolozzi, and Caro. . . . But to my mind the most interesting and powerful of the three is Caro, whose huge scarlet painted construction, *Early One Morning,* lurking at the end of the furthermost showroom, wins out over the decor and makes the nearby Hepworths look as dead as dodo's eggs. Here at last is a statement which is as straightforward, uncom-

promising and true as an equation—refreshingly sparse after the sentimentality and mannerism of Herbert Read's angst-peddling sculptors of the Fifties. —John Richardson, *New Statesman*

March–April: "The New Generation: 1965," exhibition of British sculpture, is held at Whitechapel Gallery, London. Exhibition reflects Caro's influence and authority as a teacher. Six of the nine young sculptors selected to exhibit studied with Caro at St. Martin's: Annesley, Bolus, King, Scott, Tucker, and Witkin.

March–June: Returns to teach at Bennington College. Working for a period of six weeks, he completes a series of sparse sculptures, following a conversation with Jules Olitski about making art as "naked" as possible. The sculptures are mostly linear, constructed of rods and angle irons, and include *Sleepwalk* (p. 59) and *Smoulder.*

After 1965 Caro visits the United States about three times a year, usually remaining to work for a month.

October 29–November 27: One-man exhibition at Kasmin Limited, London, includes five works of 1965: *Slow Movement* (p. 63), *Frognal* (p. 62), *Yellow Swing* (p. 64), *Kasser* (p. 73), and *Sill* (p. 67). Arts Council purchases *Slow Movement.*

His present show at Kasmin Limited is a good deal more solemn [than Whitechapel exhibition]. It looks as though Caro has decided to forbid himself anything remotely playful . . . Caro's reduction of elements has more the effect of meanness than of strength through economy. —Norbert Lynton, *Art International*

Laymen are apt to be wary of Caro—just as students are apt to admire him—because he has carried the process started by Manet to its logical conclusion. He has had the guts to make sculpture that is entirely dissociated from nature, beauty and art . . . —John Richardson, *New Statesman*

December–January 1966: Exhibits *Drum Roll* (1964), *Wide,* and *Glengary Radish* (1965) in "Seven Sculptors," Institute of Contemporary Art, University of Pennsylvania, Philadelphia, exhibition organized by Samuel Adams Green. Other participants include John Chamberlain, Donald Judd, Alexander Liberman, Tina Matkovic, David Smith, and Anne Truitt.

1966

April 27–June 12: *Titan* is exhibited in "Primary Structures: Younger American and British Sculptors," Jewish Museum, New York, organized by Kynaston McShine.

This show is the first in which the younger English and American sculptors, whose work is more or less hard-edged and geometric in shape, have been exhibited together in quantity . . . The major work in the show, not surprisingly, is Caro's *Titan* of 1964. —Andrew Hudson, *Washington Post*

Inevitably, an exhibition that embraces so many representatives of a single esthetic attitude includes a good many objects that are of indifferent merit, if not actually trivial. The best of the sculptors—in this case, the English sculptor, Anthony Caro—tend to be swamped by the presence of so many lesser figures. —Hilton Kramer, *New York Times*

May: One-man exhibition at David Mirvish Gallery, Toronto, comprises *The Horse, Sunshine, Pulse, Austen* (1965), *Shaftsbury* (1965, pp. 54, 55).

Exhibits *Aroma* (1966, p. 77) and *Paris Green* at Kasmin Limited, London.

The Museum of Modern Art, New York, purchases *Away*, later exchanged for *Source* (1967, p. 88).

May 20–September 30: Participates in exhibition of "Sculpture in the Open Air," Battersea Park, London, sponsored by Greater London Council. Exhibits *Month of May, Rouge Madras* (1965), and *Prima Luce* (1966).

Caro's works suggest an explosion in a boiler factory. His *Month of May* is a star attraction at London's current sculpture triennial in Battersea Park . . . The results are scaleless, impersonal presences engineered to relate to nothing but sculpture. —*Time Magazine*

May 27–September 25: Exhibits *Sculpture 3, Frognal,* and *Rouge Madras* in "Sonsbeek '66," Sonsbeek Park, Arnhem, Holland.

June 18–October 16: Selected, together with English painters Richard Smith, Harold Cohen, Bernard Cohen, and Robyn Denny, to exhibit in British Pavilion of XXXIII Venice Biennale, "Five Young British Artists." Members of selection committee are Sir Philip Hendy, Alan Bowness, Sir Herbert Read, David Thompson, Lillian Somerville. Exhibits *Early One Morning, Wide,* and *Yellow Swing.* Awarded David E. Bright Foundation prize for best sculptor under the age of forty-five.

Summer: Discussion with Michael Fried gives impetus to the idea of working on a series of small sculptures to be placed on tables. These first incorporate prefabricated metal handles and descend below the table surface, and are sprayed with brilliant lacquer over polished surfaces. Table pieces are generally identified by Roman numerals, though some were later given titles.

August: Caro incorporates grills and mesh screens into sculptures. Applies color with spray gun. Series includes *Carriage* (p. 81), *Source, Red Splash* (p. 78), and *The Window* (1966–67, p. 80).

October 8–November 4: One-man exhibition at Galerie Bischofberger, Zurich, comprises five works of 1966: *Hinge, Strand, Paris Green, Away* (p. 76), and *Stream.*

November 19–December 8: One-man exhibition at André Emmerich Gallery, New York. Comprises four 1966 sculptures: *Horizon* (p. 84), *Red Splash, Carriage, Span* (p. 82). *Horizon* is purchased by Rose Art Museum, Brandeis University, Waltham, Massachusetts.

There are, to be sure, a good many sculptors now working along the line pursued by Mr. Caro—some of them, as the result of Mr. Caro's example. But at the moment, and even if the tendency exists to overpraise a body of work that remains small and in some respects tentative, he seems far and away the most striking new sculptural talent to have emerged in the nineteen-sixties. —Hilton Kramer, *New York Times*

Anthony Caro . . . one of the most talked-about of the new generation of sculptors, this young Englishman is mentioned as a potential David Smith. Not to me, he isn't. —Emily Genauer, *World Journal Tribune*

1967

Makes *Prairie* (pp. 86, 87), a corrugated steel sheet and cantilevered rod structure.

Caro purchases from the estate of the late David

Smith and ships to England bronze, stainless steel, and assorted steel, including large wrenches, forgings, and tank ends, that he incorporates into later works.

Makes table sculptures of brass and steel with various finishes—chromed, polished, glazed, tempered, or sprayed with automobile paint.

April 11–May 21: Exhibits *Horse, Sculpture 3,* and *Sill* in "Color, Image, Form," exhibition of painting and sculpture presented by Friends of Modern Art, Detroit Institute of Arts, with catalog introduction by Gene Baro. Walker Art Center, Minneapolis, purchases *Sculpture 3* from this show.

April 28–June 25: *Prospect* and *Span* exhibited in "American Sculpture of the Sixties," Los Angeles County Museum. Caro's invitation to participate reflects his position of influence in American sculpture. Exhibition is organized by Maurice Tuchman. Catalog essay, "Recentness of Sculpture," by Clement Greenberg.

May 7–July 2: One-man exhibition at Rijksmuseum Kröller-Müller, Otterlo, Holland. Fifteen large sculptures executed between 1961 and 1967 and ten chrome table pieces are exhibited. In the introduction to the catalog Greenberg writes:

These [*Titan* and *Bennington*] are perhaps more purely, more limpidly, masterpieces than anything he has done before. . . . the two pieces strike the heroic, grand-manner note even more resonantly than the best of Caro's large English sculptures do. I say more resonantly, because less expectedly, less in terms of the historic connotations of the grand manner.

October 20–February 4, 1968: *Midday* exhibited in "Guggenheim International Exhibition: Sculpture from Twenty Nations," Guggenheim Museum, New York. Catalog essay by Edward Fry.

October 26–November 18: One-man exhibition at Kasmin Limited, London, comprises only two sculptures, *Prairie* and *Deep Body Blue* (1967, p. 85).

At the Kasmin Gallery there is another notable piece of sculpture which all addicts should make a point of seeing before it disappears forever into the teeming bowels of America—an important new piece by the now internationally famous Anthony Caro (who was once assistant to Moore). It is all sandy-coloured and is called *Prairie.* Four very long parallel pipes form receding horizons which float mysteriously over a ribbed base as firm as desert rock. Rigidly cubic in outline, this seems to mark a move towards a more classically enclosed space. —Nigel Gosling, *The Observer*

October 27–January 7, 1968: Exhibits *Away* at Pittsburgh International Exhibition of Contemporary Painting and Sculpture, Carnegie Institute, Pittsburgh.

1968

Development of table pieces eliminates metal handles. He incorporates steel table surfaces into large-scale sculpture. Makes *Trefoil* (p. 91).

January 7, 1968–March 11, 1969: Participates in "New British Painting and Sculpture," organized by the Whitechapel Gallery, London, for UCLA Art Galleries, Los Angeles; show tours for a year. Caro exhibits *Twenty-four Hours* and *Flats.*

Spring: Exhibits *Barford* (1965) at Hemisfair '68, San Antonio. At conclusion of the exhibition, workmen, taking the piece for scrap metal, destroy it. Caro

later reconstructs it, calling it *Farnham* (p. 58).

May 16–June 16: Henry Geldzahler organizes "Noland, Louis, and Caro," at Metropolitan Museum of Art, New York, where *Titan* is exhibited.

May 29–June 29: Exhibits *The Window* and *Lock* (1962, p. 31) in "New British Sculpture," Bristol, England, an open-air exhibition organized by the Arnolfini Gallery in cooperation with the Bristol Corporation.

May 24–August 10: *Smoulder* is exhibited in "Sculpture in a City," a touring exhibition organized by Arts Council of Great Britain, London.

June 1–July 20: *Slow Movement* is shown in "Sculpture 1960–67," an exhibition of works from Arts Council Collection, London.

June: Awarded Honorary Doctor of Letters Degree, University of East Anglia, England.

Purchases large boiler tank ends, which he cuts into thirds and quadrants. These, together with the material previously shipped from America, form the elements of *Argentine* (p. 90) and *After Summer* (p. 92).

June 22–October 20: Participates in "Ways of Contemporary Research," XXXIV Venice Biennale, Central Pavilion, Venice.

October 26–November 14: One-man exhibition at André Emmerich Gallery, New York, comprises five works of 1968: *Trefoil, Argentine, Table Piece LXIV* (p. 143), *Table Piece LXXIII,* and *Shade.*

Caro is an artist who has decisively changed the face of art in his own country and on the entire international art scene. Yet the sculpture that has prompted these important developments has been a good deal less revolutionary in concept than one might suppose. The quality of Mr. Caro's work has been consistently high, but this quality owes little to new ideas. It derives, above all, from a gift for projecting received ideas—principally the ideas of the late David Smith—onto a new level of sophistication and refinement. —Hilton Kramer, *New York Times*

November 6–16: Guest artist at the Thirtieth Annual Exhibition, Contemporary Art Society of New South Wales. Exhibits *Piano* (1968), which is shown and purchased by National Gallery of Victoria, Melbourne, in 1970.

1968–69

Purchases parts from agricultural machinery, particularly elements with flowing lines such as plowshares, as well as aircraft propellers (used in *Deep North,* 1969–70, pp. 104, 105). Horizontal planes now placed on different levels, as in *Orangerie* (1969, p. 94), *Sun Feast* (1969–70, pp. 96, 97), and *Georgiana* (1969–70, p. 103).

1969

January 1: Appointed Commander of the Order of the British Empire.

January 24–March 9: First major retrospective at Hayward Gallery, London, organized by Arts Council of Great Britain. Exhibition consists of fifty works made between 1954 and 1968. Catalog essay by Michael Fried.

The combination of self-sufficiency of total form—felt as stability, harmony and elegance—with extreme openness of area or of outline gives Caro's works of the last three to four years a character to which it would be hard not to respond with gladness and with warmth. There is a danger that the success of this exhibition—and it is bound to be both successful and influential—will create a demand and a market for work which could never be as good. —Charles Harrison, *Studio International*

All Caro's best work has a distinguished elegance of style. Once you are attuned to the idiom, the seemingly wayward accretion of various rods and angle-plates and bars is seen to be extraordinarily apt and skillful. —David Thompson, *New York Times*

August: Moves studio to larger workshop in Camden Town, London.

August 1–30: *Table Piece LXXVI* (1969) is shown in "Artists from Kasmin Limited," Arts Council Gallery, Belfast, Ireland.

September–December: Participates, together with John Hoyland, in British Section of X São Paulo Bienal, Brazil; exhibits *Lal's Turn, Titan, Smoulder, Carriage, The Window, Prairie, Trefoil,* and *Sight* (1965/69, p. 57). Caro is one of eight prizewinners.

Caro's sculpture was far the best in the Bienal, but Caro did not win the $10,000 Grand Prize, which was awarded to the German Erich Hauser, a sculptor little known outside of his own country. —Frederic Tutin, *Arts Magazine*

November 6–December 6: "Stella, Noland, Caro" at Dayton's Gallery 12, Minneapolis. *Cross Patch* (1965), *Tim's Turn* (1968), *Table Pieces XXIX* (1967), *XXXIII* (1967), and *LXI* (1968) exhibited.

1970

May 2–21: One-man exhibition at André Emmerich Gallery, New York. Included are *Orangerie, Deep North, Wending Back* (1969–70, p. 95), *Sun Feast. Wending Back* is purchased by Cleveland Museum. *Georgiana* is purchased by Albright-Knox Art Gallery, Buffalo.

Mr. Caro stands today all but unrivaled as the most accomplished sculptor of his generation. He is unquestionably the most important sculptor to have come out of England since Henry Moore . . . If he continues on his present course, adding distinction and eloquence to an already powerful oeuvre, he must certainly be counted among the great artists of his time . . . One has the impression of an artist who, having totally mastered a new and difficult area of sculptural syntax, is now permitting himself a freer margin of lyric improvisation. —Hilton Kramer, *New York Times*

Anthony Caro was almost an anomaly in sixties' three-dimensional art in that he chose to remain a sculptor. Although painting and sculpture seemed to be dissolving into the hybrid "specific" object and its next of kin, the environment . . . —Willis Domingo, *Arts Magazine*

May: Works at the Shaftsbury, Vermont, studio of Noland, whose friendship and hospitality have consistently facilitated Caro's work in America. Caro is assisted by James Wolfe, a Bennington sculptor, and later by the sculptor Willard Boepple. Works with very heavy pieces of steel purchased from Albany Steel Co., making weightier sculptures of beams and curved forms—*The Bull* (p. 107), *Picket.*

June: In London, works on sculptures stacking I-beams and precast steel shapes. Begins some sculptures at table height and extends them downward to reach the floor (*Moment*).

Summer: Philadelphia Museum of Art purchases

Clearing (1970).

August 6–September 30: Shows *Month of May* and *Orangerie* in "British Sculpture out of the Sixties," Institute of Contemporary Arts, London. Catalog introduction by Gene Baro.

September 9–October 25: Included in "Contemporary British Art," National Museum of Modern Art, Tokyo (exhibition organized with British Council). Exhibits *Pink Stack* (1969).

September 19–October 10: Exhibits *Dry Hopper* (1966) in "The Opening," David Mirvish Gallery, Toronto.

November: In Bennington. Restricts his material to structural steel—I-beams, angles, and plates. Works include *Late Afternoon, Halfway, Shadow.* Gradually comes to leave sculptures unpainted. Steel is rusted and then oiled or varnished.

November 12–January 3, 1971: Exhibits *The Window* and *Trefoil* in "British Painting and Sculpture, 1960–1970," at National Gallery, Washington, D.C., organized by Tate Gallery and British Council, London, with catalog introduction by Edward Lucie-Smith.

1971

January–March: Works in a variety of ways. Uses diamond shapes that hover over the floor—*Cool Deck* (1970–71, p. 110). Uses looping and curling forms—*Cadenza* (1970, p. 113), *Crown* (1970–71, p. 114), and *Serenade* (1970–71, p. 112). Stacks I-beams in blocks at different levels in space—*Canal, Paul's Turn, Pavane.*

Purchases large waste-disposal hoppers and cuts into and opens up their forms: *Quartet* (1970–71), *Sidestep* (p. 115), *Cherry Fair* (pp. 126, 127).

March–April: Invited by director of Western Australia Art Gallery, Perth, to judge Perth Prize at 1971 Drawing International. Travels around the world to Auckland, Wellington, and Christchurch, New Zealand, then to Perth, Adelaide, Melbourne, and Sydney, Australia. Lectures at universities and art schools en route. Visits Delhi and Bangkok.

Spring: Works on small flat-sided tub sculptures in which sides are angled and opened out (*Behold*). Begins open, symmetrical sculptures: *Ordnance* (p. 125), *Focus, Silk Road* (p. 154).

June 12–July 31: One-man exhibition at David Mirvish Gallery, Toronto. Consists of recent work: *Nocturne* (1970), *Tempus* (1970), *Crown, Celeste* (1970), *Late Afternoon,* and *Canal.*

Caro is now, I believe, the single most influential sculptor among younger practitioners, particularly in England and America . . . It says something for an artist—about his confidence and, perhaps, his generosity—that he should feel free to open up new formal possibilities and then move on to the next challenge, leaving others to explore their possible ramifications . . . —James R. Mellow, *New York Times*

A profoundly sculptural mind, Caro's four pictorial pieces in this show are either flawed or unsuccessful (with the exception of *Crown,* which sufficiently emphasizes figurative and directional qualities). . . . Still, one left impressed by the knowledge that those "flaws" and disappointments were necessitated by the very fecundity and prolificacy of his talent. —W. Neil Marshall, *Studio International*

Summer: Pat Cunningham becomes Caro's assistant in London studio.

August 15–September 12: Exhibits *The Bull* in "Deluxe Show," Houston, sponsored by De Menil Foundation.

September 16–October 8: One-man exhibition at Kasmin Limited, London, includes *Quartet, Sidestep,* and *Paul's Turn.*

1972

February 19–March 8: One-man exhibition, André Emmerich Gallery, New York. Exhibits five sculptures executed in 1970 and 1971: *Cool Deck, Cherry Fair, Grant, Behold,* and *Shadow.*

It is one of the symptoms of the great quality of Caro's art, just as it is of Pollock's, that the spirit of Cubism is retained as its features are purged and transformed . . . —Walter D. Bannard, *Artforum*

April 14–July 17: *Shaftsbury, Orangerie,* and *Cool Deck* are exhibited in "Six Contemporary English Sculptors," Museum of Fine Arts, Boston. Exhibition is organized by Kenworth Moffett.

April 19–May 10: Exhibits *Fleet* (1971) in group exhibition, Kasmin Limited, London.

May 4–June 4: Participates in "Masters of the Sixties," Edmonton Art Gallery, Alberta. Exhibits *Bailey* (1971). Exhibition travels to Winnipeg Art Gallery and to David Mirvish Gallery, Toronto.

June 11–October 8: Invited to exhibit in "Sculptures in the City," an international exhibition in the Ducal Palace and public squares, XXXVI Venice Biennale; exhibits *Midday* at Campo S. Maria del Giglio.

Summer: On Caro's invitation Helen Frankenthaler spends three weeks making sculpture in his London studio.

Autumn: In London, Caro makes a series of seven sculptures—the Straight series—by permutating and developing the structure of *Straight On,* a work composed of I-beams and angular planes cut and pierced so that the identity of the beams is destroyed. Surfaces are left unpainted.

November 9–December 2: Four of the seven sculptures from Straight series are shown in one-man exhibition, Kasmin Limited, London.

The sculptures of this new series—pictorial in their surfaces, natural in their use of materials, "cropped" from one work to the next, as live and careful as ever in their details—all speak, in their different ways, of an engagement with the very broadest attributes open to the medium of sculpture. —John Elderfield, *Studio International*

November: Works for two weeks in Rigamonte factory in Veduggio, Brianza, Italy, with James Wolfe as assistant, using soft-edge steel scraps from plates and joists. Returns in following May and November to make adjustments to the fourteen sculptures that form the Veduggio series.

Writes "Some Thoughts after Visiting Florence" (published in *Art International,* May 1974) after viewing Renaissance art in Florence.

1973

January–March: After improvising by rough-

cutting edges, obtains soft-edge rolled steel from Durham, England. Makes small sculptures, then larger pieces; begins *Durham Steel Flat* (p. 153), *Durham Purse* (p. 152).

March: Museum of Fine Arts, Houston, purchases *Night Road* (1971–72, p. 129); *Straight Flush* (1972) is acquired by Walker Art Center, Minneapolis.

May 17–June 24: "Art in Space: Some Turning Points," Detroit Institute of Arts exhibition sponsored by the Friends of Modern Art (Founders Society). *Second Day* (1970) and *Up Front* (1971, p. 120) are exhibited. Final selection by E. C. Goossen. *Up Front* is later purchased by Detroit Art Institute.

May 25–June 29: One-man exhibition of recent table pieces at André Emmerich Gallery, New York.

Caro's new table pieces were the most modest sculptures this English legatee of David Smith has done in quite a while. They are relatively small and made of welded sections of unpainted but sometimes varnished steel. They rest on the edges of tables, normally hanging over, and depend on actual balance for the maintenance of stability. This is the dramatic factor in their effectiveness. Perhaps it is a grandstanding gimmick on Caro's part—but the small scale tempers the table-hanging melodrama to a tasteful degree. —Peter Frank, *Art News*

September 28–November 17: *Yellow Swing* and *Table Piece LXXXII* (1969) included in exhibition "Henry Moore to Gilbert and George: Modern British Art from the Tate Gallery," Palais des Beaux-Arts, Brussels. Commentary by Anne Seymour.

October 13–November 11: One-man exhibition at Norfolk and Norwich Triennial Festival, East Anglia. Exhibits twenty sculptures dating from 1960 to 1972. Catalog introduction by Alstair Grieve.

December: The Museum of Modern Art, New York, acquires *Midday*.

1974

January 15–March 10: Exhibits *Carriage* in "The Great Decade of American Abstraction: Modernist Art 1960 to 1970," Museum of Fine Arts, Houston.

February 9–March 6: *Wide* is exhibited at David Mirvish Gallery, Toronto, in group show of paintings and sculptures, "Ten Years Ago . . ."

March 9–27: One-man exhibition at André Emmerich Gallery, New York. Comprises four works made in 1972–73 at Veduggio and two in 1973–74 in London: *Veduggio Wash, Veduggio Sun* (p. 149), *Veduggio Lago, Veduggio Glance, Durham Purse,* and *Durham Steel Flat. Veduggio Sun* bought by Dallas Museum of Fine Arts (April 1974).

Monumental constructions of welded and bolted steel are enriched by a patina of warm rusted browns and mottled textures which lend an organic quality to the hard metal. Caro's recent works bring new lyricism to the Constructivist tradition. While steel retains its intractable grandeur, the modes of behavior to which it is put—it can stand, lie, hover, bend, attach, buttress—make these sculptures alive and imposing presences. —Hayden Herrera, *Art News*

May 4–June 8: One-man exhibition at André Emmerich Gallery, Zurich; includes sculptures made in 1972–73 at Veduggio: *Veduggio Sound, Veduggio Plain, Veduggio Fan, Veduggio Stay, Veduggio Gasp, Veduggio Glimpse.*

Now that he no longer excites avant-garde small talk, Caro is becoming a movement in himself, fertile, prolific, but essentially going it alone. This is the stage at which an artist's lasting worth, rather than his trend-setting achievements, first becomes recognisable. . . . his most recent pieces, made in Italy and London, have significantly different qualities from the two basic varieties of work, abrupt as in *Midday* (1960) and airily deployed as in *Early One Morning* (1962), with which he first established his reputation. A decade ago he took his steel from standard industrial stock and gave his products straightforward, eyecatching, protective coats of paint. Now he has more or less abandoned the use of paint, and his work looks comparatively impromptu, rough and ready. The finished objects would no longer seem conceivably at home in the farm machinery section of an agricultural show or among the girders on a clean construction site. Rather, they belong to the foundry and the rolling mill where the steel first emerges in its raw state. —William Feaver, *Art International*

June–July: Works at York Steel Co., Toronto, using heavier steel and handling equipment such as stationary and mobile cranes; assisted by James Wolfe and later also by Willard Boepple and André Fauteux. He returns in November and completes thirty-seven sculptures, including *Dominion Day Flats* (p. 159), *Crisscross Flats* (p. 163).

August 17–October 13: Included in "Monumenta," Newport, Rhode Island, a biennial exhibition of outdoor sculpture. Catalog introduction by Sam Hunter. Exhibits *Vespers* (1974).

September 6–October 31: Shows *Span, Sun Feast, Cool Deck, Box Piece F,* and *Table Pieces CXXXVII* and *CXLII* in "Sculpture in Steel" exhibition at Edmonton Art Gallery. Catalog introduction by Karen Wilkin. Other artists included are Gonzales, Smith, Tim Scott, Michael Steiner.

September 11–October 20: One-man exhibition of seventeen table sculptures executed in 1973 and 1974 at Kenwood House, Hampstead, London. Catalog introduction by John Jacob.

Incommunicative to a fault, these offerings do not manage either to justify or revitalise the redundant bases on which they are displayed, and no amount of sculptural gymnastics at the table's edge can persuade me that Caro's increasing conservatism is anything other than a retrograde development. —Richard Cork, *Evening Standard*

These new pieces are quite different. Caro has reverted to a more brutalist style, in which sheets and bars of raw metal are bent and scraped and cut and welded together . . . paint has been rejected in favour of rusty surfaces . . . What is fascinating about the whole set is the ingenious ambiguity which Caro has achieved by laying them along the very edge of their pedestals, so that they are half-resting, half-free, floating or even falling . . . Caro has moved away from cool metropolitan engineering towards a hint of the romantic primitivism . . . —Nigel Gosling, *The Observer*

November: Makes table sculptures that do not overlap the table edge, such as *Table Piece CCIII* (p. 174).

November 9–December 4: One-man exhibition at David Mirvish Gallery, Toronto, comprises six works of 1971–74 made in Vermont: *Dark Motive* (p. 155), *End Game, Silk Road, Strip Stake, On Duty, Sailing Tonight.*

November 14–January 20, 1975: Seven table sculptures shown at Galleria Ariete, Milan.

LIST OF EXHIBITIONS

ONE-MAN EXHIBITIONS

1956

Galleria del Naviglio, Milan. March 19–28.

1957

Gimpel Fils, London. January 8–26.

1963

Whitechapel Art Gallery, London. September–October.

1964

André Emmerich Gallery, New York. December 2–19.

1965

Washington Gallery of Modern Art, Washington, D.C. February 24–March 28.

Kasmin Limited, London. October 29–November 27.

1966

David Mirvish Gallery, Toronto. May 3–June 27.

Galerie Bischofberger, Zurich. October 8–November 4.

André Emmerich Gallery, New York. November 19–December 8.

1967

Rijksmuseum Kröller-Müller, Otterlo. May 7–July 2.

Kasmin Limited, London. October 26–November 18.

1968

André Emmerich Gallery, New York. October 26–November 14.

1969

Hayward Gallery, London. January 24–March 9. Organized by the Arts Council of Great Britain.

British Section, X Bienal de São Paulo. September–December. Organized by the British Council.

1970

André Emmerich Gallery, New York. May 2–21.

1971

David Mirvish Gallery, Toronto. June 12–July 31.

Kasmin Limited, London. September 16–October 8.

1972

André Emmerich Gallery, New York. February 19–March 8.

Kasmin Limited, London. November 9–December 2.

1973

André Emmerich Gallery, New York. May 25–June 29.

Norfolk and Norwich Triennial Festival, East Anglia. October 13–November 11.

1974

André Emmerich Gallery, New York. March 9–27.

André Emmerich Gallery, Zurich. May 4–June 8.

Kenwood House, London. September 11–October 20.

David Mirvish Gallery, Toronto. November 9–December 4.

Galleria Ariete, Milan. November 14–January 20.

GROUP EXHIBITIONS

1955

"New Sculptors and Painter-Sculptors," Institute of Contemporary Arts, London. August 11–September 3.

"Contemporary Painting and Sculpture," City Art Gallery, Leeds. November 30–December 31.

1956

Summer Group Exhibition, Gimpel Fils, London. July 10–August 31.

1957

"Some Younger British Sculptors," Manchester University, Art Department. April 29–May 31.

"Contemporary British Sculpture," open-air touring exhibition arranged by the Arts Council of Great Britain. May 25–October 12.

Summer Group Exhibition, Gimpel Fils, London. July–August.

Summer Group Exhibition, Redfern Gallery, London. July–August.

"New Trends in British Art," Rome–New York Art Foundation, Rome. 1957–58.

1958

"Contemporary British Paintings, Sculptures, and Drawings," British Embassy, Brussels. April–July.

"Sonsbeek '58: International Exhibition of Sculpture in the Open Air," Sonsbeek Park, Arnhem, Holland. May–September.

"Contemporary British Sculpture," open-air touring exhibition arranged by the Arts Council of Great Britain. May 31–August 30.

"Three Young English Artists," Central Pavilion, XXIX Venice Biennale. June 14–October 19.

"The Religious Theme," Tate Gallery, London. July 10–August 21. Organized by the Contemporary Art Society, London.

Pittsburgh Bicentennial International Exhibition of Contemporary Painting and Sculpture, Carnegie Institute, Pittsburgh. December 5–February 8, 1959.

1959

5e Biennale voor Beeldhouwkunst, Middelheim Park, Antwerp. May–September.

Biennale Internazionale di Scultura, Carrara, Italy. July–August.

1ère Biennale de Paris, Musée d'Art Moderne de la Ville de Paris. October 2–25.

1960

"Contemporary British Sculpture," open-air touring exhibition arranged by the Arts Council of Great Britain. April–October.

"Sculpture in the Open Air," Battersea Park, London. May–September. Organized by the London County Council.

1961

"Ten Sculptors," Marlborough New London Gallery, London. April 14–May 18.

"Contemporary British Sculpture," open-air touring exhibition arranged by the Arts Council of Great Britain. April 22–September 30.

"New London Situation: An Exhibition of British Abstract Art," Marlborough New London Gallery, London. August–September.

International Union of Architects Congress, London. October–November.

1962

"Young English Sculptors," Ateneo, Madrid. March 2–20.

"Sculpture Today," Midland Group Gallery, Nottingham. August 18–September 8.

1963

"Sculpture: Open-Air Exhibition of Contemporary British and American Works," Battersea Park, London. May–September. Organized by the London County Council.

Group Exhibition, Kasmin Limited, London. August 9–September 21.

1964

"1954–1964: Painting and Sculpture of a Decade," Tate Gallery, London. April 22–June 28. Organized by the Calouste Gulbenkian Foundation, Lisbon.

Documenta, Kassel, Germany. June 27–October 5.

"Hampstead Artists 1943–64," Kenwood House, London. October–November.

1965

"Sculpture from the Arts Council Collection," touring exhibition arranged by the Arts Council of Great Britain.

"British Sculpture in the Sixties," Tate Gallery, London. February 25–April 4. Organized by the Contemporary Art Society in association with the Peter Stuyvesant Foundation.

Group Exhibition, Kasmin Limited, London. August–September.

"Sculpture from All Directions," World House Galleries, New York. November 3–27.

"Seven Sculptors," Institute of Contemporary Art, University of Pennsylvania, Philadelphia. December 1965–January 17, 1966.

"Kane Memorial Exhibition," Providence Art Club, Providence, R.I. March 31–April 24.

1966

"Contemporary British Sculpture," open-air touring exhibition arranged by the Arts Council of Great Britain. April 23–July 31.

"Primary Structures: Younger American and British Sculptors," Jewish Museum, New York. April 27–June 12.

"Sculpture in the Open Air," Battersea Park, London. May 20–September 30. Organized by the Greater London Council.

"Sonsbeek '66: International Exhibition of Sculpture in the Open Air," Sonsbeek Park, Arnhem, Holland. May 27–September 25.

"Five Young British Artists," British Pavilion, XXXIII Venice Biennale. June 18–October 16.

1967

"Sculpture 60–66," A touring exhibition of works from the collection of the Arts Council of Great Britain. April 8, 1967–January 6, 1968.

"Color, Image, Form," Detroit Institute of Arts. April 11–May 21.

"American Sculpture of the Sixties," Los Angeles County Museum. April 28–June 25.

"The 118 Show: Paintings/Constructions/Sculptures/Graphics," Kasmin Limited, London. August 4–September 7.

"The 180 Beacon Collection of Contemporary Art," 180 Beacon Street, Boston. October.

"Englische Kunst," Galerie Bischofberger, Zurich. October 14–November 10.

"Selected Works from the Collection of Mr. and Mrs. H. Gates Lloyd," Institute of Contemporary Art,

University of Pennsylvania, Philadelphia. October 18–November 19.

"Guggenheim International Exhibition, 1967: Sculpture from Twenty Nations," Solomon R. Guggenheim Museum, New York, October 20, 1967–February 4, 1968. Also shown during 1968 at the Art Gallery of Ontario, Toronto, February–March; National Gallery of Canada, Ottawa, April–May; and the Museum of Fine Arts, Montreal, June–August.

Pittsburgh International Exhibition of Contemporary Painting and Sculpture, Carnegie Institute, Pittsburgh. October 27, 1967–January 7, 1968.

1968

"New British Painting and Sculpture," University of California at Los Angeles. January 7, 1968–March 11, 1969. Organized by the Whitechapel Art Gallery, London. Also shown at the University of California Art Museum, Berkeley; Portland Art Museum; Vancouver Art Gallery; Henry Gallery, University of Washington, Seattle; Museum of Contemporary Art, Chicago; and Contemporary Arts Museum, Houston.

"25 Camden Artists," Camden Arts Festival, London. February 29–March 23.

"Hemisfair '68," San Antonio, Texas. April 6–October 6.

"Noland, Louis, and Caro," Metropolitan Museum of Art, New York. May 16–June 16.

"New British Sculpture," open-air and gallery exhibition organized by the Arnolfini Gallery, Bristol, England. May 29–June 29.

"Sculpture in a City," touring exhibition arranged by the Arts Council of Great Britain. May 24–August 10.

"Sculpture 1960–67," touring exhibition of works from the collection of the Arts Council of Great Britain. June 1–July 20.

"Ways of Contemporary Research," Central Pavilion, XXXIV Venice Biennale. June 22–October 20.

Documenta IV, Kassel, Germany. June 27–October 6.

30th Annual Exhibition, Contemporary Art Society of New South Wales, Blaxland Gallery, Sydney. November 6–16.

1969

"Between Object and Environment: Sculpture in an Extended Format," Institute of Contemporary Art, University of Pennsylvania, Philadelphia. April 2–May 3.

"Artists from the Kasmin Gallery," Arts Council Gallery, Belfast, Ireland. August 1–30.

"Seven Sculptors," Museum of Modern Art, Oxford. September 26–November 7. Organized by the Arts Council of Great Britain.

"Stella, Noland, Caro," Dayton's Gallery 12, Minneapolis. November 6–December 6.

1970

Group Exhibition, City Art Gallery, Leeds. July.

Group Exhibition, Kasmin Limited, London. August 4–28.

"British Sculpture out of the Sixties," Institute of Contemporary Arts, London. August 6–September 30.

"Contemporary British Art," National Museum of Modern Art, Tokyo. September 9–October 25. Organized by the British Council.

"The Opening," David Mirvish Gallery, Toronto. September 19–October 10.

"British Painting and Sculpture 1960–70," National Gallery of Art, Washington, D.C. November 12, 1970–January 3, 1971. Organized by the Tate Gallery and the British Council.

1971

Group Exhibition, Kasmin Limited, London. February 16–March 9.

"The Deluxe Show," Deluxe Theatre, Houston. August 15–September 12. Sponsored by De Menil Foundation.

Group Exhibition, David Mirvish Gallery, Toronto. August 14–September 14.

1972

Group Exhibition, David Mirvish Gallery, Toronto. January 22–February 22.

"Contemporary Sculpture: A Loan Exhibition," Phillips Collection, Washington. April 8–May 16.

"Six Contemporary English Sculptors," Museum of Fine Arts, Boston. April 14–July 17.

Group Exhibition, Kasmin Limited, London. April 19–May 10.

"Masters of the Sixties," Edmonton Art Gallery, Canada. May 4–June 4. Also shown at Winnipeg Art Gallery, June 15–July 15; and David Mirvish Gallery, Toronto, August–September.

"Scultura nella Città," Public Squares, XXXVI Venice Biennale. June 11–October 8.

1973

"Art in Space: Some Turning Points," Detroit Institute of Arts. May 17–June 24.

Basel International Art Fair, Basel. June 20–25.

"Henry Moore to Gilbert and George: Modern British Art from the Tate Gallery," Palais des Beaux-Arts, Brussels. September 28–November 17.

1974

"The Great Decade of American Abstraction: Modernist Art 1960 to 1970," Museum of Fine Arts, Houston. January 15–March 10.

"Ten Years Ago . . . Painting and Sculpture from 1964," David Mirvish Gallery, Toronto. February 9–March 6.

Basel International Art Fair, Basel. June 19–24.

"Newport Monumenta," Biennial exhibition of outdoor sculpture, Newport, R.I. August 17–October 13.

"Sculpture in Steel," Edmonton Art Gallery, Alberta. September 6–October 31. Shown at Mirvish Gallery, Toronto, January 11–February 2, 1975.

BIBLIOGRAPHY

Items are arranged in chronological sequence, according to the year of publication, and listed alphabetically by author within each year. Included are selected catalogs with extensive essays, journal and newspaper articles and reviews, as well as general reference works. In articles of broad scope, pages marked with an asterisk refer specifically to Caro.

1955

Sylvester, David. "Round the London Galleries," *The Listener*, Sept. 1, 1955.

Taylor, Basil. "Art," *The Spectator*, Sept. 2, 1955.

"Young Men's Sculpture," *The Times* (London), Aug. 12, 1955.

1956

Alloway, Lawrence. "Caro and Gravity," foreword to exhibition catalog. Galleria del Naviglio, Milan, 1956.

Crosby, Theo. "Anthony Caro at Galleria Naviglio, Milan," *Architectural Design* (London), Mar. 1956, p. 107.

1957

Alloway, Lawrence. "Art News from London," *Art News* (New York), Mar. 1957, p. 21.

Bone, Stephen. "Artists' Contrast: Redvers Taylor and Anthony Caro," *Manchester Guardian*, Jan. 9, 1957.

Forge, Andrew. "Round the London Galleries," *The Listener* (London), Jan. 17, 1957.

Rouve, Pierre. "Personality," *Art News and Review* (London), Jan. 19, 1957, p. 3.

Solomon, Alan. "Sculpture in a Big Way," *The Times* (London), Jan. 15, 1957.

Wallis, Nevile. "Different Worlds," *The Observer* (London), Jan. 13, 1957.

1960

Caro, Anthony. "The Master Sculptor," *The Observer* (London), Nov. 27, 1960.

Maillard, Robert, ed. *Dictionary of Modern Sculpture.* New York: Tudor, 1960, p. 51. London: Methuen, 1962.

Seuphor, Michel. *The Sculpture of This Century.* New York: Braziller, 1960, pp. 147, 150, 248. London: Zwemmer, 1961.

Melville, Robert. "Exhibitions," *Architectural Review* (London), Nov. 1961, pp. 351–52, 354 (*352).

1961

Alloway, Lawrence. "Interview with Anthony Caro," *Gazette* (London), no. 1, 1961, p. 1.

Sylvester, David. "Aspects of Contemporary British Art," *Texas Quarterly* (University of Texas, Austin), Autumn 1961, pp. 118–28 (*127–28).

Trier, Edward. *Form and Space: Sculpture of the Twentieth Century.* London: Thames and Hudson, 1961. New York: Praeger, 1968, pp. 44, 280, 281, 326, fig. 228.

1962

Alloway, Lawrence. "Notes from London: Painted Sculpture by Anthony Caro," *Metro* (Milan), 1962, pp. 102, 104–7.

1963

Amaya, Mario. "The Dynamics of Steel," *Financial Times* (London), Sept. 24, 1963.

Baro, Gene. "A Look at Reminiscence," *Arts Magazine* (New York), Nov. 1963, pp. 44–47.

Fried, Michael. "Anthony Caro," introduction to exhibition catalog, Whitechapel Gallery, London, 1963. Reprinted in *Art International* (Lugano), Sept. 25, 1963, pp. 68–72.

Lynton, Norbert. "Two Radicals," *New Statesman* (London), Oct. 11, 1963.

Martin, Robin. "The Sculpture of Anthony Caro," *Peace News* (London), Nov. 22, 1963.

Melville, Robert. "Constructions at Whitechapel Art Gallery," *Architectural Review* (London), Dec. 1963, pp. 431–32.

Mullins, Edwin. "Time of the Modern," *Sunday Telegraph* (London), Oct. 6, 1963.

Newton, Eric. "Anthony Caro's Sculpture at the Whitechapel Gallery," *The Guardian* (London), Sept. 19, 1963.

Reichardt, Jasia. "Caro and Environmental Sculpture," *Architectural Design*, (London) Oct. 1963, [1]p. (betw. pp. 76–77).

Russell, John. "Art News from London," *Art News* (New York), Dec. 1963, p. 49.

Russell, John. "England: The Advantage of Being Thirty," *Art in America* (New York), Dec. 1963, pp. 92–97 (*93–94).

Russell, John. "New Areas of Awareness," *Sunday Times* (London), Sept. 22, 1963.

Solomon, Alan. "Mr. Caro's New and Original Sculpture," *The Times* (London), Oct. 4, 1963.

Solomon, Alan. "Out-and-Out Originality in Our Contemporary Sculpture," *The Times* (London), Aug. 20, 1963.

Spencer, Charles S. "Caro at the Whitechapel Gallery," *Arts Review* (London), Sept. 21, 1963, p. 5.

Storey, David. "When Artists Sell Out," *The Observer* (London), Sept. 29, 1963.

Wallis, Nevile. "Anthony Caro," *The Spectator* (London), Sept. 4, 1963.

Walter, Richard. "Wanted: New Words for Caro," *Daily Mail* (London), Sept. 19, 1963.

1964

Canaday, John. "Summary of Recent Art-Show Openings in Galleries Here," *New York Times*, Dec. 5, 1964.

Lynton, Norbert. "Latest Developments in British Sculpture," *Art and Literature* (Lausanne), Summer 1964, pp. 195–211.

Spencer, Charles S. "An Introduction to Abstract Art," *The Artist* (London), Feb. 1964, pp. 122–25.

Spencer, Charles S. "Sculptor for Humanity," *Jewish Chronicle* (London), Feb. 14, 1964.

Thompson, David. "A Decade of British Sculpture," *Cambridge Opinion*, 1964.

"Conversation with Anthony Caro, Ken Noland, and Jules Olitski," *Monad* (London), Jan. 1964, pp. 18–22.

1965

Baro, Gene. "Britain's New Sculpture," *Art International* (Lugano), June 1965, pp. 26–31.

Baro, Gene. "Britain's Young Sculptors," *Arts Magazine* (New York), Dec. 1965, pp. 13–17.

Benedikt, Michael. "Anthony Caro," introduction to exhibition catalog *7 Sculptors*, Institute of Contemporary Art, University of Pennsylvania (Philadelphia), 1965.

Booker, Emma. "Anthony Caro," *Vogue* (London), Nov. 1965, pp. 94–95.

Campbell, Lawrence. "Reviews and Previews: Anthony Caro," *Art News* (New York), Jan. 1965, p. 19.

Cheek, Leslie, III. "Sculptor Achieves Tonnage," *Washington Post*, Feb. 21, 1965.

Coutts-Smith, Kenneth. "Anthony Caro," *Arts Review* (London), Nov. 13, 1965, p. 9.

Dunbar, John. "Anthony Caro: The Experience Is the Thing," *The Scotsman* (Edinburgh), Nov. 20, 1965.

Dunlop, Ian. "Sculpture You Look Down at—and Admire," *Evening Standard* (London), Nov. 4, 1965.

Forge, Andrew. "Some New British Sculptors," *Artforum* (San Francisco), May 1965, pp. 31–35.

Fried, Michael. "Anthony Caro and Kenneth Noland: Some Notes on Not Composing," *Lugano Review* (Lugano), Summer 1965, pp. 198–206.

Gosling, Nigel. "Cairo to Caro," *The Observer* (London), Nov. 7, 1965.

Greenberg, Clement. "Anthony Caro," *Arts Yearbook 8: Contemporary Sculpture* (New York), 1965, pp. 106–9. Reprinted as foreword to exhibition catalog, Rijksmuseum Kröller-Müller, Otterlo, Holland, 1967, and in *Studio International* (London), Sept. 1967, pp. 116–17, and in Whelan, 1974 (q.v.).

Grinke, Paul. "Caro's Achievement," *Financial Times* (London), Nov. 13, 1965.

Hodin, J. P. "The Avant-Garde of British Sculpture and the Liberation from the Liberators," *Quadrum* (Brussels), 1965, pp. 55–70 (*56, 57, 61, 70).

Judd, Donald. "In the Galleries: Anthony Caro," *Arts Magazine* (New York), Jan. 1965. pp. 53–54.

Lynton, Norbert. "Anthony Caro Exhibition," *The Guardian* (London), Nov. 16, 1965.

Lynton, Norbert. "London Letter," *Art International* (Lugano), Dec. 1965, pp. 23–30 (*23–24, 26).

Lynton, Norbert. *The Modern World.* New York: McGraw-Hill, 1965, pp. 158, 164. London: Hamlyn, 1968.

Mullins, Edwin. "Art," *Sunday Telegraph* (London), Nov. 7, 1965.

Reichardt, Jasia. "Colour in Sculpture," *Quadrum* (Brussels), no. 18, 1965, pp. 71–78 (*75).

Richardson, John. "Carissimo," *New Statesman* (London), Nov. 12, 1965.

Richardson, John. "Early One Morning," *New Statesman* (London), Feb. 28, 1965.

Robertson, Bryan. Preface to exhibition catalog *The New Generation 1965*, Whitechapel Gallery, London, 1965.

Robertson, Byran. "A Revolution in British Sculpture," *The Times* (London), Mar. 9, 1965.

Russell, John. "Art News from London: Anthony Caro—New Works," *Art News* (New York), Dec. 1965, pp. 36, 54, 55.

Russell, John. "The Man Who Gets There First," *Sunday Times* (London), Oct. 31, 1965.

Solomon, Alan. "Importance of the Ground in Sculpture of Anthony Caro," *The Times* (London), Nov. 4, 1965.

Stevens, Elisabeth. "Caro Has a Way with Steel and Bends It to His Will," *Washington Post*, Feb. 28, 1965.

Stone, Peter. "New Mysticism," *Jewish Chronicle* (London), Nov. 12, 1965.

Thompson, David. "After the Twisted Iron, the Girder Sections," *Sunday Times* (London), Feb. 28, 1965.

Thompson, David. "Art: Waving the British Flag," *Queen Magazine* (London), Sept. 1, 1965.

Thompson, David. "British Sculpture Up," *New York Times*, Mar. 28, 1965.

Whittet, G. S. "London Commentary: No More an Island," *Studio International* (London), Dec. 1965, pp. 241–45 (*244–45).

"Sculpture: Intellectuals without Trauma," *Time Magazine* (New York), Mar. 12, 1965, p. 66.

1966

Baro, Gene. "British Sculpture: The Developing

Scene," *Studio International* (London), Oct. 1966, pp. 171–81.

Beeren, W. A. L. "De 33e Biennale van Venetië," *Museumjournaal* (Otterlo), Nov. 1966, pp. 144–55 (*145, 152).

Devlin, Polly. "The Merchants of Venice," *Vogue* (London), May 1966, pp. 112–13.

Forge, Andrew. Interview with Anthony Caro. *Studio International* (London), Jan. 1966, pp. 6–9.

Fulford, Robert. "When Sculptor Caro Works . . . Everybody Works," *Toronto Daily Star,* May 13, 1966.

Genauer, Emily. "Anthony Caro," *World Journal Tribune,* Nov. 25, 1966.

Greenberg, Clement. "David Smith," *Art in America* (New York), Jan.–Feb. 1966, pp. 27–32 (*29).

Hodin, J. P. "Documentation: Anthony Caro," *Quadrum* (Brussels), no. 20, 1966, pp. 142–43.

Hudson, Andrew. "Bellwether of a Really New Sculpture," *Washington Post,* Oct. 2, 1966.

Hudson, Andrew. "Caro's Four Sculptures Seem Just Like a Crowd," *Washington Post,* Nov. 27, 1966.

Hudson, Andrew. "English Sculptors Outdo Americans," *Washington Post,* May 8, 1966.

Hughes, Robert. "Caro Generation," *Sunday Times* (London), Apr. 10, 1966.

Kramer, Hilton. "'Primary Structures'—The New Anonymity," *New York Times,* May 1, 1966.

Kramer, Hilton. "Sculpture: Talent Unfolds on Horizon," *New York Times,* Nov. 26, 1966.

Lucie-Smith, Edward. "Anthony Caro at Venice," *Art and Artists* (London), June 1966, pp. 24–27.

Malcolmson, Harry. Review of Caro exhibition at David Mirvish Gallery, Toronto. *The Telegram* (Toronto), May 21, 1966.

Malcolmson, Harry. "A Chasm between Artistic Points of View," *The Telegram* (Toronto), June 4, 1966.

Menna, Filiberto. "La Scultura di Anthony Caro," *Marcatrè* (Milan), Dec. 1966–Mar. 1967, pp. 154, 156–57.

Metz, Kathryn. "The 33rd Venice Biennale of Art," *Arts and Architecture* (Los Angeles), Sept. 1966, pp. 32–34 (*32).

Robertson, Byran. "Raspberry Ripple," *The Spectator* (London), Sept. 9, 1966.

Russell, John. "Portrait: Anthony Caro," *Art in America* (New York), Sept.–Oct. 1966, pp. 80–87.

Solomon, Alan. "The Green Mountain Boys," *Vogue* (New York), Aug. 1, 1966, pp. 104–9, 151–52.

Thompson, David. "Venice Biennale: The British Five," *Studio International* (London), June 1966, pp. 233–43.

"Sculpture: The Girder Look," *Time Magazine* (New York), July 22, 1966, p. 63.

1967

Amaya, Mario. "Caro and Paolozzi in Holland," *Financial Times* (London), May 17, 1967.

Ammann, Jean-Christophe. "Anthony Caro und die junge englische Skulptur," *Werk* (Winterthur), Oct. 1967, pp. 641–46.

Benedikt, Michael. "New York Letter: Some Recent British and American Sculpture," *Art International* (Lugano), Jan. 1967, pp. 56–62 (*56).

Bowen, Dennis. "Anthony Caro," *Arts Review* (London), Nov. 25, 1967, p. 442.

Brett, Guy. "Anthony Caro's New Sculpture," *The Times* (London), Nov. 6, 1967.

Bruce-Milne, Marjorie. "'Constructed, Built, Assembled, Arranged . . .'" *Christian Science Monitor* (Boston), Nov. 20, 1967.

Campbell, Lawrence. "Reviews and Previews: Anthony Caro," *ArtNews* (New York), Jan. 1967, p. 11.

Fried, Michael. "Art and Objecthood," *Artforum* (New York), Summer 1967, pp. 12–23.

Fried, Michael. "New Work by Anthony Caro," *Artforum* (New York), Feb. 1967, pp. 46–47.

Fry, Edward F. "Sculpture of the Sixties," *Art in America* (New York), Sept.–Oct. 1967, pp. 26–43 (*27, 33).

Gosling, Nigel. "Art," *The Observer* (London), Nov. 5, 1967.

Greenberg, Clement. "Recentness of Sculpture," essay in exhibition catalog *American Sculpture of the Sixties,* Los Angeles County Museum, 1967, pp. 24–26. Reprinted in *Art International* (Lugano), Apr. 1967, pp. 19–21.

Hale, Barrie. "Massive Caro, Delicate Caro," *The Telegram* (Toronto), Jan. 21, 1967.

Hefting, P. H. "Twee in een, Paolozzi en Caro in Kröller-Müller," *Museumjournaal* (Otterlo), serie 12/2, 1967, pp. 49–56. English summary, p. 63.

Hudson, Andrew. "The 1967 Pittsburgh International," *Art International* (Lugano), Christmas 1967, pp. 57–64 (*57, 58, 61, 63).

Jouffroy, Alain. "Art de Demi-Brume à Londres," *L'Oeil* (Paris), May 1967, pp. 34–41, 84.

Krauss, Rosalind. "On Anthony Caro's Latest Work," *Art International* (Lugano), Jan. 20, 1967, pp. 26–29.

Kritzwiser, Kay. "Sculptures by Caro," *Globe and Mail* (Toronto), Jan. 21, 1967.

Lynton, Norbert. "Anthony Caro Exhibition," *The Guardian* (London), Nov. 3, 1967.

Lynton, Norbert. "London Letter," *Art International* (Lugano), Christmas 1967, pp. 51–56 (*54, 55).

Mellow, James R. "The 1967 Guggenheim International," *Art International* (Lugano), Christmas 1967, pp. 51–56 (*54–55).

Nemser, Cindy. "In the Galleries: Anthony Caro," *Arts Magazine* (New York), Dec. 1966, p. 60.

Robertson, Bryan. "Mixed Double," *The Spectator* (London), Nov. 19, 1967.

Russell, John. "Strength Made Visible," *Sunday Times* (London), Nov. 12, 1967.

Russell, Paul. "Caro, Noland at David Mirvish

Gallery, Toronto," *Arts Canada* (Toronto), Jan. 1967, Supplement, p. 6.

Stone, Peter. "Sculpture That Floats with Tension," *Jewish Chronicle* (London), Nov. 3, 1967.

Taylor, W. S. "Anthony Caro," *Sheffield Morning Telegraph*, Nov. 27, 1967.

Thompson, David. "Art," *Queen Magazine* (London), Nov. 8, 1967.

"News of Art: Anthony Caro's Sculpture," *Horizon* (New York), Winter 1967, pp. 76–77.

1968

Fried, Michael. "Two Sculptures by Anthony Caro," *Artforum* (New York), Feb. 1968, pp. 24–25. Reprinted in Whelan, 1974 (q.v.).

Greenberg, Clement. "Anne Truitt, an American Artist," *Vogue* (New York), May 1968, pp. 212, 284.

Harrison, Charles. "London Commentary: British Critics and British Sculpture," *Studio International* (London), Feb. 1968, pp. 86–89.

Kline, Katherine. "Reviews and Previews: Anthony Caro," *Art News* (New York), Dec. 1968, p. 15.

Kramer, Hilton, "Anthony Caro: A Gifted Sculptor within a Tradition," *New York Times*, Nov. 9, 1968.

Kramer, Hilton. "The Metropolitan Takes Another Step Forward," *New York Times*, May 25, 1968.

Lucie-Smith, Edward. "An Interview with Clement Greenberg," *Studio International* (London), Jan. 1968, pp. 4–5.

Read, Herbert, and Bryan Robertson. "New British Painting and Sculpture," dialogue-introduction to exhibition catalog, University of California at Los Angeles, 1968. Reprinted in *Art International* (Lugano), Feb. 1968, pp. 26–30.

Rubin, William. "New Acquisitions: Painting and Sculpture—1967–68," *Members Newsletter*, Museum of Modern Art, New York, Oct. 1968, p.[10].

Russell, John. "London," *Art News* (New York), Jan. 1968, pp. 22, 62–63 (*63).

Simon, Rita. "In the Museums: Kenneth Noland, Morris Louis, and Anthony Caro," *Arts Magazine* (New York), Summer 1968, pp. 56–57.

1969

Annesley, David. "Anthony Caro's Work: A Symposium by Four Sculptors: David Annesley, Roelof Louw, Tim Scott, and William Tucker," *Studio International* (London), Jan. 1969, pp. 14–20.

Bates, Merete. "The Core of Caro," *The Guardian* (London), Jan. 25, 1969.

Bowling, Frank. "Letter from London: Caro at the Hayward," *Arts Magazine* (New York), Mar. 1969, p. 20.

Brett, Guy. "Elegance of Caro's Sculpture," *The Times* (London), Jan. 27, 1969.

Burr, James. "Mystery in Full Daylight," *Apollo* (London), Feb. 1969, pp. 147–48.

Caro, Anthony. Statement in *Art Now* (New York), Sept. 1969.

Cone, Jane Harrison. "Caro in London," *Artforum* (New York), Apr. 1969, pp. 62–66.

Causey, Andrew. "Art: Shaped in Steel," *Illustrated London News*, Feb. 22, 1969, pp. 20–21.

Dempsey, Michael. "The Caro Experience," *Art and Artists* (London), Feb. 1969, pp. 16–19.

Dunlop, Ian. "Caro, New Language of Modern Sculpture," *Evening Standard* (London), Jan. 27, 1969.

Dunlop, Ian. "Is This Caro's Secret?" *Evening Standard* (London), Feb. 10, 1969.

Fawcett, Anthony. "Sculpture in View: Off the Mark," *Sculpture International* (Oxford), Apr. 1969, pp. 36–39 (*39).

Fried, Michael. Introduction to Caro exhibition catalog, Hayward Gallery, London, 1969.

Giles, Frank. "Groping among the Girders," *Sunday Times* (London), Feb. 16, 1969.

Goldwater, Robert J. *What Is Modern Sculpture?* New York: Museum of Modern Art, 1969, pp. 105, 107, 142.

Gosling, Nigel. "International Father," *The Observer* (London), Jan. 26, 1969.

Gotch, Christopher. "The Measure of a Man's Achievement," *Hampstead and Highgate Express* (London), Mar. 14, 1969.

Harrison, Charles. "Grã-Bretanha: Anthony Caro," in *Catalógo, X Bienal de São Paulo*, 1969, pp. 86–89. Text in Portuguese and English.

Harrison, Charles. "London Commentary: Anthony Caro's Retrospective Exhibition at the Hayward Gallery," *Studio International* (London), Mar. 1969, pp. 130–31.

Kenedy, R. C. "London Letter," *Art International* (Lugano), Mar. 20, 1969, pp. 46–51 (*49–51).

Krauss, Rosalind. "New York: Anthony Caro at André Emmerich," *Artforum* (New York), Jan. 1969, pp. 53–55.

Lucie-Smith, Edward. *Movements in Art since 1945*. London: Thames and Hudson, 1969. American edition: *Late Modern: The Visual Arts since 1945*. New York: Praeger, 1969, pp. 178, 206, 228–34.

Lynton, Norbert. "Sculpture on the Table," *The Guardian* (London), Feb. 17, 1969.

Melville, Robert. "Turner's Only Rival," *New Statesman* (London), Feb. 7, 1969.

Mullins, Edwin. "Removing the Barriers," *Sunday Telegraph* (London), Jan. 26, 1969.

Neve, Christopher. "A New Kind of Sculpture: Anthony Caro at the Hayward Gallery," *Country Life* (London), Jan. 30, 1969.

Niven, Barbara. "Fine Assertion of Space," *Morning Star* (London), Feb. 5, 1969.

Overy, Paul. "Anthony Caro," *Financial Times* (London), Feb. 4, 1969.

Richards, Margaret. "Art: Poetic Engineer," *The Tribune* (London), Feb. 7, 1969.

Robertson, Bryan. "Caro and the Passionate Object," *The Spectator* (London), Jan. 24, 1969.

Russell, David. "London: Magritte, Caro, Environ-

ments," *Arts Magazine* (New York), Mar. 1969, pp. 49–50.

Russell, John. "Anthony Caro," *Sunday Times Magazine* (London), June 15, 1969.

Russell, John. "The Triumph of Anthony Caro," *Sunday Times* (London), Jan. 26, 1969.

Salvesen, Christopher. "Anthony Caro's Iron Idylls," *The Listener* (London), Jan. 30, 1969.

Spencer, Charles. "Caro—Functional Art," *Fashion* (London), Feb. 1969, p. 44.

Spencer, Charles. "Private View: Caro and Oiticica, Object and Environment," *Art and Artists* (London), Apr. 1969, p. 4.

Taylor, W. S. "Caro, Sculptor of the Building Site," *Morning Telegraph* (Sheffield), Mar. 3, 1969.

Thompson, David. "Intimately Related to Us?" *New York Times*, Feb. 16, 1969.

Tutin, Frederic. "Brazil São Paulo 10," *Arts Magazine* (New York), Nov. 1969, pp. 50–51.

Wilson, Winefride. "This Week in the Arts: Adventure Playground," *Tablet* (London), Feb. 8, 1969.

Wolfram, Eddie. "Anthony Caro," *Arts Review* (London), Feb. 15, 1969, pp. 79, 87.

1970

Baro, Gene. "Caro," *Vogue* (New York), May 1970, pp. 208–11, 276.

Domingo, Willis. "In the Galleries: Anthony Caro at Emmerich," *Arts Magazine* (New York), May 1970, p. 66.

Fried, Michael. "Caro's Abstractness," *Artforum* (New York), Sept. 1970, pp. 32–34. Reprinted in Whelan, 1974 (q.v.).

Fuchs, R. H. "Omtrent Anthony Caro," *Museumjournaal* (Otterlo), Feb. 1970, pp. 24–30. English summary, p. 55.

Kramer, Hilton. "A Promise of Greatness," *New York Times*, May 17, 1970.

Lynton, Norbert. "British Art Today," *Smithsonian* (Washington, D.C.), Nov. 1970, pp. 38–47 (*38–39).

McLean, Bruce. "Not Even Crimble Crumble," *Studio International* (London), Oct. 1970, pp. 156–59.

Overy, Paul. "British Sculptors and American Reviewers," *Financial Times* (London), Aug. 21, 1970.

Russell, John. "Closing the Gaps," *Art News* (New York), May 1970, pp. 37–39. Reprinted in Whelan, 1974 (q.v.).

1971

Harrison, Charles. "Virgin Soils and Old Land," *Studio International* (London), May 1971, pp. 201–5.

Henning, Edward. "Anthony Caro, Wending Back," *Bulletin of the Cleveland Museum of Art*, Oct. 1971, pp. 239–43.

Marshall, Neil. "Anthony Caro's 'Clearing': The David Mirvish Gallery," *Arts Canada* (Toronto), Feb. 1971, p. 61.

Marshall, W. Neil. "Anthony Caro at David Mirvish," *Studio International* (London), Dec. 1971, pp. 254–55.

Mellow, James. "How Caro Welds Metal and Influences Sculpture," *New York Times*, July 18, 1971.

Spurling, Hilary. "Art," *The Observer* (London), Sept. 26, 1971.

Taylor, Robert. "Contemporary Sculpture," *The New Book of Knowledge Annual*. New York: Grolier, 1971, pp. 100–1.

1972

Bannard, Walter D. "Caro's New Sculpture," *Artforum* (New York), June 1972, pp. 59–64.

Cone, Jane Harrison. "Smith and Caro: Sculptures at Museum," *Baltimore Museum of Art Record*, Nov. 1972, p. [4].

Kritzwiser, Kay. "A High Quality Package of Old & New," *Globe and Mail* (Toronto), Jan. 29, 1972.

Kritzwiser, Kay. "Sleek Shapes in the Sculpture Courts," *Globe and Mail* (Toronto), July 22, 1972.

Masheck, Joseph. "A Note on Caro Influence: Five Sculptors from Bennington," *Artforum* (New York), Apr. 1972, pp. 72–75.

Rose, Barbara. "Through Modern Sculpture, from Matisse to Caro," *Vogue* (New York), Apr. 15, 1972, p. 30.

Russell, John. "A Sense of Order," *Sunday Times* (London), Nov. 12, 1972.

Sandler, Irving. "Anthony Caro at Emmerich," *Art in America* (New York), May-June 1972, p. 35.

Shepherd, Michael. "Things Seen," *Sunday Telegraph* (London), Nov. 12, 1972.

Shirey, David. "Caro's Steel Constructions on View," *New York Times*, Feb. 26, 1972.

Siegel, Jeanne. "Reviews and Previews: Anthony Caro," *Art News* (New York), Apr. 1972, p. 12.

Stone, Peter. "Serene and Subtle," *Jewish Chronicle* (London), Nov. 17, 1972.

Tuchman, Phyllis. "An Interview with Anthony Caro," *Artforum* (New York), June 1972, pp. 56–58. Reprinted in Whelan, 1974 (q.v.).

Vaizey, Marina. "Carpets and Caro," *Financial Times* (London), Nov. 30, 1972.

1973

Baker, Kenneth. "Anthony Caro: Meaning in Place," *Arts Magazine* (New York), Sept.–Oct. 1973, pp. 21–27.

Baker, Kenneth. "How Do You Define a Place?" *Christian Science Monitor* (Boston), July 20, 1973.

Carmean, E. A., Jr. "Anthony Caro's 'Night Road,'" *Bulletin of the Houston Museum of Fine Arts*, Fall 1973, pp. 46–51.

Cork, Richard. "Make Mine a Double Sculpture," *Evening Standard* (London), Dec. 1, 1973.

Elderfield, John. "New Sculpture by Anthony Caro," *Studio International* (London), Feb. 1973, pp. 71–74.

Frank, Peter. Review of Caro exhibition at Emmerich Gallery. *Art News* (New York), Sept. 1973, pp. 85–86.

Gilbert-Rolfe, Jeremy. "Anthony Caro, André Emmerich Gallery Uptown," *Artforum* (New York), Sept. 1973, pp. 87–88.

Gosling, Nigel. "Painting and Sculpture," *Observer Colour Magazine* (London), Sept. 2, 1973.

Kramer, Hilton. Review of Caro exhibition at Emmerich Gallery. *New York Times,* May 26, 1973.

Wood, Hamilton. "Weighty Sculptures on the Terrace," *Eastern Evening News* (London), Oct. 22, 1973.

1974

Blakeston, Oswell. "Anthony Caro," *Arts Review* (London), Sept. 20, 1974, p. 563.

Caro, Anthony. "Some Thoughts after Visiting Florence," *Art International* (Lugano), May 1974, pp. 22–23.

Cork, Richard. "London Art Review: Sculpture Back on a Pedestal," *Evening Standard* (London), Sept. 19, 1974.

Diamonstein, Barbaralee. "Caro, De Kooning, Indiana, Motherwell, and Nevelson on Picasso's Influence," *Art News* (New York), Apr. 1974, pp. 44–46.

Dienst, Rolf-Gunter. "Anthony Caro," *Das Kunstwerk* (Stuttgart), July 1974, p. 33.

Feaver, William. "Anthony Caro," *Art International* (Lugano), May 1974, pp. 24–25, 33–34.

Feaver, William. "Kenwood: Anthony Caro," *Financial Times* (London), Sept. 25, 1974.

Gosling, Nigel. "Art: Two Happy Marriages," *The Observer* (London), Sept. 15, 1974.

Grimley, Terry. "Art: The Evolution of Anthony Caro," *Birmingham Post,* Aug. 3, 1974.

Herrera, Hayden. "Anthony Caro," *Art News* (New York), May 1974, pp. 92–95.

Jacob, John. Introduction to exhibition catalog *Anthony Caro, Table Top Sculptures 1973–74,* Kenwood, Hampstead, London, 1974.

Martin, Barry. "New Work: Anthony Caro," *Studio International* (London), Apr. 1974, pp. 202–3.

Masheck, Joseph. "Reflections on Caro's Englishness," *Studio International* (London), Sept. 1974, pp. 93–96.

Overy, Paul. "An American Innovator," *The Times* (London), Sept. 17, 1974.

Spencer, Charles. "Five Anglo-Jewish Artists," *Jewish Chronicle* (London), June 7, 1974.

Stone, Peter. "Art: For the Top of the Table," *Jewish Chronicle* (London), Sept. 20, 1974.

Tisdall, Caroline. "Kenwood: Caro," *The Guardian* (London), Sept. 17, 1974.

Whelan, Richard. *Anthony Caro.* Harmondsworth, Middlesex: Penguin, 1974. Additional texts by Michael Fried, Clement Greenberg, John Russell, and Phyllis Tuchman.

Wilkin, Karen. "Sculpture in Steel," introduction to exhibition catalog, Edmonton Art Gallery, Alberta, 1974.

"Anthony Caro—Gallery André Emmerich," *Neue Zürcher Zeitung* (Zurich), May 8, 1974.

PHOTOGRAPH CREDITS

Unless listed below, photographs have been kindly supplied by the owners or custodians of the works. We are especially indebted to Tony Caro's photographers and friends who have recorded his work over the years, in particular John Goldblatt and John Webb.

Artforum, New York: 87; Rudolph Burckhardt, New York: 70 right; Noel Chanan, London: 2; Richard Cheek, Cambridge, Mass.: 82, 96; André Emmerich Gallery, New York: 7, 51, 97, 110, 127, 149, 173 top; André Emmerich Gallery, Zurich (Eggmann): 147, 174 top; John Goldblatt, London: 35, 39, 42, 44, 45, 46, 52, 62, 63, 67, 71, 76, 84, 85, 86, 91, 93, 104, 105, 112, 113, 114, 115, 129, 137, 153, 157, 165 bottom, 170, 171 top, 172 top, 174 bottom; Carlos Granger, London: 37, 57, 144, 145, 165 top; Solomon R. Guggenheim Museum, New York: 33 lower left; Nigel Henderson, London: 18, 19, 20 right; Peter Juley, New York: 176 top; Kasmin Ltd., London: 49, 64, 74, 81, 92 bottom, 126, 132, 134, 135, 160, 172 bottom, 173 bottom; Kim Lim, London: 24, 36, 41; Guy Martin, London; 60, 77, 171 bottom; Robert E. Mates and Paul Katz, New York: 152; Leonard Von Matt, Berne: 33 upper left; Peter Mauss, Bennington, Vt.: 150; David Mirvish Gallery, Toronto: 27, 92 top, 120; David Mirvish Gallery, Toronto (Corkin): 78, 159, 163; Museum of Fine Arts, Boston: 94; The Museum of Modern Art, New York (Allison): 119, 130; The Museum of Modern Art, New York (Keller): 25, 143 bottom; The Museum of Modern Art, New York (Sunami): 33 lower right, 69; Anthony Panting, London: 20 left; Neil Rappaport, Pawlet, Vt.: 23, 107; Ernst Scheidegger, Paris: 33 upper right; David Scribner, Bennington, Vt.: 58, 117, 122, 123, 125, 154, 155; Service photographique du Musée National d'Art Moderne, Paris: 140; David Smith Papers, Archives of American Art, Smithsonian Institution, Washington, D.C.: 34, 35 top, 141 left, 142; Marc Vaux, Paris: 176 center; John Webb, London: 28, 54, 55, 59, 80, 89, 90